# 100 YEARS OF RUSSIAN ART

# 100 YEARS OF

**1889–1989**

# RUSSIAN ART

## FROM PRIVATE COLLECTIONS IN THE USSR

Edited and with introductions by **DAVID ELLIOTT** and **VALERY DUDAKOV**

Lund Humphries, London

in association with Barbican Art Gallery and the Museum of Modern Art, Oxford

1989

Copyright © Barbican Art Gallery,
Corporation of the City of London, the Museum of Modern Art, Oxford
and the Cultural Foundation of the USSR, Moscow

First edition 1989
Published by Lund Humphries Publishers Ltd
16 Pembridge Road, London W11
in association with
Barbican Art Gallery, London
and the Museum of Modern Art, Oxford

*British Library Cataloguing in Publication Data*
100 years of Russian art, 1889–1989:
from private collections in the USSR
1. Russian arts, 1889–1989
I. Elliott, David    II. Dudakov, Valery
III. Barbican Art Gallery
IV. Museum of Modern Art, Oxford, England
700´.947

ISBN 0-85331-549-3

This is the catalogue of the exhibition
*100 Years of Russian Art 1889–1989*
*from Private Collections in the USSR*

Barbican Art Gallery, 27 April to 9 July 1989
Museum of Modern Art, Oxford, 30 July to 17 September 1989
Southampton City Art Gallery, 28 September to 12 November 1989

Organised by the Museum of Modern Art, Oxford and Barbican Art Gallery
with the Cultural Foundation of the USSR, the Soviet Peace Fund
and the USSR Club of Art Collectors

Sponsored by the Oppenheimer Charitable Trust

Organising Committee of the Cultural Foundation of the USSR:
Georgy Miasnikov, First Deputy Board Chairman
Alexander Gladkov, Chief of the International Division
Valery Dudakov, Chief Expert

The organisers are grateful to Her Majesty's Government
for agreeing to indemnify the exhibition under the National Heritage Act 1980
and the Museums and Galleries Commission for their help
in arranging this indemnity

Exhibition selected by David Elliott and Valery Dudakov

Organised in UK by Carol Brown, Barbican Art Gallery
and David Elliott, Museum of Modern Art, Oxford
with the assistance of Tomoko Sato, Barbican Art Gallery

Edited by Carol Brown
Designed by Richard Hollis

Photography by L.Melikhov, V.Nekrasov, A.Vasiliev and S.Zemnokh
Text translations by Stanley Bedford, Rosanna Kelly, Larissa Kovaliova,
Richard McKane and Catherine Phillips

Made and Printed in Great Britain
by BAS Printers Limited, Over Wallop
Stockbridge, Hampshire

Cover illustration
Pavel Filonov: **At Table (Easter)** 1912–13
Cat.58

# CONTENTS

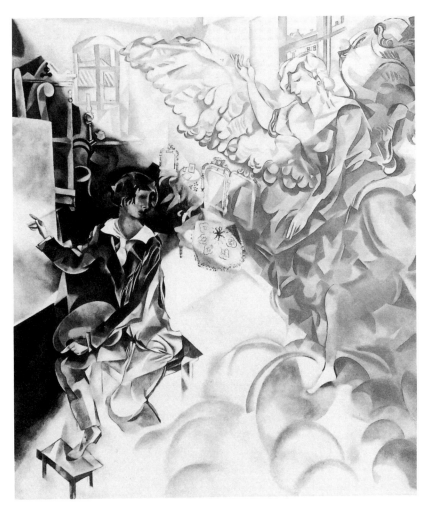

Marc Chagall:
**Muse, Apparition** 1917
Cat.27

# FOREWORD

This exhibition *One Hundred Years of Russian Art 1889–1989* is a timely successor to *Russian Style 1700–1920: Court and Country Dress*, the last exhibition of Russian art held at the Barbican early in 1987, which borrowed extensively from the collections of the State Hermitage Museum in Leningrad. Now, in this exhibition, we are able to show examples from the no less impressive holdings of Russian and Soviet art which reside in private collections throughout the Soviet Union.

This is the first time that it has been possible to give an overview of the development of modern art in Russia to the present day. For many different reasons, not every artistic tendency is represented but the essential narrative is revealed. In this respect it is the natural culmination of the series of exhibitions on modern Russian art which, during the past ten years, has been initiated and brought to Britain by the Museum of Modern Art in Oxford.

The view the exhibition gives of modern Russian culture is not tendentious; this is linked to the chain of events and disclosures that in the West we associate with *glasnost* – the new openness – which is at present transforming attitudes throughout Soviet society. It could not have taken place even two years ago and its organisation is a part of a continuing process of reassessment and historical reorientation.

Many people in the Soviet Union and Great Britain have contributed towards the successful organisation of the exhibition, not least the artists and collectors who have most generously lent their work. In Moscow the exhibition was co-selected by Valery Dudakov, an art historian working with the Cultural Foundation of the USSR. We are also indebted to Victoria Chervichenko, Marina Mishina, and Olga Milovanova for the preparation of the exhibition and the catalogue in the USSR. We should also like to acknowledge the assistance of Mr. Savelij Yamschikov, President of the USSR Club of Art Collectors.

In Britain, The Contemporary Art Society and Petronilla Silver were instrumental in the early stages of discussions, Claudia Jolles, the Kunstverein Freiburg, and Corinna Lotz have also given advice. We are particularly grateful to the Oppenheimer Charitable Trust whose generous sponsorship has enabled the exhibition to be brought to Great Britain.

---

John Hoole
CURATOR
BARBICAN ART GALLERY
LONDON

David Elliott
DIRECTOR
MUSEUM OF MODERN ART
OXFORD

David Elliott

# ONE HUNDRED YEARS: PAST AND FUTURE

One hundred years of Russian art – 1889 to 1989 – covers a period of fundamental social and political change. The culture that developed out of the October Revolution of 1917 was rooted in the past but it presented images of the new Soviet State. During the 1930s, the means of art became increasingly identified with the ends of politics. For some this was an example to be followed; for others it was a threat or a warning.

At the end of the nineteenth century the structure of Russian society seemed barely to have emerged from the shadows of the Middle Ages. The growing pains since have been immense; suffering, both self-inflicted and imposed by others, has been keenly felt by its people. This is stamped indelibly on the history of its art.

Pavel Filonov's study, *At Table (Easter)* 1912–13 (Cat. 58) illustrated in colour on the cover of this catalogue, casts light on the characteristics which have determined the path of Russian art. This painting encapsulates three apparently conflicting, but ultimately reconcilable, elements. In different manifestations they run through most of the work in this exhibition.

Firstly, there is the influence of folk or primitive art, as depicted in the lumpen shapes of Filonov's figures. *Lubki* [printed broadsheets], paintings on glass and lacquer, toys and painted shop and inn signs have all contributed to the 'national' archetype which helps to form our idea of Russian art.

Secondly, there is innovation, the forceful desire to establish new forms and ways of looking at things. Filonov's painting, like those of Malevich, Larionov or Pirosmani made at the same time, is uncompromisingly modern in its calculated rejection of academic art. During the 1920s Filonov made more radical experiments, painting multifaceted images which communicate the teeming energy and chaos of modern life.

Thirdly and perhaps more fundamentally, there is the conviction that art is essentially a philosophical activity. Here, in Filonov's painting this takes a mystical form offsetting religious against secular life. The traditional Easter breakfast taken after the Midnight Service presents an image of simplicity, order and renewal. The fish, a symbol of the Church, lies on the table; two angels, one bearing spring flowers, preside over the toast: *Christ is risen*; a couple tentatively and almost secretively touch hands.

Pavel Filonov: **At Table (Easter)** 1912–13
Cat.58

Opposite:
Francisco Infante:
**Artefacts** 1968–86
Cat.69

9

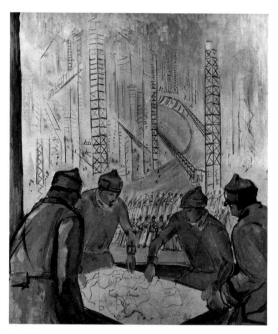

Pavel Kuznetsov: **Guarding the Socialist Motherland** *c*.1935
Cat.99

Russian artists have found it difficult to understand how
the West has managed to isolate art as an entity created for
its own sake, divorced from the wider world of ideas. In
Russia, belief in its varying forms – philosophy, religion,
metaphysics or ideology – is the foundation of culture and
existence. The formulation of such beliefs into theory and
action has been one of the distinguishing features of Russian
twentieth-century art and accounts for the many rival groups
which have proliferated.

During the 1930s this rich pluralism was dragooned into
a carefully orchestrated unanimity. In 1934 this became
canonised in the official doctrine of Socialist Realism in which
art was subjugated to the demands of the Party and the
economic imperatives of the Five Year Plans. Under this new
'scientific' system the three broadly defined tendencies –
primitivism, innovation and philosophy – described above
were compartmentalised and then imprisoned within the new
canon. Folk and primitive art embodied the spirit of *narodnost*
(art for and by the people). Innovation in its political rather
than formal sense, was expounded within the idea of *ideinost*.
Philosophy became transfixed within the materialist
interpretations of *partiinost*, the relationship of art to the aims
of the Party, and *klassovost*, the class base of the work of art
and its attitude towards the class war. The official style which
bore these concepts was 'Revolutionary Romanticism' – a
vapid and rhetorical form of realism which depicted a
simplified world inhabited not by people but by ciphers for
the 'heroes' and 'enemies' of Stalinist Socialism.

Although now felt to be old-fashioned these concepts
were enshrined in the qualifying criteria of the Artists' Union
of the USSR and it has been only in the very recent past that
these have ceased to mould the official view.

The timing of this exhibition fits into the context of
such changes; two years ago it could not have taken place. It
results from that chain of cultural reforms we associate with
*glasnost* – the new openness. The necessity of building the
present – art, society, culture – on an objective view of the
past has been realised. Censorship has been abolished and, for
the first time since the eighteenth century, there is freedom
to publish without prior State regulation. Books, previously
banned, can be obtained. Films, shelved for many years, are
now being screened. Works of art which have gathered dust
in stores are now exhibited. Throughout the Soviet Union a
cultural pluralism is being established which has not been
experienced since the 1920s. Young artists have responded to
the exhilaration of change by producing a flood of work which
in its dynamism and willingness to confront new artistic issues
breaks away from the shackles of hidebound dogma. This
must provide grounds for future optimism.

The work in this exhibition has been selected

Konstantin Gorbatov: **Pskov** 1919
Cat.65

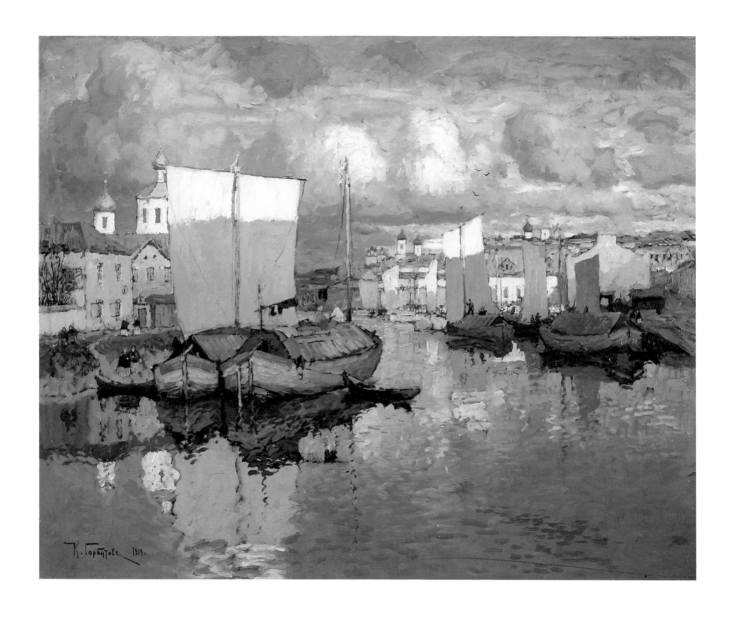

exclusively from private collections; in this lies both its strength and its weakness. It is not generally appreciated that a flourishing art market has been sustained since the Revolution and that there are many substantial private collections in the major cities. The taste of these collectors does not always comply with that of the State museums, and accordingly we see here a history of Russian art through a different, more personal perspective.

The sentiments as well as the dimensions of the *grandes machines* of Socialist Realism were not always in keeping with the sensibilities, interests and wall sizes of many private collectors. They did, however, collect and preserve works which did not meet with official approval: the pre-Revolutionary Symbolists, Pyotr Utkin, and Nikolai Doseikin; artists who had emigrated, such as Boris Grigoriev, Nathan Altman or Nikolai Roerich; the mystical and religious painters of the 1910s and 1920s – Vera Khlebnikova, Vasily Chekrigin and Leonid Chupyatov; the little recognised 'expressionists' of the early 1930s, Aleksandr Drevin and Solomon Nikritin; the 'unofficial' artists of the 1950s, 1960s and 1970s – Oskar Rabin, Lev Kropivnitsky, Oleg Tselkov, Ilya Kabakov, Francisco Infante and Erik Bulatov. It was this generation who, after Stalin's death in 1953, began the daunting labour of re-building modern art in Russia.

All these artists are well represented in private collections and their inclusion has highlighted the limitations, as well as the uncharacteristically dialectical nature, of the Western stereotype of Soviet art. This, set out crudely, 'balances' the high quality of the 'abstract' avant-garde against the 'low quality' of different realist schools. Such blatant and anachronistic ideology bears little scrutiny against the facts. It is surely axiomatic that hack work of any tendency is of little but academic interest as there are 'good' and 'bad' artists in all schools. What becomes clear here though is that there was not one Russian avant-garde but many and in confusing aesthetic values with political ideology we are in danger of misunderstanding what actually happened. The kind of crude opposition described above did not occur until the 1950s during the Cold War when abstract art was promoted as being representative of the 'free' cultures of the Western Democracies in opposition to State institutionalised Socialist Realism.

The notion of realism in Russian art and literature is radically different from that in the West. The word does not necessarily bear the same literal and earnest implications of faithful depiction – there is not one reality but many and this is reflected in the use of the term. The critic, Nikolai Chernyshevsky, writing in the middle of the last century, described Gogol's satirical novels as 'poetic realism'; the acronym OBERIU, a group of absurdist writers active in

Vasily Chekrigin: **The Toilet of Venus** 1918
Cat.33

Leningrad in the late 1920s stood for The Association for Real Art. Malevich, also, working from 1915 on a series of non-objective Suprematist paintings was in his way, a 'metaphysical realist'. The young Naum Gabo and Antoine Pevsner entitled their 1920 treatise on the machine forms of Constructivism *The Realistic Manifesto* and even though it has been claimed that this was little more than a ruse to get past the censor the title could be justified by the fact that in Russian culture 'realism' often lies in the eye of the beholder.

In the context of the 1910s and 1920s the mutually exclusive polarities of Abstraction and Realism are false. From the painting of icons to the present day, pictorial language in Russian art has been both hierarchical and symbolic. This explains why during the period of the Cultural Revolution and of the first Five Year Plan (1928–32) artists such as Malevich or Tatlin, who during the previous decade had employed non-objective elements as a basis for their work now of their own accord returned to forms of figuration. The new world of the 1930s also demanded adherence to the Party Line and 'intelligibility to the masses'. Ultimately this led to a destruction of their ideas as it meant a return to the conservative traditions of late nineteenth-century academic realism and left no room for the egalitarian aims of functional design and the identification of new forms which had been important characteristics of the avant-garde in the 1920s.

Although limited by the availability of work in private collections, this exhibition reveals the essential narrative of modern Russian art. It starts with the search for identity – a crisis which spread across the whole Slav world during the late nineteenth century. Viktor Vasnetsov along with Nikolai Roerich and Konstantin Gorbatov look back in their painting to an exotic golden age. Less literal in approach, but equally rooted in the past, Mikhail Vrubel combines a demonic romanticism with the knowledge and sensibility of ancient Orthodox mosaics.

The artists in St Petersburg who, at the turn of the century, gathered around Diaghilev's World of Art looked to the West – to the elegance and pathos of a disappearing age of nobles, courtiers and palaces as in Alexandre Benois' watercolours of Versailles (Cat. 9, ill. in col. p.86), or in Nikolai Sapunov's *Dance* of *c*.1912 (Cat. 181, ill. in col. p.87). Their contribution to art lay not only in their conoisseurship but also in their willingness to combine art forms, moving from the academic ghetto to design, theatre, costumes, sets, typography, fine printing – even furniture. In this they anticipated the avant-garde Productivists of the 1920s who moved away from the Fine Arts to work in design.

In Moscow the influences of contemporary French painting took a lead. Initially it was Symbolism and the frescoes of Puvis de Chavannes which made an impact on the

Konstantin Korovin: **Portrait of a Woman** *c*.1915
Cat.87

Marc Chagall: **Soldiers with Bread** 1914
Cat.26

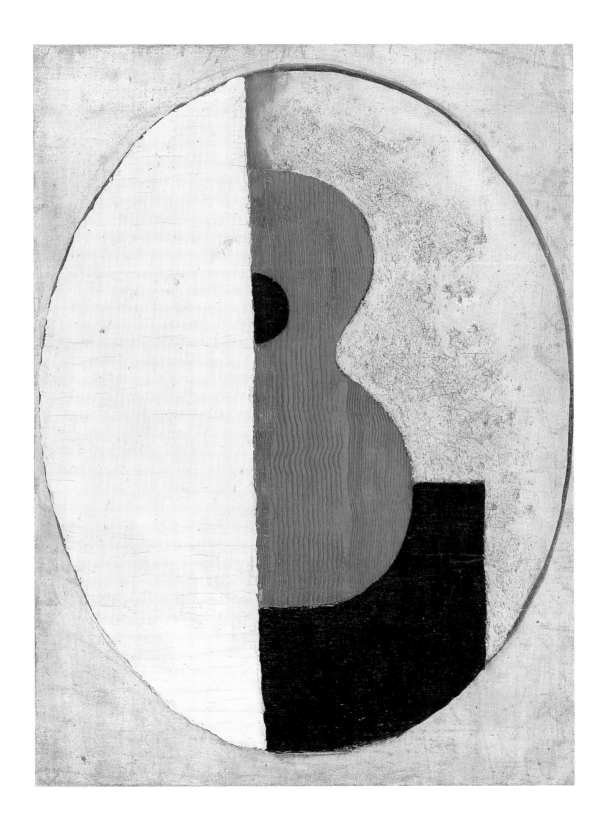

dreamily allusive painting of Viktor Borisov-Musatov; Impressionism also was, for a time, taken up by Konstantin Korovin and Leonid Pasternak. Russian art now struggled to catch up and young artists would in the space of a few months work through and discard styles which in the West had undergone years of gestation.

By 1907, the time gap had been closed and a new generation of collectors were buying the latest work to come out of Paris. This is why so many important early paintings by Picasso, Matisse and Derain still remain in Soviet museums. Within a short time young Russian artists were responding to this challenge and were creating new work themselves. Mikhail Larionov, Natalia Goncharova and Aleksandr Shevchenko were the leaders of this generation; in the paintings shown here they respond first to the influence of Impressionism to move away from this towards a style of specifically Russian Neo-primitivism. Out of this, they developed a completely different kind of work, Rayism or Luchism – images of the natural world expressed through striated brushstrokes in which the subject becomes fused with the physical surface of the painting; Shevchenko's *Idleness and Shadow* of 1914 (Cat. 191, ill. in col. p.101) is a fine example of such work.

Another tendency in the pre-First World War avant-garde took Cézanne as its point of departure. Robert Falk, Aristarkh Lentulov and Pyotr Konchalovsky were all exhibiting with the Moscow Knave of Diamonds Group, and had, by the end of the decade, established personal styles which, while not as avant-garde as those of the Suprematists or Constructivists, were neither provincial nor derivative. For the first time in Britain a series of major works by these artists is shown which includes Lentulov's impressive *Victory Battle* of 1914 (Cat. 111, ill. in col. p.17) and homage to the October Revolution *Peace, Celebration, Liberation* of 1917 (Cat. 113, ill. in col. p.113).

Futurism was also an important influence from abroad but it became transformed in a Russian context into Cubo-Futurism, a new synthetic movement. Rodchenko's early *Portrait of N.A.R.*, 1915 (Cat. 168, ill. p.66) showing his sister-in-law and her son is made in this vein as is Popova's *Guitar*, 1914 (Cat. 158, ill. in col. p.15). The dynamics of the Italian Futurists are made clear in Aleksandr Bogomazov's *Tram*, 1914 (Cat. 13, ill. in col. p.102) and *Steam Engine*, 1915 (Cat. 15) as well as in Mayakovsky's *Self Portrait*, c.1915 (Cat. 134, ill. in col. p.115). But by this time two specifically Russian art movements had begun to develop: Suprematism centred around Malevich and his circle – represented by Popova, Udaltsova, Suetin and Kagan, and Constructivism shown here by Rodchenko, Varvara Stepanova, Aleksandr Vesnin and Aleksandra Ekster. While Suprematism reflected

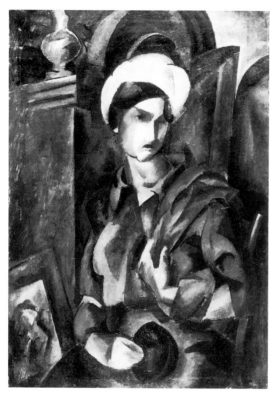

Robert Falk: **Woman in Turban** 1918
Cat.55

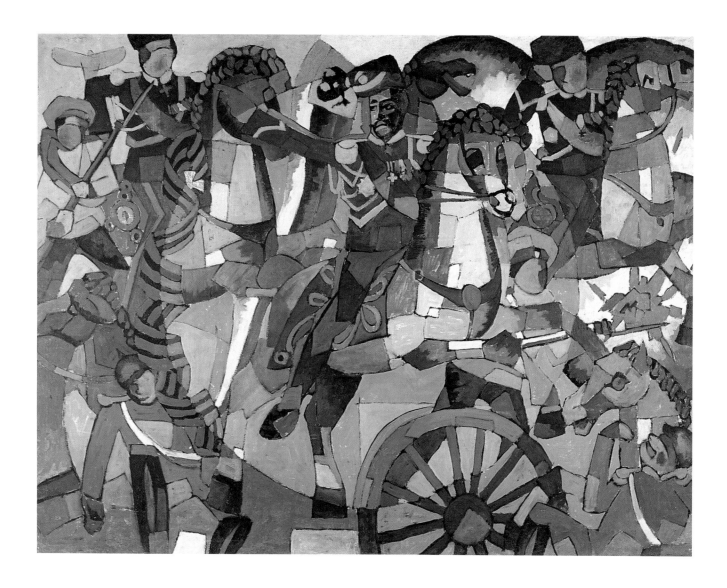

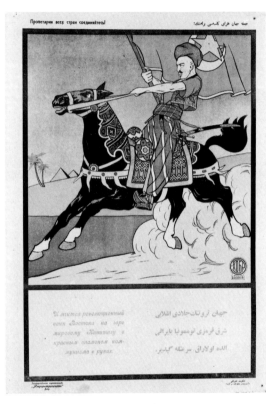

Ludwig Knit: **Revolutionary Rider with Banner** 1920
Cat.78

a hierarchical cosmic order of being, Constructivism was materialistic and more concerned with the basic language of art and structure. In 1921 one Moscow Constructivist group stopped making art as an end in itself and devoted itself entirely to design, photography, architecture and the applied arts. In a seminal exhibition $5 \times 5 = 25$, Aleksandr Rodchenko exhibited three monochrome canvases and declared that experiments within the laboratory of art could proceed no further. From this moment art had to be useful and play its part in moulding the new society of the Soviet future. The posters and ceramics in the exhibition show how propaganda, art and design were now combined.

Our view of twentieth-century Russian art generally focuses on the two capitals – Moscow and Leningrad – but there were also important groups working in the Ukraine, Georgia and Central Asia. The exhibition has included work to show this wider activity – not only the Civil War propaganda posters [1918–21] produced for the Moslem communities of Azerbaijan but also examples of the flourishing Kiev avant-garde in which Bogomazov and Ekster were active. In Tbilisi, Georgia, the art of Pirosmani has long achieved the status of a national treasure and was a considerable inspiration to the Neo-primitivist work of Larionov, Goncharova, Shevchenko and Kyril Zdanevich, while in Tashkent, where Aleksandr Volkov worked and taught, Central Asian motifs became a starting point for his avant-garde paintings.

After the cultural dislocation of the 1930s and 1940s the threads of continuity in modern art were almost broken but there were tendencies for reform both from inside and outside the system. Nikolai Andronov and Viktor Popkov both pioneered a less romantic and idealised form of realism which although controversial was officially exhibited.

At the same time, during the mid-1950s, an unofficial, sometimes called 'dissident', art movement grew up in the new Moscow suburb of Lianozovo. Not accepted by the Artists' Union these artists, some of them self-taught, showed their works privately, selling to friends and foreign collectors. Occasionally their open-air exhibitions were broken up by the police. Oskar Rabin's backward-looking but stark Moscow realism typifies one aspect of this work while Lev Kropivnitsky and Vladimir Nemukhin show in their paintings an awareness of the international movements of Art Informel and Abstract Expressionism. Vladimir Veisberg's sensitive portraits and still lifes represent yet another strand of modern art – one which looks back to the example of the Knave of Diamonds group through the influence of Robert Falk, Veisberg's teacher.

The art of the subsequent decade is more inward-looking and critical. There is a satirical edge to Kabakov's

painting of a small dog about to be crushed by the elephant of 'progress' (Cat. 73, ill. in col. p.148) as there is to Tselkov's grimacing red masks, one of which is adorned by the pervasive medal. Erik Bulatov's postcard view of the Stalinist fountains and pavilions at the Exhibition of Economic Achievements of the USSR in Moscow is almost cancelled out by the large and ironical slogan painted over it: 'Have a Nice Stay' (Cat. 21, ill. in col. p.146–7).

Yet not all modern art in Russia makes a social comment. The metaphysical approach of Suprematism continues in the large photo sculptures of Francisco Infante. In these the geometrical motifs of Suprematism are integrated with landscape. His work is at the forefront of that tradition of experiment in art which was initiated by the avant-garde of the 1920s.

The young artists, Vadim Zakharov and Andrei Roiter, both members of the Moscow Hermitage group, continue the detached style of Kabakov and Bulatov into the 1980s. In his large paintings and installations, Zakharov combines ironical texts with dark threatening images. The image of the elephant is for him an analogue of a lumbering and insensitive system. Roiter's paintings traverse many different styles but those shown here make a critical comment on the meaning of information and statistics. Complexity is lost, the most obvious tautology is put in its place. This generation seems wary of the naive utopianism of the avant-garde of the 1920s. It uses a language of distance and irony as a means of taking the initiative. The commitment and energy of these artists and their peers is impressive. We are relying on them to play a formative and active role in the re-establishment of a critical, philosophical and dynamic presence in modern culture – to act within the strongest traditions of Russian art that we see here.

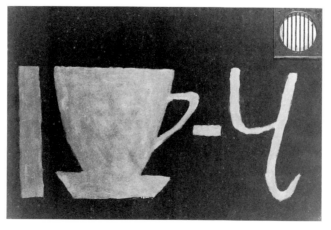

Andrei Roiter: **One Cup of Tea** 1987
Cat.177

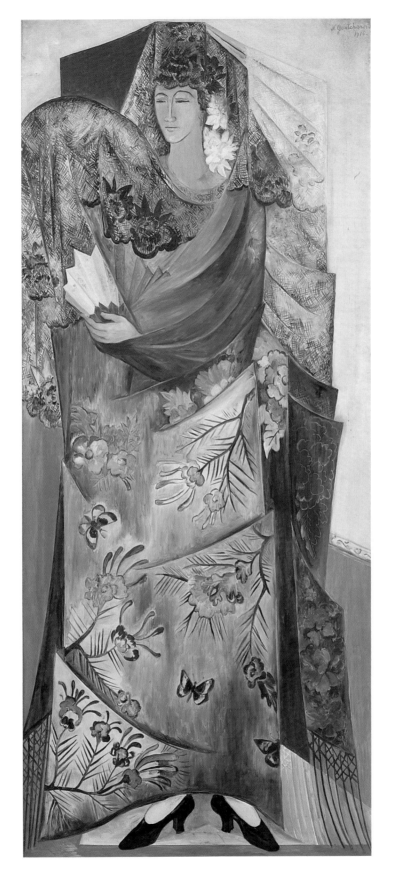

Natalia Goncharova:
**Spanish Woman** 1916
Cat.64

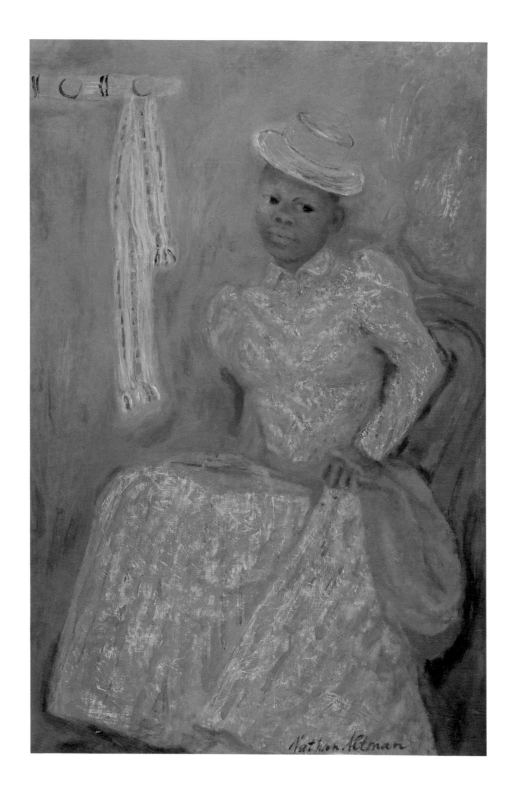

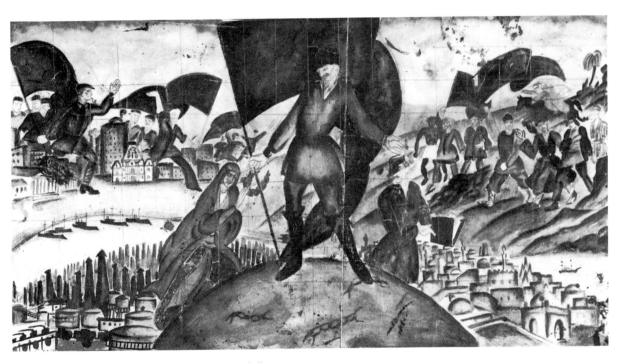

Unknown artist: **The Union of Town and Countryside in Azerbaijan** *c*.1919
Cat.242

Valery Dudakov

# INTRODUCTION TO THE EXHIBITION

The exhibition *100 Years of Russian Art 1889–1989 from Private Collections in the USSR* is devoted to a fascinating period in the art of our country. Russian art has developed hand in hand with the times. Harsh social realities and utopias, the search for life's meaning, a yearning for the absolute, and dreams of a rebirth of beauty were all reflected in Russian art more frequently and more directly than in Western European art. Dostoyevsky's belief that 'beauty will save the world', was the hope of Russian artists not only around the turn of the last century but also in more recent times.

This is the first time such an exhibition has been organised abroad. It has developed out of a series of exhibitions of work from both State and private collections on the history of the avant-garde at the time of the Revolution. Two hundred and fifty historical examples of paintings, sculpture, 'agit-porcelain' and propaganda posters are shown with contemporary art. These works belong not to State museums but to thirty-eight private collections as well as to some of the contemporary artists whose works are exhibited. Many of the collectors, who have allowed works to be shown, are members of the Club of Art of Collectors which is affiliated to the Cultural Foundation of the USSR.

Art collecting in Russia is not simply a privilege that has been enjoyed in recent times; it follows a national tradition. Towards the end of the last century new types of collections began to take over from the old family collections of the Stroganovs, Rastopchins, Golytsins and Shuvalovs. These were made by rich merchant collectors who, moved by patriotism, collected not only masterpieces of Western European art, but also Russian antiquities, icons and old printed books, taking a special interest in Russian painting.

P.M.Tretyakov, K.T.Soldatenkov and the Botkin brothers began collecting paintings, drawings, and sculpture made by their contemporaries, and in Russia a special type of patronage developed, based on a close relationship between artists and collectors. The collection of the four Shchukin brothers was later to enrich many State museums and Sergei Ivanovich Shchukin's collection of major French paintings from the mid-nineteenth to the early twentieth centuries provided a training ground for those artists who were to give birth to the new movements in Russian painting. It was here that many painters first encountered what the artist and critic Igor Grabar described as the art 'not of yesterday but of today, or rather tomorrow'.

The Morozov brothers came from a rich Russian family of 'industrial barons' and also shared the passion for collecting. Around 1895 Mikhail Abramovich, the elder brother, began collecting paintings by Russian and French artists. After his early death, his widow donated his fine collection to the Tretyakov Gallery. The collection of his younger brother was formed at a later date but quickly became one of the most important collections in Russia, representing French and Russian painting, sculpture and monumental-decorative art of the early twentieth century. It is largely through this collection that the Russian public became aware of the work of Cézanne, Van Gogh, Gauguin and Picasso.

Ilya Semyonovich Ostroukhov, the landscape painter and one of the most important figures in the Russian art world at the turn of the century, was also a well-known collector. Alongside this collection and the important and varied collections of N.P.Ryabushinsky, E.V.Lyapunova, V.O.Girshman, A.A.Korovin and others in the art world, there were more modest and specialised collections which reflected the particular interest of their owners. Dr I.I.Troyanovsky, for example, collected works by artists of the World of Art, Blue Rose and Knave of Diamonds groups and the St Petersburg patron, L.Zheverzheyev, President of the Union of Youth association, collected works from this and other avant-garde groups. Private art galleries were also set up before the Revolution in St Petersburg, Moscow, Kiev and Odessa, the owners of which, such as N.I.Dobychina, K.F.Lemercier and V.A.Izdebsky not only promoted and sold works by new artists but also collected modern art.

The October Revolution opened a new period in Russian history. The cultural heritage became the property of the people and its preservation was one of the most important concerns of the Soviet authorities. On the day the Winter Palace was stormed, commissars of the Revolutionary Military Committees were appointed to 'preserve museums, palaces, art collections' and 'centres of artistic heritage'. The people were called upon to care for monuments and works of art, and in November 1917 a ministry was created 'for museums and the preservation of historical monuments of art and antiquity'. One of the commission's tasks was to make an inventory of art treasures in private collections; unfortunately many of these were taken out of the country. In Petrograd alone between 1917 and 1919 almost three thousand important collections were investigated, and private collections were transferred to museums or given into the State's care. Works by contemporary artists filled the old and newly-opened museums and galleries. The Commission of Fine Arts of the People's Commissariat of Enlightment (IZO Narkompros) recommended that the State museums acquire works by artists of the avant-garde and many artists of the new movements were represented in the new Museum of Painting in Moscow.

Private collecting did not disappear at this time but supplemented State involvement. At the beginning of the 1920s the journal *Sredi Colleksionerov* [Among Collectors] was published, which printed articles about collections, collectors, exhibitions and auctions, and in the years of the New Economic Policy many auction halls and commission shops appeared. Many of the collections that had remained intact were further developed and others came into being. The Rybakov collection, works from which are shown here, was made at this time.

In the 1930s, many scientists and artists were collectors, for example E.V.Gelster, the ballerina; L.A.Ruslanova, the singer; N.D.Afanasev, an engineer; and the academician M.F.Glazunov, whose collections had to survive the difficult war years. A great many

new collections were created in the late 1940s, but the real peak of enthusiasm came in the mid-1950s when interest in the painting of the 1910s and 1920s revived, both in the Knave of Diamonds group, and in the work of the other avant-garde movements. Many outstanding works of Russian twentieth-century art were collected by E.A.Gunst, I.I.Paleyev, A.L. Myasnikov, Z.K.Gordyeva and B.N.Okunyev. The heirs of the artists themselves also played an important role. Through the efforts of E.E.Lansere, A.V.Falk, M.A.Lentulova, the Drevin family, the Rodchenko family, T.A.Shevchenko, V.D.Shterenberg and T.S.Kuprina, many remarkable works were preserved, some of which have been donated to the State art museums.

In our times the transfer of private collections to museums has been a common phenomenon. A.Ya.Abramyan, the academician, donated his marvellous collection of twentieth-century Russian painting to the city of Yerevan, and, recently in Moscow, the Museum of Private Collections was founded at the initiative of I.S.Zilbershteyn, to which many interesting collections of graphics, sculpture and painting have been donated. The country's most important museums also regularly receive gifts; the Tretyakov Gallery, for example, was most fortunate to receive part of the outstanding Costakis collection.

We are particularly indebted to George Costakis for his passion for the avant-garde art of the 1910s and 1920s. He literally drew many artists and their works out of oblivion, and brought them into our current understanding of art history. It is in many ways thanks to this that interest in twentieth-century Russian art has grown appreciably, both in the USSR and abroad. Research by art historians, collectors, and museum workers has also furthered the discovery of works by these forgotten artists and entire artistic movements. As a result, many post-war artists in Russia, who only knew twentieth-century Russian and Western European art in reproduction or by repute have now been able to gain access to these works at first hand. During the 1950s, this 'second discovery' was a stimulus to new, unorthodox movements of contemporary Soviet art. The work of these artists of the new realism, the unofficial movements, conceptual art, and of the 'new wave' of the 1980s was principally inspired by the avant-garde art of the 1910s and 1920s, and collectors interested in this earlier period of Russian art were also keen to purchase contemporary works.

In considering the heritage of contemporary Soviet non-traditional art, it is clear that despite its new form and content these movements are also very much tied to the tradition of the Russian national school. This new art of the twentieth century did not develop only out of a re-assessment, but was a continuation of the traditions of the end of the last century.

Mikhail Vrubel: **Portrait of A.G. Rubinshteyn** 1889
Cat.228

From the mid-nineteenth century, a socially-orientated critical realism turned to new themes. Repin, Antokolsky, Polyenov and Vasnetsov more frequently chose subjects concerned with moral problems or the poeticisation of history, using motifs from old Russian folk tales.

The works of Viktor Vasnetsov express the feelings of the neo-romantic national movement and combine literary concerns with historical portraiture, and a grotesque naturalism. Vasnetsov's art, along with that of his contemporaries, embodied a national ideal.

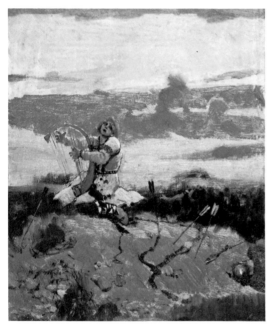

Viktor Vasnetsov: **The Last Song** 1881
Cat.218

In Isaac Levitan's landscapes, the feeling of fresh, open air in his early work altered at the end of his life as he searched for simple, but all-embracing, symbols of nature, which he realised with refined lyricism.

In the 1880s the young artists Mikhail Vrubel, Viktor Borisov-Musatov, Konstantin Korovin and others began the search for new methods of achieving realism. They manifested a neo-romantic inclination towards philosophy, concerning themselves with the relationship between art and life, the search for an ideal, and the re-establishment of a historical tradition. New principles were affirmed in the Abramtsevo circle, which formed around its patron, the industrialist S.E.Mamontov. Significantly these applied not only to painting and sculpture but also to theatre design and architecture. Vrubel expressed the spirit of the circle:

> I am at Abramtsevo again and I am seized by, no not seized by but sense, that subtle notion which I want to capture on canvas and in my decorative work. This is the music of a whole man, not a sensibility disembodied by the attractions of the regimented and poverty-striken West.

Vrubel formed a bridge between the art of the nineteenth and the twentieth centuries. He searched for the relationship between the subjective world of the spirit and the objectivity of the real world:

a tragic conflict between dream and reality which was to characterise Russian art in the new century. This can be seen clearly in Vrubel's series of works on the theme of the demon, in which he contrasted the symbols of light and darkness, and of destruction and resurrection (Cat. 231, ill. p.75). It was not without difficulty that Vrubel burst through the heritage of academicism to work in a style which made possible a unity between sensory expression in colour and form and symbolic meaning. He found new means of communicating feeling and thought, unburdened by naturalism.

Konstantin Korovin: **Winter** 1915
Cat.86

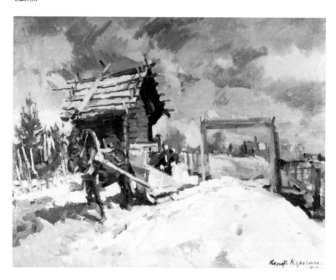

Borisov-Musatov followed a similar path. Initially influenced by the French Nabis and Post-Impressionists, his work became a complex, symbolical synthesis. The 'ladies' and 'ghosts' in his paintings are chance apparitions dissociated from the world of reality, yearning for a return to a primordial state.

Valentin Serov's work was another critical factor in the development of Russian art. He never renounced the heritage of realism, but achieved a perfection of expression which was to guide future generations. In his last cycles on classical themes he concentrated on the creation of a style based on a modern treatment of mythology. Konstantin Korovin, Vrubel and Serov's friend, turned to Impressionism in the search for a new poetic means to interpret nature. He hoped to create paintings as 'a feast for the eyes', and to mould reality, in Serov's words, 'through the prism of his temperament'. Korovin's Impressionist style was of considerable influence, particularly in the Moscow School of Painting, Sculpture and Architecture [MUZHVZ].

Leonid Pasternak, a fellow teacher, like many members of The Union of Russian Artists and The Wanderers, also looked to Impressionism. Nikolai Doseikin, one of the early Russian Impressionists, lived permanently in Paris but showed with the Union of Russian Artists. The influence of French Symbolism can be found in his rare mythological works.

The inter-relationship between East and West was of great significance for Russian art of this period. Dostoyevsky's feeling that

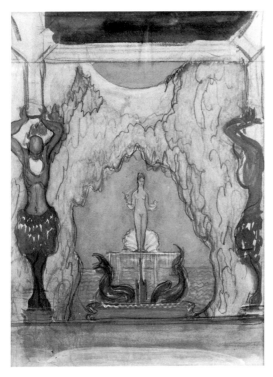

Valentin Serov: **Diana and Actaeon** 1911
Cat.188

'to be really Russian perhaps only means becoming a brother of all humankind' was something which became firmly rooted in the consciousness of the intelligentsia.

Towards the end of the nineteenth century, The World of Art group founded in St Petersburg hoped to assimilate not only the national but also a Western cultural heritage. The artists and active participants of The World of Art, including Benois, Diaghilev, Somov, Golovin, Bakst, and Filosofov, believed that an understanding of modern European painting would facilitate the rebirth of national art and in so doing crossed the border between the art of the nineteenth century and that of the fast approaching twentieth. These artists embraced not only painting, graphics and sculpture but also architecture, ballet, opera, theatre, poetry and art criticism and were most active in St Petersburg, disseminating information about the latest Western European developments. Alexandre Benois, the ideologist and theoretician of the group, led the association with Sergei Diaghilev and ran the journal of the same name. He was also one of its most brilliant artists. In his painting of Versailles at the time of Louis XIV, 1906 (Cat. 9, ill. in col. p.86) his views of ancient Italian villas, and St Petersburg at the time of the Tsar Alexander I, Benois reconstructed a lost past as if through the eyes of a contemporary witness, encouraging the viewer to believe in the reality of a dramatised 'historical landscape'. His approach provided a prototype for artists of the avant-garde working at the beginning of the century, who shared his desire to create an art based on its own intrinsic values, independent of the subject-matter of the real world.

In the theatrical works and portraits of Aleksandr Golovin, nature was transformed into a fantastic decoration, often with heroic and mystical undertones. Yevgeny Lansere's historical paintings and decorative landscapes were also endowed with a characteristic monumentality intensified by the delicate nuance of colour. Similarly, Zinaida Serebriakova's peasant scenes had a monumentality in which a modern, heroicised neo-classicism was apparent. In her dramatised portraits she turned to early nineteenth-century traditions and to images far removed from her own time.

Boris Kustodiev was one of the most eminent national painters. Poeticising the merchant life of the provinces and patriarchal old Russia, he brought shades of irony and the grotesque to lovingly painted scenes of folk festivals, fêtes, and carnivals. He quoted folk art and the figures of popular literature in everyday portraits of merchants which, in their stylised flatness and brightly decorated form, immortalise the Russian character as a timeless ideal.

The works of Nikolai Roerich focus on the architecture and legends of medieval Russia and pagan Slav times. Nature here is spiritualised and permeated by a mystical pantheism. He presented a national ideal evolving a symbolic and allegorical language from the monumental art of old Russia and a modern graphic style.

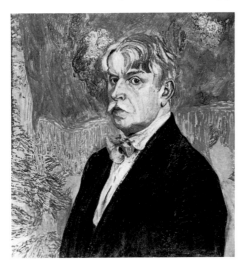

Aleksandr Golovin: **Self Portrait** 1919
Cat.60

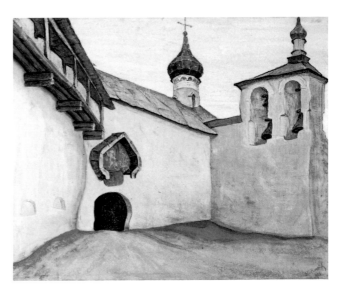

Nikolai Roerich: **Pskovo-Pechersky Monastery** 1907
Cat.175

Following in the path of The World of Art group, The Union of Russian Artists, and The Brotherhood of Moscow Artists, new artistic movements and groups were founded which became particularly active around 1905. These forerunners of the avant-garde continued the search for a new, contemporary language and the 1910s became a time of complexity and contradiction. Former values were overthrown to be replaced by new theories and counter-theories. The pace of artistic life increased dramatically, techniques and styles changing swiftly during these the pre-Revolutionary years.

The Crimson Rose exhibition, organised in Saratov in 1904, took its name from the symbol of hope, youth and earthly passion as described by the philosopher Solovyev, and united artists connected with the Russian Symbolist movement. The organisers, Pavel Kuznetsov and Pyotr Utkin, invited Sergei Sudeikin, Nikolai Sapunov and others to participate; Vrubel and Borisov-Musatov (whom they considered their teachers) were also shown. Utkin's painting *Night* of 1904 (Cat. 217, ill. in col. p.90) is characteristic, showing the link between Russian Symbolism, the Nabis and Belgian art nouveau. Here, encircled by golden leaves, nightbirds fly in and an eagle claws at a duck in a vision of nature made complex through its symbolism.

The Russian Symbolists were close to the masters of The World of Art in their presentation of an ambiguous, twilight world. Their references to folklore also reflected the interests of the Abramtsevo circle. They seemed to sense the possibility of transition from the real world to one that was imagined and more meaningful, and strove towards a simplicity and restraint in which the tremulous feeling of nature is nevertheless preserved.

Martiros Sarian: **Landscape with Wild Goats** 1907
Cat.182

In Moscow in 1907, Kuznetsov, Utkin, Sarian, Sapunov, Sudeikin, Krymov and Arapov mounted the Blue Rose exhibition. Blue, the colour of the sky, of water and of boundless space held a symbolic meaning for these artists. They encouraged a mystical interpretation which combined poetic dream with reality, sadness and hope. The Blue Rose artists were closely connected with the Symbolist poets and writers in Moscow who were associated with the journals *The Balance* and *The Golden Fleece*. According to the theories of Vyacheslav Ivanov, Aleksandr Blok, Andrei Bely and

other Russian Symbolists, reality was simply a stimulus, a starting point for the artistic image. Artists of the Blue Rose accordingly invented their own world in which fantasy and childhood dreams, feelings of foreboding and a sense of the supernatural combined to allow poetic imagination to soar above reality.

These Symbolist artists also attempted to absorb the techniques of other arts within painting. Musical and poetic associations were expressed through rhythm, movement, texture and colour. They worked towards new principles which were to crystallise in the work of the later radical movements.

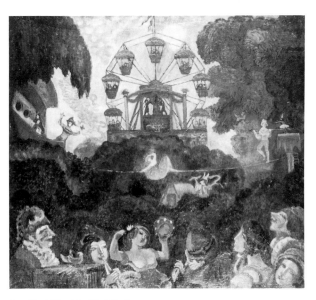

Sergei Sudeikin: **The Big Wheel** 1910
Cat.202

The Blue Rose group was the first to be united by a single aesthetic, yet each artist retained an individuality. Sarian's work has the clear decorative quality of a romantic Eastern fable, and Sapunov's *Dance* of c.1912 (Cat. 181, ill. in col. p.87) with its earthly and infernal passions, contrasts dark tones and bright lights with tragic foreboding. Sudeikin's *The Big Wheel* of 1910 (Cat. 202, ill. p.27) shows a characteristic theatricality; lively and whimsical it points to the tragi-comedy of existence. This playful world could not substitute reality for long, however, and artists of the Blue Rose soon re-evaluated their position.

By the end of the 1920s, Kuznetsov, the former leader of this group, had achieved a new harmony in the eternal themes of his Eastern 'Kirghiz' series. Daily life on the steppes, inseparable from nature and devoted to age-old traditions provided everyday subjects in which he was able to discover the constant and universal laws of life. In his paintings, the endless steppes are set against the beauty of nature, and the people have a simple yet majestic wisdom; each motif he depicts becomes a sign which is at once real and symbolic. Kuznetsov achieves perfection through a harmony of composition and colour, and reality here is completely embodied in the visionary world of the artist.

Larionov, Goncharova, Shevchenko, Jawlensky and Yakulov were also closely linked to the journal *The Golden Fleece* and the

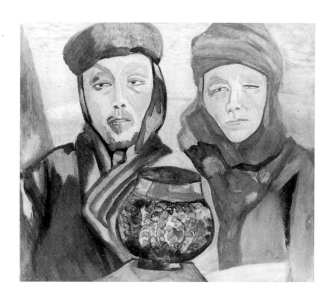

exhibitions organised by its publisher, N.Ryabushinsky, in which many leading artists of the early twentieth century from Russia and abroad were included. Works by Gleizes, Bonnard, Braque, Derain, Matisse, Le Fauconnier and other French artists were shown alongside paintings by Larionov, Goncharova, Kuznetsov, and Utkin. Russian artists were able to measure their work against the Western European school, to the enrichment of both. Russian artists also began to establish international reputations, exhibiting in both Germany and France.

Alexei Jawlensky and Vasily Kandinsky played an important role in both Russian and German art. Both were represented in the Blaue Reiter exhibitions in Germany and took part in Russia in the Knave of Diamonds and other avant-garde exhibitions, and together logically formulated a style which abstracted forms from nature.

Pavel Kuznetsov: **Kirghiz Family** 1910
Cat.95

## THE KNAVE OF DIAMONDS

The first primitive works of Mikhail Larionov and Natalia Goncharova were shown at the exhibitions of The Golden Fleece and The Wreath-Stephanos (Moscow 1907). They developed the Impressionist and decorative traditions of Boristov-Musatov adding an irony taken from Symbolism to reach a further complexity. They were also interested in the 'primitive' folk art of the provinces: shop signs, cheap popular prints, toys, billboards and advertisements, and were the first to start collections of such material.

From 1905 to 1908 Larionov and Goncharova worked towards a unified vision. Consciously simplified forms began to dominate their Impressionism and their colours became stronger and more expressive as they freely created a world close to that of folk art. Whereas Larionov's work was ironic, Goncharova's had a more emotional and expressive quality, but these two leaders of the avant-garde shared a determination not to be restrained by any formal criteria or by the dictates of fashion. In the 1910s Goncharova openly declared that 'one should fear neither painting, nor literature, nor illustration, nor all the bugbears of modernism'. She claimed the right for artists to appropriate all means according to their own aims.

Many artists of the new generation gathered around Larionov and in 1910, with Goncharova, the Burlyuk brothers, Konchalovsky, Mashkov, Lentulov, Kuprin, Milman, Rozhdestvensky and Falk, he opened an independent exhibition, the Knave of Diamonds. The title itself expressed their enthusiasm and confidence, and threw a direct challenge to the public. Diamonds from a pack of cards were a familiar reference to prison uniforms and, since the time of the Italian Renaissance, the knave had been recognised as the symbol of art. Within a year a group of artists with the same name was formed which was to become the most influential exhibiting group of the period.

While each artist of the group had an individual style there was much to unite them. They developed a primitivism using bright, decorative and sumptuous colour, which adopted elements of the

Mikhail Larionov: **The Walk** 1906
Cat.103

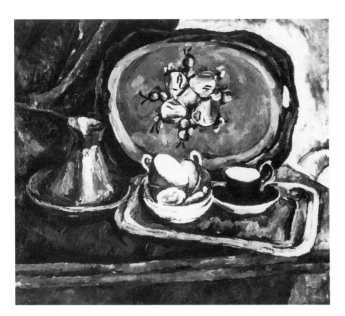

Pyotr Konchalovsky: **Still Life with Tray** 1919
Cat.83

popular and folk arts. The heritage of French paintings from
Cézanne to the Cubists was also evident.

The influence of Cézanne is clearly visible in Pyotr
Konchalovsky's powerful still lifes as well as in the work of Aleksandr
Kuprin in which the energy expressed through brush stroke and
colour gave his paintings a heightened drama. Ilya Mashkov,

liberated from the constraints of literal description, intensified
colour and freely composed the objects he painted, emphasizing their
form and structure. In his *Nude Models in the Studio* (Cat. 124, ill.
p.59) this distortion of reality took on a harsh, irreversible character,
which challenged the aesthetics of former traditions.

One of Mashkov's students, Aleksandr Osmyorkin, in his
*Nude against a background of Persian Printed Cloth*, 1915 (Cat. 145,
ill. p.29) paints the model in a frozen pose reminiscent of a provincial
photograph. The artist underlines physical form, but what is more
surprising is his use of folk motifs; the painting is at the same time
both refined and primitive.

Aristarkh Lentulov joined the Knave of Diamonds group and
quickly assimilated modern painting techniques from Fauvism to
Simultaneism, but he always retained a colourful and inventive
quality that marks his kinship with his Russian predecessors. A
kaleidoscope of vibrant forms, characteristic of Futurism, dominates
his paintings. He drew them out like a magician produces a ribbon,
taking motifs from traditional Russian cheap popular prints and
Eastern primitivism as well as from the 'newest' elements of Western
European art. Like Tatlin, Popova, Puni and others, Lentulov began
experimenting with form and texture introducing new materials in
an attempt to unite painting and sculpture. Less radical than his
contemporaries, Lentulov's collages simply enhanced the effect of the
painting rather than breaking new ground.

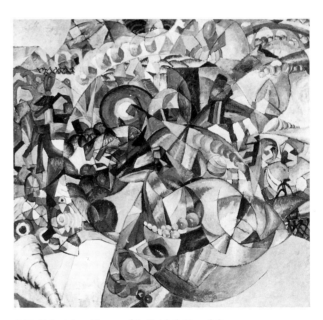

Aristarkh Lentulov: **Allegory of the Patriotic War of 1812** 1914
Cat.110

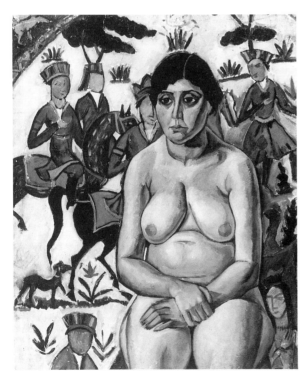

Aleksandr Osmyorkin: **Nude against a Background
of Persian Printed Cloth** 1915
Cat.145

Robert Falk was also one of the organisers of the Knave of
Diamonds, but of a younger generation. In his early work, like that
of many of his contemporaries, he used simplified, flat forms and
muted colour associations, but beneath there is a contemplative
quality peculiar to Falk. His paintings show an engagement with the
subject, and an inner psychological concentration to which form and
structure are subordinated. Even in his more mature, Cubist work
Falk maintained a spiritual quality which is particularly evident in
his portraits.

During the 1910s, artistic life developed at an abrupt, accelerated tempo. Declarations, manifestoes, and slogans appeared, at times extravagant and deliberately shocking. But it was through the exhibitions themselves that the value of the avant-garde movements was established.

Many artists exhibited both in Russia and abroad and painters such as Nathan Altman, Yuri Annenkov, Valentina Khodasevich, Aleksandra Ekster, Lyubov Popova and David Shterenberg, studied Cubism in Paris in the studios of Gleizes, Metzinger, Le Fauconnier, Ozenfant and Delaunay. Altman, for example, lived in France for two years and worked in the studios of Baranov-Rossiné, M.Vasilieva, and the famous studios at La Ruche, which nurtured many young radical artists. Expression burst forth from his paintings through the harsh, mathematical logic of Cubism.

The continuing importance of traditional Russian painting can also be seen clearly in Petrov-Vodkin's work, alongside the influence of German and French Symbolism. His paintings are reminiscent of Russian icons in their simple, expressive form, clear composition and intense colour. Like the old Russian masters, he uses colour symbolically; his images become all-encompassing and metaphysical. He creates a world close to reality, but one which has its own eternal, inner harmony.

Petrov-Vodkin also devised a spherical perspective which he used to descibe space and time, a technique he continued to develop in later works. Such modernisation of traditional art forms was one approach adopted in the 1910s and was to bear fruit especially in the next decade; but it was the more radical movements which sought completely new forms that were to be the greatest influence on the arts from 1910 to 1920. These movements, not always termed correctly as 'Futurism', were those to which the most significant writers and artists of the time were connected.

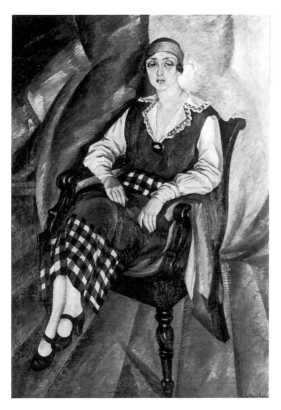

Valentina Khodasevich: **Portrait of a Woman** 1916
Cat.77

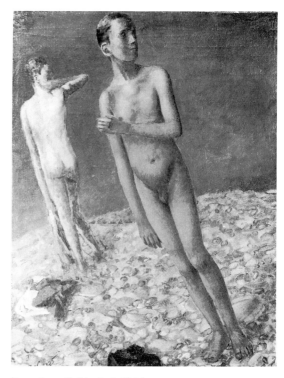

Kuzma Petrov-Vodkin: **At the Height** 1925
Cat.153

The artistic changes which had taken place in Europe over decades were, in Russia, concentrated into a particularly short period. One result was a clash between different movements which at times seemed diametrically opposed. Even the academic traditions which The Wanderers and World of Art had struggled against were affected, giving birth to Neo-academism. Yakovlev, Shukhaev, and in part, Petrov-Vodkin, worked in this style with its clearly defined colour, form and logical structure. They, like the artists of the avant-garde, rejected the amorphous forms and ambiguity of Symbolism.

At the beginning of the 1910s Larionov, and Goncharova became the most authoritative figures among the young artists of Russian Futurism. In 1911 they left the Knave of Diamonds, criticising the association for blindly following French traditions, and created their Donkey's Tail (1912), Target (1913) and No.4 (1914) exhibitions.

Larionov and Goncharova began to work in a style which was based on folk traditions. The origins of this so-called Neo-primitivism were found in Russian folk toys, primitive icons and the popular arts. The term Neo-primitivism, taken from Shevchenko's brochure of the same name, was applied to work which showed these influences.

Shevchenko, the Zdanevich brothers, Chekrigin, Chagall, Malevich, Tatlin and the sculptor Konyonkov were all connected with Neo-primitivism. The Target exhibition of 1913 introduced for the first time in Moscow the work of the Georgian primitivist Pirosmani. His use of simple yet expansive forms revealed his training in the old folk tradition, and whether portraying the life of the old people, historical events, or nature, he uncovered a profound meaning. He fused national Georgian epics and an accessible symbolism with refined mastery.

Goncharova in her pursuit of truth, endowed Neo-primitivism with a rare power of expression. She energetically distorted figures, sharpened rhythms and heightened colour and her subjects, though not always clear, are wild and dramatic.

Larionov with Goncharova in 1912 initiated Luchism or Rayism, which, together with Kandinsky's 'pure spirituality' were the first movements considered to be abstract or non-objective. One exponent of Rayism, Aleksandr Shevchenko, combined Larionov's radical inventions with elements of Cubism; decoration here dominates the painting. Kyril Zdanevich similarly shows the influence of French painting and playfully uses both Cubo-Futurism and the radical styles of the avant-garde.

The work of Vasily Chekrigin, one of Larionov's younger

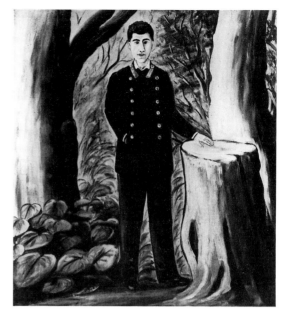

Niko Pirosmani: **Portrait of I.Zdanevich** 1913
Cat.156

contemporaries, while orientated towards the new movements, took on an individual character that cannot easily be classified. His cycle of drawings, *The Resurrection of the Dead* (Cat.34–6, ill. pp.31 & 46), created immediately after the Revolution, is a utopian view of the renaissance of humanity. He presents a perception of the cosmos and universal feeling which grew out of the influence of the philosophers, Fyodorov and Tsiolkovsky, and of Russian Futurism.

Natalia Goncharova: **Spring in Town** 1911
Cat.63

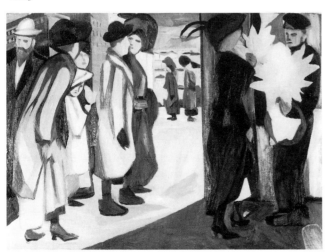

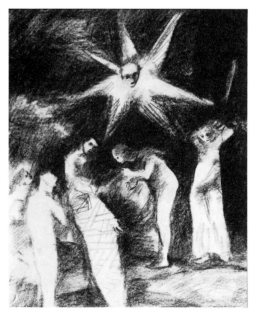

Vasily Chekrigin: From the series
**The Resurrection of the Dead** 1919–21
Cat.35

One of the most famous Russian Futurists, the poet Vladimir Mayakovsky, was not bound by the dictates of any movement and in his painting and drawing, as in his poetry, he sought a concise, declamatory and expressive style. He brought literature and painting together to great effect particularly in his posters on the First World War and after the Revolution, in his stencilled propaganda posters for the windows of the State Telegraph Agency [ROSTA].

Vladimir Mayakovsky: **Portrait of Lily Brik** 1916
Cat.132

David Burlyuk: **Red Earth** 1909
Cat.22

Vladimir Mayakovsky: **Patriotic Poster against the Austrians** 1914
Cat.129

Unlike Mayakovsky with his instinctive approach, David Burlyuk, the 'father of Russian Futurism' consciously worked through many styles. He provided a link between many different artistic movements and groups, countries and towns, and somehow catalysed the development of the avant-garde uniting Impressionism, Fauvism and more radical styles. At one and the same time he was capable of painting decorative landscapes, of making outrageous performances and of inventing collages using sand, sawdust, glass and other materials; painting for him was simply one of many means of self-expression.

The group centred around the artist-doctor Nikolai Kulbin, which organised the 'Impressionists' exhibition of 1909, was similarly transitional. It combined the new-found freedom of subject-matter, form and expressive colour with the techniques of Symbolism to

Mikhail Matiushin: **The Strip of Road** *c*.1913
Cat.126

create an eclectic, decorative style. The St Petersburg Union of Youth, as it became known, with the Moscow Knave of Diamonds and Larionov's group, was another radical association. Their first exhibition was held in 1910 and included Matiushin, Matveev, Rozanova, and Filonov; the Burlyuk brothers, Larionov and Goncharova also played an active part.

One of these artists, the painter and composer Mikhail Matiushin, developed ideas concerning the relationship of colour to space and time. Through his paintings and theoretical writings he formulated the theory of a 'broadened vision' in which he advocated a synthesis of form and symbol and introduced the concept of a fourth dimension to painting.

Filonov, the most significant artist of the Union of Youth group, evolved a pictorial system in which not only formal concepts but also philosophical ideas were expressed. He brought these together in 1912 in the article *Canon and Law* and developed them further, in the 1920s, in his theory of 'analytical art'. A group of artists who called themselves The Masters of Analytical Art formed around him.

Aleksandr Bogomazov, the leader of the Ukrainian avant-garde and with Ekster, the organiser of the Kiev group The Ring, was also a theoretician and artist. In his early works the influence of an intuitively understood pointillism can be seen, which in his mature work gave way to the more expressive sharp geometric forms, that characterised Cubo-Futurism.

In Russia, Marc Chagall assimilated the lessons of primitive art. In the early 1910s he was close to the French Cubists of Apollinaire's circle, yet the life of the Russian people was a theme which he continued to treat with imagination. He painted his birth place, Vitebsk, with a particular innocence and his drawings are a world of invention and visionary daydreams, in which mourning and joy, creation and the fate of the world are fused with a humour that is particularly Russian.

Shterenberg worked for many years in France and the lessons of Léger and Ozenfant show through in his still lifes. These paintings are virtually abstract; forms are reduced to the point of austerity, and the real objects behind his ovals, triangles and rhombuses are barely recognisable. Shterenberg preserved these characteristics in later works which reflect the drama of the post-Revolutionary years. In the words of the critic, A.Efros, 'This is Suprematism, bursting into objectification'.

Ivan Puni was one of the leaders of the new non-objective painting, and took part in the Union of Youth, Knave of Diamonds, Tramway V, 0.10 exhibitions. Both in Russia and later in France he and his wife Zenia Boguslavskaya introduced the art world to the newest achievements in Russian and Western art.

Puni retained a close link with realism, but constructed his compositions on the laws of a-logic; a collage technique which Puni, together with Malevich and Kliun, formulated in the 1910s. He continued using this technique during the 1920s, uniting it with the Neo-academicism that was coming into being. Puni swiftly and consistently worked through all the stages of the avant-garde, acquiring the techniques of the newest movements, from Neo-Impressionism to Suprematism.

Georgy Yakulov's work was connected with the theatre and music. Lyricism and the grotesque, reality and fantasy, tradition and innovation are fused in his portraits and theatre designs. His synthetic style does not fit neatly within the standard categories of art history. He worked with Aleksandr Tairov, the theatre director, and his portrait of Alisya Koonen, Tairov's wife and leading actress in the Kamerny Theatre, is included in the exhibition.

Ivan Puni: **Cakes** *c*.1917
Cat.164

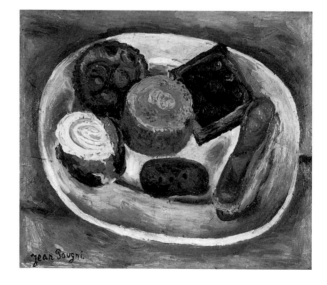

In 1915 Kazimir Malevich announced the arrival of Suprematism which he considered the highest form achieved by the new art. The 'black square', represented 'zero form' which he saw as the final form of objectification. This opened up the path to a new vision, free from description of the material world, which Malevich endowed with a special philosophical meaning.

Tatlin proposed an alternative form of art: Constructivism. Working first over the surfaces of a painting using various materials, textures, and planes, and then in a series of counter-relief constructions, he made what he considered to be models of the future restructuring of the world according to new artistic laws.

Kliun, Puni, Popova, Pestel, Rodchenko, Stepanova, Udaltsova and others also worked in these extreme avant-garde movements of Suprematism and Constructivism; they were few in number but extremely active.

Malevich was the key figure of the avant-garde. The Impressionism of his early landscapes, the transition to Post-Impressionism in his series of boulevards and flower-girls, the Neo-primitivism and Cubism of the early 1920s led Malevich towards Suprematism – this non-figurative, abstract painting, full of prophecy. At the end of the 1920s however, Malevich returned to the first sources of his experiments and moved away from Suprematism to a figurative painting that was symbolic and socially meaningful. He nevertheless, preserved the dramatic tension of his Suprematist works and the desire to reach beyond reality into other worlds. In such paintings as *Three Figures* 1913–28 (Cat.118, ill. in col. p.119) the symbolism of the early years of the Revolution can be traced. Here, sky is the universe, man is the creator, the inquisitive investigator, and earth is the continuity, the basis of everything that grows.

Lyubov Popova: **Composition** 1917–19
Cat.161

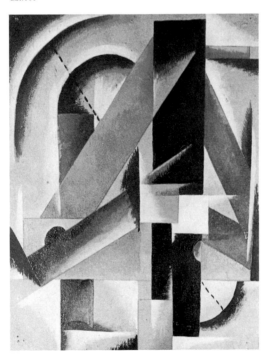

Lyubov Popova was also one of the central figures of the Russian avant-garde. A student of Le Fauconnier and Metzinger, she explored Cubo-Futurism and from 1916 created a series of 'architectonic paintings' – mature Suprematist works. She took part in exhibitions of the Knave of Diamonds group; the Cubo-Futurist exhibitions Tramway V, 0.10 in Petrograd (1915); the avant-garde exhibition The Store in Moscow (1916) and became a member of the Supremus (1916) group. After the Constructivists' exhibition $5 \times 5 = 25$ held in Moscow (1921) she gave up painting, feeling it had no practical function, and turned to graphic, industrial, textile and theatre design.

Nadezhda Udaltsova followed a similar path although her Suprematist compositions of the mid-1910s were more delicate, decorative and less dynamic than those of Popova. After the Revolution both artists were active participants in the development of the arts in the young Soviet country, working in IZO Narkompros, and teaching in the re-opened Free Workshops [SVOMAS] and later in the art institute VKhUTEMAS-VKhUTEIN.

Nadezhda Udaltsova: **Composition** 1916
Cat.213

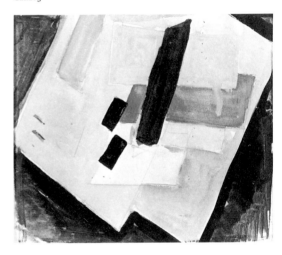

The discoveries of the avant-garde of the 1910s were realised not only in the development of the fine arts. Aleksandr Vesnin's non-objective compositions created in collaboration with Tatlin, were applied to architecture and theatre design, and the paintings and drawings of Alexandra Ekster provided the basis for her bold experiments for the theatre.

Ekster took part in, and organised the exhibitions The Link in Kiev and The Wreath-Stephanos in Moscow. From the end of the 1900s she had worked in Paris with Picasso and Braque, knew Apollinaire and Marinetti, and travelled widely, forming a link with European artists. In the 1910s she participated in almost all the Russian exhibitions of contemporary art and taught young artists in her studios in Kiev and Odessa. During the 1920s her designs for Tairov's Kamerny Theatre in Moscow and in cinema became definitive works of the early Revolutionary period.

In developing Constructivism, Aleksandr Rodchenko broke down painting into its primary elements, so that composition,

texture, and colour were independent from subject and figurative form. He applied the results of these experiments to design and in the post-Revolutionary years gave up painting. Together with Mayakovsky, he created the first Soviet advertising agency, carried out architectural projects, designed clothes and built furniture, worked with photography and, together with Lissitzky, laid the foundations of photo-advertising. Many ideas which Rodchenko had evolved in his 'Constructions' were taken up in later years by engineers and architects as well as artists.

Varvara Stepanova, Rodchenko's wife, created with him a series of Constructivist works, and took part in the exhibition $5 \times 5 = 25$ (1921). Her work in the theatre and design was also of fundamental importance to the new Soviet art.

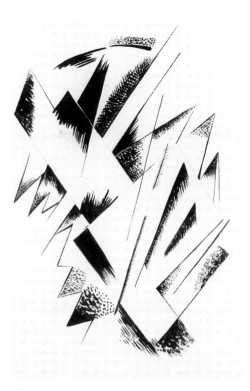

Aleksandra Ekster: **Composition** 1921
Cat.52

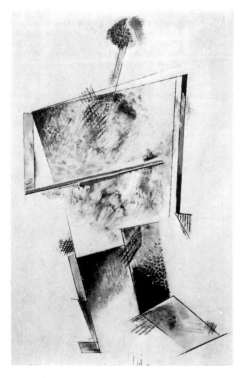

Varvara Stepanova: **Muzhik** [Peasant Woman] 1921
Cat.201

Pyotr Miturich also created multi-media works and in his graphic collages and large-scale, figurative-literary cubes (Cat.135, ill. p.60), combined Tatlin's innovatory work in three dimensions with the literary discoveries of Khlebnikov with whom he was a close friend.

In this intense period, painting and theory developed in parallel as artists formulated their own artistic principles. The Russian avant-garde assimilated many artistic phenomena, sometimes only recognising them fleetingly; discovery, experiment and continuous renewal dominated theory and artistic practice. It was only after the Revolution that these ideas could be fully assimilated, and their wealth exploited.

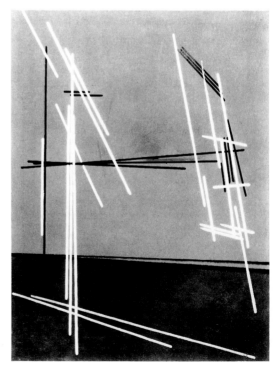

Aleksandr Rodchenko: **Construction** 1919
Cat.170

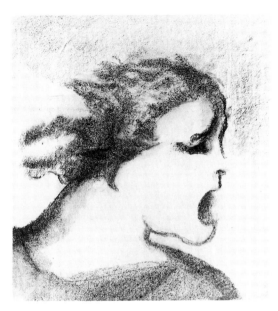

Vasily Chekrigin: **Shouting Woman** 1919–21
Cat.37

The Revolution posed new artistic problems. In the years that immediately followed, the many varied artistic movements and tendencies of the pre-Revolutionary years were united by the need to address the problem of transforming the country. Art turned to the broad masses of the people, seeking a new creator, and a new audience. Artists of all generations, from The Wanderers to the newest groups applied their skills to monumental propaganda; to the decoration of squares, mass festivals and theatrical events and to the design of books and posters. Artists were commissioned to work on the preservation of monuments, they taught in art institutes, and organised the work of independent circles and workers' clubs. The bold discoveries and experiments of these first years of the Revolution created the framework of Soviet culture.

Artists of the avant-garde joined the Revolution with great fervour. Many continued to paint and took part in the work of the new art institutes: INKhUK, VKhUTEMAS, GAKhN, GINKhUK, UNOVIS, and others, which were set up as research laboratories. Here they considered art's function to transform life and studied the laws of colour, form and space. The theories which Malevich, Matiushin, Petrov-Vodkin, Filonov and others had formulated now became basic principles.

In 1918 Chagall founded an Art Academy in Vitebsk, where the mass art of agitational propaganda was taught, and decorations for festivals and demonstrations were prepared. The art school UNOVIS [Affirmers of New Art] founded by Malevich in 1919, existed in Vitebsk, Petrograd, Moscow, Smolensk, Orienburg and other cities. Lissitzky, Yermolaeva and Malevich's students, Chashnik, Suetin, Yudin and others realised the ideas of Suprematism in posters, monumental painting, theatre design, agit-ceramics, industrial design and architecture.

In 1918 the Free Workshops [SVOMAS] were founded in Moscow and in 1920, on Kandinsky's initiative, INKhUK [Institute of Artistic Culture] was established. Under the leadership of Rodchenko, Stepanova, Babichev, Kliun, and Popova, younger artists and other Constructivists developed their work which was to influence strongly art and design in the 1920s.

In Petrograd in 1918 the Zorved [sharp-knowledge] group was founded by Matiushin in the Free Workshops, and at the beginning of the 1920s the school called The Masters of Analytic Art was founded under the leadership of Filonov. In Moscow and Petrograd as in Tver, Smolensk, Saratov, Kiev and Odessa young artists debated the issues of the day.

VKhUTEMAS was of particular significance in the 1920s. Kandinsky, Rodchenko, Tatlin, Konchalovsky, Mashkov, Shevchenko, Falk and Shterenberg were professors and their many students worked in the separate faculties of painting, sculpture, graphics, industrial design, architecture and theatre design.

In the first years after the Revolution the poster became an outstanding phenomenon in Russian cultural history. Deni, Moor, Lebedev, Mayakovsky, Cheremnykh and Rodchenko all worked in this powerful medium. The poster answered the call of the new Soviet authorities for an active and accessible means through which important political problems could be tackled. The explosive force of individual posters of the Civil War, with their bright colour and easily readable script is unique. Narrative realism, symbolism, experimental art and much more, intertwined to form new styles. These posters though made for the immediate moment have lasting value and embody the spirit of the Revolution.

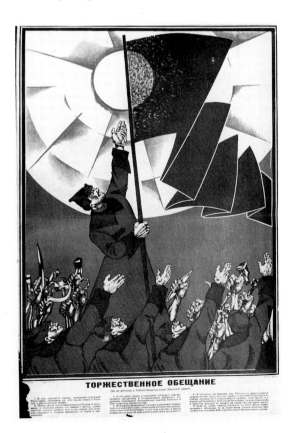

Dmitri Moor:
'Take a Solemn Oath
when Enlisting
in the Red Army' 1918
Cat.136

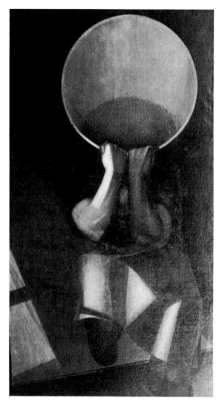

Leonid Chupyatov: **Worker** 1928
Cat.40

Agit-porcelain was also produced and fulfilled a similar function, introducing Revolutionary slogans to everyday life. Outstanding artists such as Chekhonin, Shchekotikhina-Pototskaya, Altman, Kuznetsov, Danko-Alekseenko, Kobyletskaya and Suetin worked in this medium, bringing their own styles and techniques to this newly revived art form.

New painting styles were also developed. The associations AKhRR [Association of Artists of Revolutionary Russia], OST [Society of Easel Painters], OMKh [Society of Moscow Artists], 4 Arts and many others, debated their right to be recognised as the genuine representatives of art in the Soviet Union. A major point of contention was which kind of realism should sweep aside the varied styles of avant-garde art of the 1920s.

At this time many art movements were born, struggled and co-existed during the course of the first ten years of the Revolution, but the social and political climate of the time was to place a dramatic seal on the development of artistic styles and individual talents.

Antonina Sofronova and Mikhail Sokolov in the Art School founded in Tver in 1921 worked in a strict Cubist manner which had developed out of Suprematism. In its dramatic, radical forms it was strikingly different from the pre-Revolutionary aestheticism.

Lev Zhegin and Vasily Chekrigin were the organisers and leaders of the Makovets association, to which Sergei Gerasimov, Shevchenko, Zefirov and others belonged. These artists, previously connected with Futurism, looked to past traditions, hoping to give new life to Renaissance, Baroque and classical styles. They often turned to biblical themes, transforming their meaning in the spirit of a new ethical symbolism.

Leonid Chupyatov, one of the most gifted of Petrov-Vodkin's students, also expressed his notion of the duty of the artist as creator through religious and mystical subjects. His paintings are tragic and deeply symbolic, following a philosophy rooted in national traditions, yet at the same time bordering on Surrealism.

The structure of art education during the 1920s allowed artists to find their own path; they went freely from workshop to workshop, changed teachers, and tried various styles. This very lack of a system often resulted in a superficial attitude towards technique and consequently the need for professionalism became a major concern for many associations.

The achievements of the Society of Russian Sculptors, however, was considerable. Sarra Lebedeva, made remarkable sculptures of Lenin, Chkalov, the aviator, and Tatlin. Aleksandr Matveev, who first exhibited with the Blue Rose group worked in a modern classicism, and Dmitri Tsaplin combined primitive and expressive qualities.

Aleksandr Deineka, together with his older colleague, Shterenberg, brought acute, contemporary problems into painting. They were leading members of The Society of Easel Painters [OST]. The energy of their time was concentrated into their compositions, still lifes and portraits.

Aleksandr Tyshler's work took an individual path. He was a member of the Projectionist group and at the beginning of the 1920s experimented with abstract, dynamic forms. Moving from the late 1920s, he found a style which was both grotesque and lyrical. His work was based mainly on Jewish folklore yet it is infused with the conflicts and tension within Soviet society of which he was painfully aware.

Many of Solomon Nikritin's works are also permeated with that same drama which was increasingly felt throughout Soviet society in the 1930s. It was a time of powerful change, when the struggle for the creation of Socialism was overlaid by persecution and repression. *The Old and the New* 1934 (Cat.144, ill. in col. p.136), is a symbolic representation of society and politics in Russia.

The beginning of the 1930s brought significant changes to the artistic life of the country. Art was regulated and subordinated to propagandistic and didactic aims. Many art movements were criticised for indulging in formalism and for not following Socialist Realism which was officially considered the only possible form of Soviet art. An art developed and was encouraged, that set out to reflect ruling ideological principles and which was regulated by the problems of internal politics. Any style which did not comply with this social scheme was denied the right to exist, so that independent art was forced into the background, and even underground.

Fyodor Bogorodsky, who had been attached to Futurism in his youth, and then became a member of the AKhRR, is best known for his studies of orphaned children who, in the early 1920s, were a common feature of Soviet society, but later he went on to paint landscapes and compositions in the spirit of idyllic Stalinist romanticism.

Kuznetsov's numerous works from this period are more honest and have greater depth. They show an almost naive desire to understand the environment, and a duality revealing a hidden drama of the times often emerges.

Some artists unable to hold out against ideological pressure and regulation moved away from subjects of social concern to make domestic, 'chamber' art. The still lifes of Vladimir Lebedev are cold and decorative. In the works of Filonov's student, Pavel Zaltsman, who trained as a Master of Analytical Art, a penetrating realism also reflects something of the heroic romanticism of Socialist Realism.

Vladimir Tatlin: **Portrait of a Man** 1930s
Cat.208

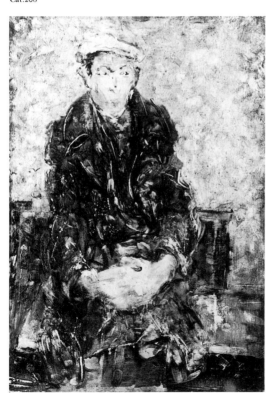

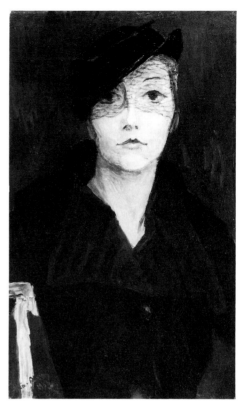

Nathan Altman: **Woman in Black with Veil** 1933
Cat.5

Other artists such as Altman worked in France during the 1930s and, like Falk, painted works unconnected with social themes.

Drevin and Udaltsova continued to work in Russia; Drevin's expressive painting shows both naivety and wisdom and has a vital immediacy. Vladimir Tatlin's still lifes and portraits of this period are painted in dim, twilight tones and preserve the living soul of art even though the theories and forms of his earlier Constructivism are completely expunged.

Malevich's work of the 1930s took on new qualities during these last years of his life. While continuing to repeat motifs from earlier paintings or making new 'supranatural' works, he painted realistic portraits. The penetrating, non-lyrical portrait of his mother of 1932 (Cat.119) is a very close description of physical reality and in the portrait of his brother of 1933 (Cat.120, ill. in col. p.135) a new, harsh realism shows through; the portrait is stern and merciless, as indeed were the times. The red wagons in the background not only echo Suprematism, but are also a vivid reminder of the Revolution.

The 1940s and 1950s were a time of considerable suffering for the Soviet people. The ravages and deprivations of the war and post-war years were compounded by the Stalinist terror. But the country rose again gradually and heroically. Artists continued to draw, paint and sculpt and many – Deineka, Tyshler, Kuprin, Falk, Kuznetsov, Udaltsova, Osmyorkin and others – created important works, which have yet to be researched and evaluated. The official art of these years which crowded museums and State apartments, however, was never to be found in private collections.

Vladimir Lebedev: **Woman in Pink** *c*.1935
Cat.107

The historic changes of the mid-1950s after the death of Stalin brought signs of renewal and democratisation which were to have a profound effect on art. Previously neglected artists were resurrected and a younger generation brought new life to the arts. At the end of the 1950s and the beginning of the 1960s, young artists such as Andronov and Popkov, in their attempts to express hidden truths, shared a romantic dream of renewal and turned to the traditions of the avant-garde artists of the 1920s for inspiration. With uncompromising energy they concentrated on harsh and painful social themes which reflected upon the history of the country.

Aleksandr Deineka: **Leningrad 1942** 1942
Cat.45

In Nikolai Andronov's portraits and lyrical landscapes, there is an inner tension and drama, which relates to the paintings of the Knave of Diamonds group and the symbolism of the Makovets. Viktor Popkov combines the influence of old Russian monumental frescoes with the style of The Wanderers and the reductive forms of the OST painters of the 1920s. In encouraging the search for a new language Popkov was a leading figure of his generation.

During the 1950s and 1960s artists formed a non-conformist sub-culture which was separate from official movements. Many who had experienced life in the Stalinist camps had long rejected regimentation and censorship. Oskar Rabin, for example, opposed propagandistic official culture and his paintings took on a grotesque and often uncompromising character. Lev Kropivnitsky in his abstract works claimed the freedom of art from social limitations and the right of the artist to be part of an international discourse.

Oleg Tselkov, having assimilated the artistic language of the avant-garde, created social fantasies, often coded in an aggressive style. Mikhail Shvartsman's 'hieratic' paintings attempt to reinterpret the artistic heritage of other cultures in the spirit of Malevich's Suprematist utopias. He utilises the art of the past, taking sacred symbols, elements of icon painting and architectural motifs into an ideographic, totemic structure which he endows with mystical meaning.

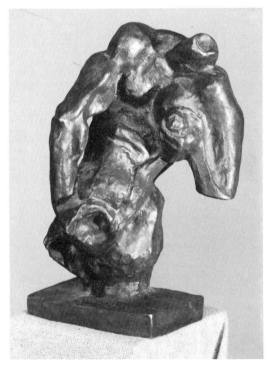

Ernst Neizvestny: **Torso** 1968
Cat.141

In the 1960s and 1970s this sub-culture gave birth to a specifically Russian form of Conceptual Art which, along with its striving for paradox and allusion, was concerned with the social world of everyday experience. Ilya Kabakov elevates the debris and nonsense of daily life to symbols of spiritual emptiness and isolation, and the world of Erik Bulatov is filled with slogans, and the senselessness of frightening social games. The new synthesis of media proposed by Francisco Infante in *Artefacts* 1968–86 (Cat.69, ill. p.8)

concentrates on the relationship between the objects created by the artist and nature and the environment.

The artists of the 1980s have developed out of this earlier generation. Grigory Bruskin deals with different aspects of social symbolism, Andrei Roiter parodies the stereotypes of mass culture, while in Vadim Zakharov's work the world of the absurd rules aggressively.

Many artistic movements have developed in Russian and Soviet art during the twentieth century. This exhibition cannot be comprehensive, following as it does their development through works to be found in private collections or owned by the artists themselves. Private collections cannot and should not fully represent the art of this time – this is for the State museums. Our aim is more modest. In presenting a part of this heritage, we hope to show that in the diversity of Russian and Soviet art, and in its variety of forms, lies the sureness of its future development.

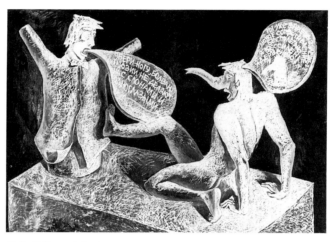

Vadim Zakharov: A-6 1985
Cat.237
*'Get your legs out of the way, blockhead.*
*Illusions don't make us elephants and one-eyed.'*
*'You know yourself very well, but any opposition*
*is useless. I'm powerless, I'm made of wood.'*

# ARTISTS' BIOGRAPHIES AND LIST OF WORKS

**Sizes** are given in centimetres, height by width by depth.
For **posters**, sizes of both image and sheet are given after the printing technique.

## Poster Abbreviations

**BAKKAVROSTA:** Caucasian section of the Russian Telegraph Agency (ROSTA) in Baku
**Glavpolitprosvet:** Central Republic Political Educational Committee
**Gosizdat:** State publishing house
**Izd. Politupr. RVSR:** Literary publishing section of the Political administration of the Republic's Revolutionary Military Council

## Ceramics Abbreviations

As many of the ceramic bodies were made long before they were decorated, their markings are listed separately under the heading of 'Body':
**GFZ:** State Porcelain Works, from 1925 the M.V.Lomonosov Porcelain Works; before 1918 it was known as Imperial Porcelain Works [IFZ]
**LFZ:** Leningrad Porcelain Works named after M.V.Lomonosov

## Acronyms and Abbreviations of Organisations

**AKhRR.** Assotsiatsiya Khudozhnikov Revolyutsionnoy Rossii [Association of Artists of Revolutionary Russia] (1922–8), then the Association of Artists of the Revolution (AKhR, 1928–32).

**AKh.** Akademiya Khudozhestv [Academy of Arts]. Until 1918 it was in St Petersburg/Petrograd; from 1932 to 1947 it was attached to the Repin Institute in Leningrad; since 1947 the Academy of Arts of the USSR has been in Moscow.

**GINKhUK.** Gosudarstvennyy Institut Khudozhestvennoy Kultury [State Institute for Artistic Culture] set up on the basis of INKhUK in Petrograd/Leningrad in 1923.

**INKhUK.** Institut Khudozhestvennoy Kultury [Institute of Artistic Culture] (1920–3).

**INZhSA im. I.Repin.** Institut Zhivopisi, Skulptury i Arkhitektury im. I.Ye.Repina (Leningrad) [Repin Institute of Painting, Sculpture and Architecture].

**IZO Narkompros.** Otdel Izobrazitelnogo Iskusstva Narodnogo Komissariata po Prosveshcheniyu RSFSR [Fine Arts Section of the People's Commissariat for Education of the Russian Republic] (1918–21).

**KOMFUT.** The Left federation of 'Communist-Futurists' (1919), which published its manifesto in the newspaper *Iskusstvo Kommuny* [Art of the Commune].

**LEF.** The association 'Left Front of the Arts' (1923–30).

**MGKhI im. V.I.Surikova.** Moskovskiy Gosudarstvennyy Khudozhestvennyy Institut im. V.I.Surikova [Moscow Surikov State Art Institute].

**MIDI (MIPIDI).** Moskovskiy Institut (Prikladnogo i) Dekorativnogo Iskusstva [Moscow Institute of (Applied and) Decorative Art] (1945–52).

**MIII.** Moskovskiy Institut Izobrazitelnykh Iskusstv [Moscow Institute of Fine Arts].

**MOLKh.** Moskovskoe Obshchestvo Lyubiteley Khudozhestv [Moscow Society of Art Lovers].

**MTKh.** Moskovskoe Tovarishchestvo Khudozhnikov [Moscow Fellowship of Artists] (from 1893).

**MUZhVZ.** Moskovskoe Uchilishche Zhivopisi, Vayaniya i Zodchesvta [Moscow School of Painting, Sculpture and Architecture] (until 1918).

**MVKhPU.** Moskovskoe Vysshee Khudozhestvenno-Promyshlennoe Uchilishche [Moscow Higher Artistic Industrial College], formerly the Stroganov Institute.

**NOKh.** Novoe Obshchestvo Khudozhnikov [New Society of Artists] (from 1904).

**OBERIU.** [Association for Real Art].

**OBMOKhU.** Obshchestvo Molodykh Khudozhnikov [Society of Young Artists] (1919–32).

**OMKh.** Obshchestvo Moskovskikh Khudozhnikov [Society of Moscow Artists] (1927–32).

**OPKh.** Obshchestvo Pooshchreniya Khudozhestv [Society for the Encouragement of the Arts] (St Petersburg).

**ORS.** Obshchestvo Russkikh Skulptorov [Society of Russian Sculptors].

**OSA.** Obyedinenie Sovremennykh Arkhitektorov [Union of Contemporary Architects] (1925–31).

**OST.** Obshchestvo Stankovistov [Society of Easel Painters] (1925–32).

**PGSKhUM.** Petrogradskie Gosudarstvennye Svobodnye Khudozhestvenno-Uchebnye Masterskie [Petrograd State Free Art Educational Workshops].

**POSNOVIS.** Posledovateli Novogo Iskusstva [Followers of New Art], group formed by Malevich in Vitebsk in 1920, later called UNOVIS.

**PROLETKULT.** Cultural and educational organisation Proletarskaya Kultura [Proletarian Culture] (1917–32).

**ROSTA.** Rossiyskoe Telegrafnoe Agenstvo [Russian Telegraph Agency].

**SRKh.** Soyuz Russkikh Khudozhnikov [Union of Russian Artists] (1903–23).

**SVOMAS.** Svobodnye Masterskie [Free Workshops] (1918–20).

**TASS.** Telegrafnoe Agenstvo Sovetskogo Soyuza (Telegraph Agency of the Soviet Union].

**TPKhV.** Tovarishchestvo Peredvizhnykh Khudozhestvennykh Vystavok [Fellowship of Travelling Art Exhibitions – The Wanderers] (1870–1922).

**TsUTRISh.** Tsentralnoe Uchilishche Tekhnicheskogo Risovaniya im. A.Shtiglitsa (sic) [Central College of Technical Drawing named after Count A.Stieglitz (St Petersburg).

**UNOVIS.** Utverditeli Novogo Iskusstva [Affirmers of New Art] or Uniya Novogo Iskusstva (Union of New Art), founded by Malevich in 1920 and active in Moscow, Orenburg, Smolensk, set up on the basis of POSNOVIS.

**VKhUTEMAS / VKhUTEIN.** Vysshie Gosudarstvennyy Khudozhestvenno-Tekhnicheskie Masterskie [Higher State Artistic and Technical Workshops] (1921–6), set up in Moscow on the basis of SVOMAS, later Vysshie Gosudarstvennyy Khudozhestvenno-Tekhnicheskiy Institut [Higher State Art Technical Institute] (1926–30).

**ALTMAN**, Nathan Isaevich / 1889–1970

*Painter, graphic artist, sculptor and theatre designer.* Studied at Art School, Odessa (1901–7) under Kostandi and Ladyzhensky, and 'Free Russian Academy' of Vasilyeva, Paris (1910–12). Taught at SVOMAS, Petrograd (1918–20). Member of IZO, KOMFUT and INKhUK. From 1906 participated in exhibitions including World of Art, Knave of Diamonds. Sketched and sculpted portraits of Lenin from life; decorated Palace Square, Petrograd, for first anniversary of October Revolution (1918); designed part of theatrical production of Mayakovsky's *Mystery Bouffe* (1921); designs for political ceramics (early 1920s). Lived and worked in Paris (1929–35). Returned to Leningrad in 1936.

**1**  **Woman with Silver Belt** 1911
Oil on canvas, 87×65cm
Collection S.A.Shuster and Ye.V.Kryukova

**2**  **Still Life with Blue Carafe** 1911, *Ill. in col. p.104*
Oil on canvas, 76×61cm
Collection V.A.Dudakov and M.K.Kashuro

**3**  **Portrait of Nadezhda Ye. Dobychina** 1913, *Ill. below*
Oil on canvas, 85×67cm
Collection Ye.B. and A.F.Chudnovsky

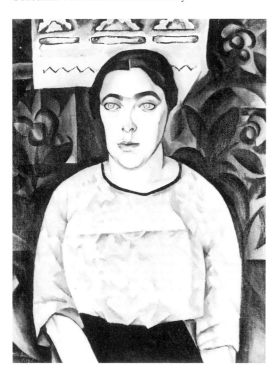

Nathan Altman: **Portrait of Nadezhda Ye.Dobychina** 1913
Cat.3

**4**  **Cup '25 October 1917'** 1922
On cup, profile portrait of Lenin, marching Red Army soldiers, monogram 'RSFSR' and inscription '25 October 1917'; on saucer, emblems of the new republic.
Body: 'Aleksandr III'; Stamp IFZ covered with green paint. 'GFZ' with date 1922.
Painted over glaze. Height of cup 8cm; diameter of saucer 15.9cm
Collection V.Nemukhin

**5**  **Woman in Black with Veil** 1933, *Ill. p.38*
Oil on canvas, 54×32cm
Collection I.M.Ezrakh

**6**  **Negress** 1929, *Ill. in col. p.21*
Oil on canvas, 96×61cm
Collection Ye.B. and A.F.Chudnovsky

**ANDRONOV**, Nikolai Ivanovich / Born 1929

*Painter.* Studied at Art School, Leningrad, and INZhSA im. I.Repin (1948–52) under Frents. From 1951 participated in exhibitions in USSR and abroad including USA, West Germany, England. Part of generation of young realist painters who challenged official style of Socialist Realism, late 1940s and 1950s. Taught at Moscow Textile Institute (1956–8). Lives and works in Moscow.

**7**  **Self Portrait with Saw** 1964, *Ill. in col. p.141*
Oil on canvas, 108×115cm
Collection V.S. and L.I.Semyonov

**BELOV**, Pyotr Aleksandrovich / 1929–88

*Theatre designer.* Studied at Central Art School, Moscow (1944–9), stage design at Nemisovich-Danchenko Theatre Faculty, Moscow Art Theatre (1949–53), and Surikov Art Institute (1950–8). Head Designer at Moscow Region Youth Theatre (1957–67), and Soviet Army Central Theatre (1967–74). Head of Theatre Design Laboratory for Volga Region branch of the Theatre Institute (1978–88). Honoured artist of the RSFSR.

**8**  **Hour Glass** 1987, *Ill. below*
Gouache on cardboard, 45×47cm
Collection Family of P.A.Belov

Pyotr Belov: **Hour Glass** 1987
Cat.8

**BENOIS**, Alexandre Nikolaevich / 1870–1960
*Painter, graphic artist, theatre designer, art historian and critic.*
Occasional student at Academy of Arts, St Petersburg (1887–8). Studied at Law Faculty of University of St Petersburg (1890–4). One of organisers of World of Art group. From 1891 participated in exhibitions including Society of Russian Watercolourists, World of Art, SRKh. Frequently travelled in France, Germany and Italy (1890–1910). Produced series of landscapes of Versailles, views of St Petersburg and its environs. Executed illustrations to Pushkin's *Queen of Spades* and *The Bronze Horseman*. Editor of journal *Mir Iskusstva* [World of Art] (1901–3). Also exhibited with art group of same name. Designed ballet, opera and theatre productions in St Petersburg, Moscow (1901–3), and for Diaghilev's private company. Curator of Hermitage Museum and member of Commission for Preservation of Antiquities and Monuments of Art (1918–22). Author of numerous works on art history and critical articles. From 1926 lived in Paris. Also worked for Comédie Française, Paris, and La Scala, Milan. Exhibited abroad including Paris (1926, 1929, 1940, 1953), London (1936, 1938, 1953, 1960), Milan (1988).

**9**  Versailles 1906, *Ill. in col. p.86*
Watercolour, white wash, pastel on paper on board, 20×47cm
Collection M.N.Sokolov

**10**  St Petersburg, The Winter Canal 1900s
Watercolour on paper 31×23cm
Collection S.D.Lansere

**11**  Villa Mandragona, Frascati 1911
Watercolour, pastel on paper mounted on board, 49×65cm
Collection Yu.A.Ignatyeva

Aleksandr Bogomazov: **Portrait of the Artist's Wife** 1915
Cat.14

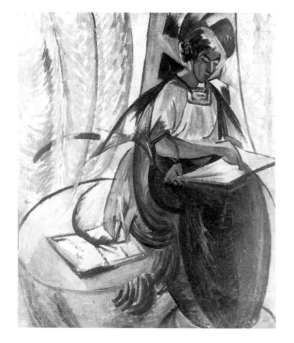

**BOGOMAZOV**, Aleksandr Konstantinovich / 1880–1930
*Painter, graphic artist, monumental artist.* Studied at Art School, Kiev under Menk and Murashko (1902–11), the studio of Yuon and Rerberg in Moscow (1905–7). From 1907 participated in exhibitions including The Link, Knave of Diamonds, The Ring. Wrote the book *Elementy Zhivopisi* [Elements of Painting] 1914 (unpublished). Leading member of Ukrainian Futurists. Worked in the Caucasus (1914–17). Returned to Kiev in 1917, and designed decorations for revolutionary holidays (1919) and agit trains (1920). Taught at Kiev School of Art Printing (1918–22) and at Institute of Plastic Arts (1922–30).

**12**  Expectation *c.*1900, *Ill. in col. p.89*
Oil on canvas, 38×38cm
Collection V.A.Dudakov and M.K.Kashuro

**13**  Tram 1914, *Ill. in col. p.102*
Oil on canvas, 142×74cm
Collection V.A.Dudakov and M.K.Kashuro

**14**  Portrait of the Artist's Wife 1915, *Ill. below left*
Oil on canvas, 63×55cm
Collection A.I.Shlepyanov

**15**  Steam Engine 1915
Oil on canvas, 100×105cm
Collection V.A.Dudakov and M.K.Kashuro

**BOGORODSKY**, Fyodor Semyonovich / 1895–1959
*Painter.* Studied at Moscow Institute (1914–16), the studio of Leblond (1914) and VKhUTEMAS (1922–4) under Arkhipov. From 1926 participated in exhibitions in Nizhni Novgorod, with AKhRR, Union of Artists. Created a series of works about homeless children (1925–6). Lived with Maxim Gorky in Sorrento (1929–30). From 1930 lived and worked in Moscow. His works were shown in USSR and abroad including Japan (1927), Venice (1928, 1932, 1934), New York (1929) and London (1934); and one-man shows in Rome (1929) and Moscow (1931, 1934, 1966).

**16**  Sketch for 'Music' 1936
Oil on canvas, 101×72cm
Collection Family of F.S.Bogorodsky

**BORISOV-MUSATOV**, Viktor Elpidiforovich / 1870–1905
*Painter.* Studied at MUZhVZ (1890–1, 1893–5) under Konovalov in Saratov, the Academy of Arts (1891–3), the studio of Chistyakov, St Petersburg, and under Cormon, Paris (1895–8). Influenced by work of Puvis de Chavannes. From 1893 participated in exhibitions including MUZhVZ and MTKh. Lived in Saratov (until 1903) and then Tarusa. His works were shown in Germany and France (1904–5); and one-man shows in Moscow (1907, 1917). Leading inspiration of Blue Rose artists and forerunner of Russian Symbolism.

**17**  Woman on the Veranda *c.*1900, *Ill. overleaf*
Oil on canvas, 97×81cm
Collection Ye.B. and A.F.Chudnovsky

Viktor Borisov-Musatov: **Woman on the Veranda** *c.1900*
Cat.17

**BRODSKY**, Isaak Izrailovich / 1883–1939
*Painter and graphic artist.* Studied at Art School, Odessa
(1896–1902) under Kostandi and Ladyzhevsky, and Academy
of Arts (from 1902) under Myasoedov, Tsionglinsky and
Repin. From 1904 participated in exhibitions including
Academy of Arts, sRkh, TPKhv, World of Art. Studied abroad
on a grant from Academy of Arts, visiting Germany, Austria,
France, Italy and Spain (1909–11). From 1924 member of
AKhRR. Sketched Lenin from life and produced a series of
works dedicated to him, one of the most famous of which was
*Lenin in the Smolny*. From 1932 taught at INZhSA im. I.Repin.
His works were shown in London (1910, 1938), Rome (1911),
New York (1924, 1929), Venice (1932), Sofia (1939).
Assembled a collection of works of art, which is now in part
in Art Museum of Berdyansk and in Brodsky Museum,
Leningrad. One of the artists whose work provided a model
for Socialist Realism.

**18**   Street in the Town, Evening 1922, *Ill. in col. p.129*
Oil on board, 38×45.5cm
Collection I.A. and Ya.A.Rzhevsky

**BRUSKIN**, Grigory Davidovich / Born 1945
*Painter.* Studied at Moscow Textile Institute (until 1968).
Participated in exhibitions in Moscow (1984, 1987), Vilnius
(1983) and abroad in Chicago (1987), Berne (1988) and
London (1988). His recent work has codified contemporary
social types in an ironical way. In Sotheby's Moscow art sale
(1988) a work by Bruskin achieved a record price for a
contemporary Russian artist.

**19**   Four Spaces 1982, *Ill. below*
Oil on canvas, 65×54cm
Collection V.G.Kravchuk

**20**   Eight Figures 1986, *Ill. in col. p.144*
Oil on canvas, 46×38cm
Collection V.G.Kravchuk

Grigory Bruskin: **Four Spaces** 1982
Cat.19

**BULATOV**, Erik Vladimirovich / Born 1933
*Painter and graphic artist.* Studied at Moscow Secondary Art
School and MGKhI im. Surikova (1952–8) under
Pokarzhevsky. His early work was influenced by Falk and
Favorsky. Since early 1960s developed with Vasiliev and
Kabakov a studied and seemingly impersonal irony in his
work, which deals with the physical and spiritual realities of
living in a culturally monolithic and inflexible system. Since
1956 participated in exhibitions in USSR and abroad in New
York, Washington, Venice, Turin; and one-man shows in
Zurich, Frankfurt, Bonn (1988), Amsterdam, Paris and West
Berlin (1988), London (1989).

**21**   Have a Nice Stay 1973–4, *Ill. in col. p.146–7*
Oil on canvas, 80×230cm
Collection A.I.Sidorov

**BURLYUK**, David Davidovich / 1882–1967

*Painter and poet.* Studied at Art Schools, Kazan (1898–9), Odessa (1899–1900, 1909), Munich (1902–3) under von Dietz where he met Kandinsky, Paris (1904) under Cormon and at MUZhVZ (1910–14). From 1906 participated in exhibitions including The Wreath, The Link, Knave of Diamonds. At family home, Georgia, and inspired by Marinetti's example, founded Hylea group of young Futurist poets and artists (1911). Wrote a number of manifestoes. Travelled in Russia with Mayakovsky and Kamensky, giving lectures and talks on Futurism and was called the 'father of Russian Futurism' (1913–14). Lived in Japan (1920–2) and from 1922 in USA; published the journal *Tsvet i Rifma* [Colour and Rhyme].

**22**  Red Earth 1909, *Ill. p.32*
Oil on canvas, 70×130cm
Collection S.A.Shuster and Ye.V.Kryukova

**23**  Landscape through an Open Window *c.*1911, *Ill. in col. p.93*
Oil on canvas, 70×56cm
Collection I.M.Ezrakh

**CHAGALL**, Marc Zakharovich / 1887–1985

*Painter and graphic artist.* Studied at the studio of Pen, Vitebsk (1906), the School of the Society for the Encouragement of the Arts, St Petersburg (1907–8), the studio of Zayderberg (1908) and Zvantseva's school (1908–10) under Bakst and Dobuzhinsky. From 1911 participated in exhibitions including the Salon des Indépendants, World of Art, Donkey's Tail, Target. Lived in Paris, worked in La Ruche (1910–14). In 1914 first one-man show at the Galerie Der Sturm in Berlin. Returned to Vitebsk in 1914 and was head of the Art School in 1918. Left the school under pressure from Malevich and followers. Lived in Moscow (1920–2). Moved to Berlin, participated in the Exhibition of Three (Altman, Chagall, Shterenberg). From 1923 lived in Paris. Exhibition in Galerie Barbazanges, Paris (1924). First retrospective in Basle (1933).

**24**  Jewish Wedding *c.*1914, *Ill. below*
Indian ink and gouache on board, 20×30cm
Collection A.K.Gordeeva

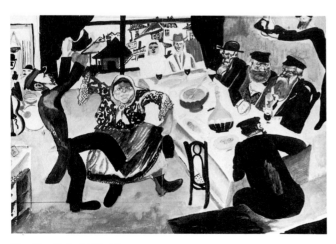

Marc Chagall: **Jewish Wedding** *c.*1914
Cat.24

**25**  Chemist in Vitebsk 1914, *Ill. in col. p.105*
Oil and tempera on canvas, 40×52cm
Collection V.A.Dudakov and M.K.Kashuro

**26**  Soldiers with Bread 1914, *Ill. in col. p.14*
Watercolour on paper, 51×37.5cm
Collection A.K.Gordeeva

**27**  Muse, Apparition 1917, *Ill. p.6*
Oil on canvas, 157×140cm
Collection A.K.Gordeeva

**CHEKHONIN**, Sergei Vasilyevich / 1878–1935

*Graphic artist, miniaturist, painter on ceramics and enamel.* Studied at Drawing School of OPKh, St Petersburg (1896–7) under Tsionglinsky, Sabaneev and Shreyber, and Tenisheva School (1887–1900) under Repin. From 1904 worked in the Abramtsevo pottery workshop, Moscow. Published satirical drawings (1904–5). Worked at Paulin's Kikerin Ceramics Factory (1907). From 1909 participated in exhibitions including Union of Russian Artists, World of Art, Russian Book Plates, Exhibition of Russian Ceramics. Most outstanding book illustrator in the pre-revolutionary years after 1910. From 1912 member of World of Art group. Was in charge of a school of enamel painting in Rostov Yaroslavsky (1913–17). Director of the State Ceramics Factory (1918–23, 1925–7). With Vrubel and Golovin produced panels for the façade of the Metropol Hotel, Moscow, and a number of ceramic panels for buildings in Leningrad. Became one of the leading artists making agitational ceramics (1918–23), and produced the first examples of Soviet ceramics (a plate, RSFSR, for the anniversary of the Revolution in October 1918). From 1928 lived in Paris. One-man show, Paris (1928).

Sergei Chekhonin: 'RSFSR' 1921
Cat.29

**28**  Plate with Flowered Emblem 1918
Body: 'IFZ' covered with dark green paint 'GFZ 1918'
Painted over glaze. Diameter 23.9cm
Collection V.Andreev

**29**  Plate 'RSFSR' 1921, *Ill. previous page*
Body: IFZ 1903
'IFZ 1921'
Inscription in crimson paint on base 'After design by
Chekhonin'. Monogram of factory painter, G.Sudarchikov in
blue paint.
Painted over glaze. Diameter 24.1cm
Collection V.Andreev

**30**  Plate 'From the Highest Peaks of Science' 1921,
*Ill. in col. p.123*
Along edge and dish, inscription 'From the highest peaks of
science we can see the dawn of the new day sooner than is
possible than from down below, amongst the confusion of
everyday life'. Body: 'IFZ'
'IFZ' covered over with dark green paint, 'GFZ 1921'.
Painted beneath and over glaze, gilded. Diameter 24cm
Collection T.Rubinshteyn

**31**  Cup and Saucer 'Red Band' 1922
Body: 'IFZ 1892' and '1893'
'GFZ' with 'U' and '1922'
Painted over glaze. Height of cup 6.5cm;
diameter of saucer 11cm
Collection V.Nemukhin
**Cup 'USSR'** 1923
'GFZ'
Painted over glaze. Height 6.7cm
Collection T.Rubinshteyn

**CHEKRIGIN**, Vasily Nikolaevich / 1897–1922
*Painter and graphic artist.* Studied at icon-painting school, the
Kiev Pecherskaya Lavra [Monastery of the Caves] (from
1906), and MUZhVZ (1910–14), under Kasatkin. Illustrated
Mayakovsky's first book of poetry, *I* (1913), with Zhegin.
Travelled to Germany, France, Austria and London (1914)
returning to Moscow at outbreak of First World War, and
exhibited in No.4 exhibition organised by Larionov (1914).
Affiliated with Futurists and other avant-garde Moscow
groups (1913–14), by end of decade making utopian drawings
based on the ideas of philosopher, Nikolai Fedorov, about the
transmutation of souls into the stars of the cosmos and making
cycle of drawings *The Resurrection of the Dead*. Member of
Commission for the Preservation of Objects of Artistic Value
in Moscow (1917–18) and member of IZO (1920). Worked on
the decoration of Kiev for public holidays (1918–20) and in
the Children's Theatre, Moscow (1920). Founder and leader
of the Makovets group (1922). One-man memorial show,
Moscow (1923).

**32**  Portrait of Vladimir Tatlin 1913, *Ill. in col. p.100*
Oil on canvas, 68.5×52cm
Collection I.G.Sanovich

**33**  The Toilet of Venus 1918, *Ill. p.12*
Oil on canvas, 72×54cm
Collection I.G.Sanovich

**34**  From the series **The Resurrection of the Dead** 1919–21
*Ill. above right*
Charcoal on paper, 44×44cm
Collection Ye.B. and A.F.Chudnovsky

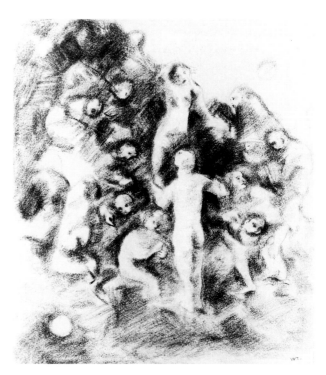

Vasily Chekrigin: From the series
**The Resurrection of the Dead** 1919–21
Cat.34

**35**  From the series **The Resurrection of the Dead** 1919–21
*Ill. p.31*
Charcoal on paper, 37×31cm
Collection V.A.Dudakov and M.K.Kashuro

**36**  From the series **The Resurrection of the Dead** 1919–21
Charcoal on paper, 29×29cm
Collection V.A.Dudakov and M.K.Kashuro

**37**  Shouting Woman 1919–21, *Ill. p.36*
Charcoal on paper, 37×34cm
Collection Ye.B. and A.F.Chudnovsky

**CHEREMNYKH**, Mikhail Mikhailovich / 1890–1962
*Poster artist, caricaturist, graphic artist and theatre designer.*
Studied at MUZhVZ (1911–17) under Korovin and Malyutin.
From 1910 published drawings. From 1910s participated in
exhibitions including the ROSTA windows, Exhibition of
Paintings from the Artists of the Professional Union, Ten
Years of the October Revolution and graphics exhibitions
(from 1926). It is said he was responsible for the original idea
of the famous ROSTA windows (1919) and worked with
Mayakovsky and others on them. Produced many satirical
drawings for magazines and newspapers and worked as a
theatre designer.

**38**  The Story about the Bublik [bread roll] **and the Woman
who did not recognise the Republic** 1920
Poem by Vladimir Mayakovsky
Gosizdat, St Petersburg
Lithograph poster in four colours, 72×105, 73.5×106.5cm
Collection L.Kropivnitsky

**CHUPYATOV**, Leonid Terentyevich / 1890–1942
*Painter, graphic artist and theatre designer.* Studied at School of the Society for the Encouragement of the Arts, St Petersburg (1909), the studio of Tsionglinsky (until 1912), studio of Bernshteyn (until 1916), and SVOMAS, Petrograd (1918–20) under Petrov-Vodkin. From 1917 participated in exhibitions including World of Art. Taught at Art School of the Baltic Fleet (1918–20), Kiev Art Institute (1926–8), Academy of Arts (1929), and GINKhUK (from 1933). During 1920s, one of the leading artists to combine mystical, abstract and realistic elements in his paintings.

**39**  **The Hunt** 1927, *Ill. below*
Oil on canvas, 101×146cm
Collection S.A.Shuster and Ye.V.Kryukova

Leonid Chupyatov: **The Hunt** 1927
Cat.39

**40**  **Worker** 1928, *Ill. p.37*
Oil on canvas, 189×107cm
Collection T.V.Rubinshteyn and V.A.Moroz

**41**  **The Crown of Thorns** Undated, *Ill. in col. p.130*
Oil on canvas, 100×113cm
Collection N.Ye. and A.I.Shlepyanov

**DANKO-ALEKSEENKO**, Natalia Yakovlevna / 1892–1942
*Sculptor.* Studied at Stroganov Artistic Industrial Institute, Moscow (1900–2), the Vilnius Art School, the studio of Yanson (1906–8), the workshop of Dillon and the studio of the sculptor Shervud, St Petersburg (1906–8). From 1909 worked in the workshop of the sculptor Kuznetsov. Participated in the execution of reliefs and sculptures for buildings in Moscow, St Petersburg and Kiev and for the Russian pavilions at exhibitions in Turin and Rome (1910–11). From 1914 Kuznetsov's assistant at Imperial Ceramics Factory. Sculptor at State Ceramics Factory and Leningrad Ceramics Factory (1919–41). From 1919 participated in group exhibitions and held one-woman shows in Leningrad (1929, 1946). Produced ceramics for architectural applications, such as the bas-reliefs in the metro station Sverdlov Square [Ploshchad Sverdlova] and the river-boat station at Khimki in Moscow (1936–7).

**42**  **Militia Woman** 1920, *Ill. below*
Relief inscription '1920' on base. On back of pedestal inscribed in clay 'N.Danko' and stamp 'IK' (modeller I.Kuznetsov).
Painted over glaze. Height 20cm
Collection V.Dudakov and M.K.Kashuro

**43**  **Starving** 1921, *Ill. below*
Group of two adults with two children. On base, relief inscription '1921'. Made at time of serious famine in Volga region 1921
Painted over glaze. Height 17.5cm
Collection V.Nemukhin

 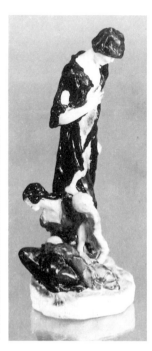

Natalia Danko-Alekseenko:
**Militia Woman** 1920
Cat.42

Natalia Danko-Alekseenko:
**Starving** 1921
Cat.43

**DEINEKA**, Aleksandr Aleksandrovich / 1899–1969
*Painter, graphic artist, sculptor and monumental artist.* Studied at Art School, Kharkov (1915–17) under Pestrikov and Lyubimov, VKhUTEMAS, Moscow (1920–5) under Favorsky. Member and organiser of OST (1925–7) and the society October (1928–30). Lived and worked in Moscow. From 1924 participated in exhibitions. Produced drawings for journals including *U Stanka* [At the Workbench], *Bezbozhnik* [Atheist], *Prozhektor* [Searchlight], and *Krasnaya Niva* [Red Cornfield], and designed posters. Produced panels for the Soviet pavilions in Paris (1937), Minsk (1938) and Moscow, and mosaics for the Moscow metro. His works have been exhibited extensively in Russia and abroad since the 1920s. Taught at VKhUTEIN (1928–30) and MIDI (1945–52). Vice-President of Academy of Arts (1962–6).

**44**  **Girl Seated on a Chair** 1924, *Ill. in col. 127*
Oil on canvas, 118×72.5cm
Collection S.N.Gorshin

**45** **Leningrad 1942** 1942, *Ill. p.39*
Oil on canvas, 30×40cm
Collection Family of F.S.Bogorodsky

---

**DENI** [DENISOV], Viktor Nikolaevich / 1893–1946
*Graphic artist.* Early 1900s studied under Ulyanov. Before
Revolution worked for satirical magazines. During Civil War
(1918–21) made many propaganda posters and verses in
support of new Soviet State. From 1921 became a regular
contributor to *Pravda* and other magazines and newspapers.

**46** **Manifesto. All Power to the Landowners and
Capitalists!!!** 1920, *Ill. below*
Gosizdat, Moscow
Lithograph poster in five colours, 63.1×50.2, 68.2×52.8cm
Collection L.Kropivnitsky

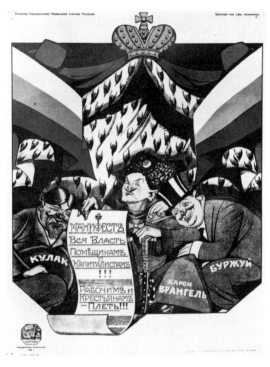

Viktor Deni: 'All Power to the Landowners and Capitalists!!!' 1920
Cat.46

---

**DOSEIKIN**, Nikolai Vasilyevich / 1863–1935
*Painter, sculptor and theatre designer.* Studied at the studio of
Shreyder, Kharkov, with Kiselyov, Moscow, and the
workshop of Kruglikova, Paris. Lived in Paris (1896–1914)
and then in Moscow. From 1888 participated in exhibitions
including the Paris Salons (1898, 1906), TPKhV, MOLKh MTKh,
and SRKh. Member of TPKhV from 1900. Writer of a number
of articles on art. One of the main links between Russian and
French Symbolist movements.

**47** **Elegy** 1912, *Ill. in col. p.88*
Oil on canvas, 64×82cm
Collection B.M.Odintsev

---

**DREVIN**, Aleksandr Davidovich / 1889–1938
*Painter.* Studied at Art School, Riga (1908–13) under Purvit.
From 1912 participated in exhibitions including Knave of
Diamonds, Moscow Painters, and AKhRR. From 1914 lived in
Moscow. Member of IZO Narkompros and the Association of
Extreme Innovators (1918–20). Taught at VKhUTEMAS/
VKhUTEIN (1920–30) and was a member of GAKhN. Travelled
with his wife, Nadezhda Udaltsova, in the Urals (1926–31),
Altai (1929–31), and in Armenia (1932–4), Produced three
cycles of works based on his travels (paintings and graphics).

**48** **Landscape with White House** 1931, *Ill. in col. p.134*
Oil on canvas, 74.5×92cm
Collection V.S. and L.I.Semyonov

**49** **Oxen Drinking, Altai** 1931
Oil on canvas, 66×81cm
Collection V.S. and L.I.Semyonov

**50** **Portrait of Nadezhda Udaltsova** [his wife] 1933–5
*Ill. below*
Oil on canvas, 62×53cm
Collection A.A. and Ye.A.Drevin

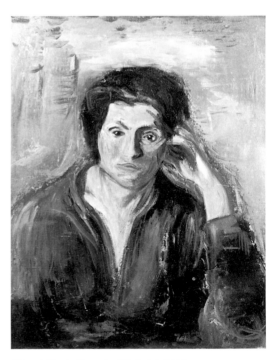

Aleksandr Drevin: **Portrait of Nadezhda Udaltsova** 1933–5
Cat.50

---

**EKSTER** [EXTER], Aleksandra Alexandrovna / 1882–1949
*Painter, graphic artist and theatre designer.* Studied at Art
School, Kiev (until 1907). From 1908 travelled regularly to
Paris, studied at Académie de la Grande Chaumière, in the
studio of Charles Delval, and became acquainted with Picasso,
Braque, Apollinaire and Max Jacob. From 1907 participated
in exhibitions including The Wreath, The Link, Union of
Youth, Knave of Diamonds, No.4, Tramway V, The Store.
Lived in Kiev, Moscow and Paris; travelled to Italy and

Aleksandra Ekster:
**Bacchanal,**
frieze composition for I.Annensky's play *Famira-Kifared* 1916
Cat.51

became acquainted with the Italian Futurists (1909–14). From 1916 began to work for theatres, particularly Aleksandr Tairov's Kamerny Theatre. Lived in Odessa (1917–18). Taught in Kiev (1918–19), at VKhUTEMAS, Moscow (1920–2), Léger's Academy, Paris (from 1925) and in her own studio in Paris. Set designs and costumes for Protozanov's film *Aelita* (1923). Travelled in France and Italy (1923) and emigrated to France (1924).

**51    Bacchanal,** frieze composition for I.Annensky's play
*Famira-Kifared* 1916, *Ill. above*
Gouache and watercolour on paper, 50×245cm
Collection A.B.Chizhov

**52    Composition** 1921, *Ill. p.35*
Indian ink on paper, 48×32cm
Collection D.V.Sarabyanov

**FALK**, Robert Rafailovich / 1886–1958
*Painter, sculptor and graphic artist.* Studied at the studios of Yuon and Dudin, also at Mashkov's Private School (1903–4) and MUZhVZ under Serov and Korovin (1905–9). From 1906 participated in exhibitions including The Golden Fleece, Knave of Diamonds, Izdebsky's Salons, World of Art. Travelled to Italy (1910–11). Lived and worked in Moscow, Paris (1928–36) and Samarkand (1941–4). Member of IZO (1918–21) and INKhUK (1920). Taught at VKhUTEMAS/ VKhUTEIN (1918–28), the Art College, Samarkand (1941–2) and at MIDI (1945–52). One of few painters of integrity in his generation to survive the ravages of Stalinism in the arts. As a link with the past, an inspiration to the young generation of painters in 1950s, including Bulatov and Veisberg.

**53    Self Portrait against a Roof** 1909
Oil on canvas on board, 50×54cm
Collection S.A.Shuster and Ye.V.Kryukova

**54    Liza in an Armchair, Portrait of the Artist's Wife** 1910
*Ill. in col. p.107*
Oil on canvas, 108×80cm
Collection Ye.B. and A.F.Chudnovsky

**55    Woman in Turban** 1918, *Ill. p.16*
Oil on canvas, 118×85cm
Collection Ye.B. and A.F.Chudnovsky

**56    Portrait of Aleksandr Drevin** 1923
Oil on canvas, 120×88.5cm
Collection S.A.Shuster and Ye.V.Kryukova

**FIDMAN**, Vladimir Ivanovich / 1884–1949
*Graphic artist, poster painter and designer.* Studied at Academy of Arts (1910) and Art School, Odessa. Posters, magazine illustrations, caricatures, sketches for stamps, architectural designs and industrial design. Participated in exhibitions including AKhRR.

**57    'The Enemy is after Moscow, the Heart of Soviet Russia. The Enemy must be Destroyed. Onward Comrades'** 1919, *Ill. below*
Izd. Politupr. RVSR, Moscow
Lithograph poster in two colours, 97×69.7, 107×71.8cm
Collection L.Kropivnitsky

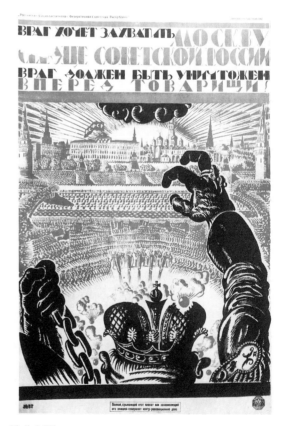

Vladimir Fidman:
**'The Enemy is after Moscow,
the Heart of Soviet Russia. The Enemy must be Destroyed.
Onward Comrades'** 1919
Cat.57

**FILONOV**, Pavel Nikolaevich / 1883–1941

*Painter and graphic artist.* Studied at School of the Society for the Encouragement of Arts, St Petersburg (1897–1901), the studio of Dmitriev-Kavkazsky (1903–8) and Academy of Arts, St Petersburg (1908–10). From 1910 participated in exhibitions including Union of Youth, Donkey's Tail, Community of Artists. Founder-member of the group Union of Artists (1910–13). Travelled to Austria, Italy and France (1912). Wrote the article *Kanon i Zakon* [Canon and Law], the first explanation of the principles of 'analytical' art (1912). Designed the decor for the tragedy *Vladimir Mayakovsky* at the Luna Park Theatre, St Petersburg (1913). Published manifesto of analytical painting, *Sdelannye kartiny* [Made Paintings] (1914). Member of GINKhUK, and head of the ideological department, Petrograd Academy (1923). Established the collective Masters of Analytical Art (1925). Responsible for illustrations to *Kalevala* [Kalevala are Karelian–Finnish epics about feats of mythological country, Kaleva]. One man-shows in Leningrad (1929–30, never opened), Novosibirsk (1967) and Leningrad (1988).

**58**  **At Table (Easter)** 1912–13, *Ill. on cover and on p.9*
Oil on paper, 37×47.5cm
Collection Ye.B. and A.F.Chudnovsky

**GOLOVIN**, Aleksandr Yakovlevich / 1863–1930

*Painter, graphic artist, theatre designer and sculptor.* Studied at MUZhVZ architecture and painting under Makovsky, Polyenov and Pryanishnikov (1881–6), and then in Paris under Blanche (1889), Collain and Meerson (1897). Worked in Moscow until 1901 and then in St Petersburg. From 1894 participated in exhibitions including MTKh, MOLKh, SRKh, World of Art. Travelled to Italy, Spain and France (1895). Designs for the Petersburg Imperial Theatres (1899–1917), and sets and costumes for performances in Moscow and Leningrad. Also designed the drop-curtains for the Marinsky Theatre, St Petersburg and the Odessa Theatre. Made Sketches of a *Russian Dining Room* for Yakunchikova (1898), designed the Russian pavilion at the International Exhibition in Paris (1900) with Korovin, produced ceramic panels for the façade of the Metropol Hotel, Moscow (1900) with Vrubel, and book illustrations. His works were shown in Paris (1900) and Brussels (1928). Also one-man shows in Moscow (1940, 1956, 1960, 1963) and Leningrad (1940, 1956).

**59**  **Bird** vessel *c.*1900
Majolica, reduced firing, green glaze, 41×31×16cm
Collection V.A.Dudakov and M.K.Kashuro

**60**  **Self Portrait** 1919, *Ill. p.60*
Tempera on canvas, 72×69cm
Collection V.Ya.Andreev

**GONCHAROVA**, Natalia Sergeevna / 1881–1962

*Painter, graphic artist and theatre designer.* Studied at MUZhVZ under Volnukhin, Trubetskoy and Korovin (1898–1909). From 1904 participated in exhibitions including Salon d'Automne, The Golden Fleece, Knave of Diamonds, Donkey's Tail, Target, No.4. Together with Larionov organised exhibitions and societies, and one of the creators of Neo-primitivism (from 1907) and Rayism [Luchism] (from 1912). Began to work for theatres (1904) and designed *Zobeida's Wedding* (1904), *The Golden Cockerel* by Rimsky-Korsakov (1914), *The Fan* by Goldoni (1915), *The Firebird* by Stravinsky (1926). Left Moscow to live in Paris (1915). Her works were shown in the USSR and abroad including Moscow (1913, 1969), Petrograd (1914), Paris (1956) and London (1962).

**61**  **Pond** 1905
Oil on canvas, 78×60cm
Painted with and signed by M.F. Larionov
Collection I.G.Sanovich

**62**  **Apple Blossom** 1909, *Ill. below*
Oil on canvas, 92×103cm
Collection S.A.Shuster and Ye.V.Kryukova

Natalia Goncharova: **Apple Blossom** 1909
Cat.62

**63**  **Spring in Town** 1911, *Ill. p.31*
Oil on canvas, 70×91cm
Collection Ye.B. and A.F.Chudnovsky

**64**  **Spanish Woman** 1916, *Ill. in col. p.20*
Oil on canvas, 202×88cm
Collection V.S. and L.I.Semyonov

**GORBATOV**, Konstantin Ivanovich / 1876–1928
*Painter and graphic artist.* Studied under Burov, Samara (1890), at TSUTR (1895), the studio of Klark, Riga (1896–1903) and Academy of Arts (from 1903) under Kiselyov and Dubovsky. Lived in Italy (1912–13). From 1905 participated in exhibitions including Academy of Arts, Society of Russian Watercolourists and TPKhV. Member of TPKhV from 1917. Drawings for the satirical journals *Zhalo* [Sting], *Sekira* [Hatchet] and *Zarnitsa* [Summer Lightning] (1905–6). Lived abroad from 1924.

**65**   Pskov 1919, *Ill. in col. p.11*
Oil on board, 48×62cm
Collection I.A. and Ya.A.Rzhevsky

**GORODETSKY**, Sergei Mitrofanovich / 1884–1967
*Poet, artist and poster painter.* One of the most important poets of the pre-revolutionary and Soviet periods. Produced posters in the 1920s using Futurist and Cubist devices. Worked in the editorial offices of BAKKAVROSTA from the 1920s and of many publishing houses in Moscow and other towns. Participated in exhibitions including AKhRR and the 47th Travelling Exhibition of Paintings.

**66**   The Workers Destroy Capital *c.*1919
Watercolour poster design on paper, 146.3×91.5cm
Collection L.Kropivnitsky

**GRIGORIEV**, Boris Dmitrievich / 1886–1939
*Graphic artist and painter.* Studied at Stroganov Institute (1903–7) under Shcherbinovsky, and Academy of Arts (1907–12) under Kardovsky and Kiselyov. From 1909 participated in exhibitions including Fellowship of Independents and World of Art. Lived in Paris (1912–14). From 1913 member of World of Art group. Produced the cycle *Sowing/Broadcasting* (1917). Worked for the journals *Satirikon* and *Novy Satirikon* [New Satyricon]. Moved to Paris in 1919.

**67**   The Circus Artiste's Dream *c.*1915, *Ill. below*
Oil on canvas, 62×122cm
Collection T.V.Rubinshteyn and V.A.Moroz

Boris Grigoriev: **The Circus Artiste's Dream** *c.*1915
Cat.67

**68**   Cabaret 1918, *Ill. in col. p.111*
Mixed media on board, 85×100cm
Collection Ye.B. and A.F.Chudnovsky

**INFANTE**, Francisco / Born 1943
*Painter.* Studied at Moscow Secondary Art School, MGKhI (1956–62). Participated in the exhibitions of the Movement group (1962–8). Designed moving spatial constructions, kinetic theatre and artificial cosmic systems. From 1968 produced installations in natural surroundings. Organised the group Argo (1970). Produced Artefacts in the form of slides (since 1976). His works were shown in thirty-seven exhibitions in the USSR and fifty abroad, and also nine one-man shows. Lives and works in Moscow.

**69**   Artefacts, twelve images from the series: **Suprematist Game** (1968); **The Life of a Triangle** (1977); **The Square's Travels** (1977); **Procession** (1978); **Centre of Twisted Space** (1979–80); **Contrivance** (1981); **The Construction of a Sign** (1984–6), *Ill. p.8*
Photographs mounted on board, each *c.*50×50cm
Collection the artist

**IVANOV**, Sergei Ivanovich / 1885–1942
*Graphic artist.* Studied at Stroganov Institute and Moscow School of Painting, Sculpture and Architecture. Designed many political posters.

**70**   'Cholera' 1920
Gosizdat, St Petersburg
Lithograph poster in four colours, 57.9×42.9, 70.2×48cm
Collection L.Kropivnitsky

**JAWLENSKY**, Aleksei Georgievich / 1864–1941
*Painter.* Studied at Military School, Moscow (1877–84), Academy of Arts (1889–93), and the studio of Repin, St Petersburg (from 1890), where he met Verevkina [Mariane von Werefkin], his future wife. Worked at Ažbé School, Munich from 1896, where he met Kandinsky. From 1903 participated in exhibitions including Munich and Berlin Sezession, Salon d'Automne in Paris, World of Art, SRKh, The Wreath, Knave of Diamonds, Der Blaue Reiter. Travelled in France (1903–5). In 1909, together with Münter and Kandinsky founded New Association of Artists in Munich. 1911 founder-member of Blaue Reiter. Last trip to Russia in 1914. From 1915 lived in Switzerland.

**71**   Still Life 1902, *Ill. in col. p.92*
Oil on board, 41×26cm
Collection V.A.Dudakov and M.K.Kashuro

**72**   Landscape, Murnau 1907
Oil on board, 50×55cm
Collection V.A.Dudakov and M.K.Kashuro

**KABAKOV**, Ilya Iosifovich / Born 1933
*Artist and graphic artist.* Studied book illustration at Moscow Secondary Art School, MGKhI named after Surikov (1951–7), and under Dekhterev. Participated in exhibitions since the end of the 1950s. His works were shown in Sopot, Posnan (1966), Rome (1967), Cologne, Lugano (1970), Paris (1976), Washington (1977) and London (1977). One-man shows in Paris (1985), Berne (1985), Marseilles (1986), Düsseldorf (1986), Paris (1987), New York (1988) and London (1989). In his ironical stories and illustrations, adopts a pseudo-naive stance to lay bare the cruelties and absurdities of a manipulative and inflexible system.

**73**   **The Death of Alya's Dog** 1969, *Ill. in col. p.148*
Mixed media on panel, 160×220cm
Collection Ye.M.Nutovich

**KAGAN**, Anna Aleksandrovna / 1902–74
*Painter, graphic artist and ceramic painter.* Studied at School of Art, Vitebsk (1919–22) under Malevich. Member of UNOVIS, and participated in exhibitions of the group in Vitebsk (1920, 1921), in Moscow (1920, 1921, 1922), and in Petrograd (1923). The exhibition in Petograd, Malevich's attempt to implement Larionov's idea of anonymous exhibition, included her *White Suprematism* (1923), hung without label. Together with the sculptor Pavlov, helped Malevich to create Architektons at State Institute of Artistic Culture, Leningrad (1924–5). Unlike many of Malevich's students, continued abstract painting rather than being interested in new Socialist Realism, and transformed Suprematist abstraction into architectonic abstract painting (1928–30). Stopped exhibiting in new artistic climate where only subjects socially worthy and didactic drew response. In late 1920s and early 1930s decorated ceramics.

**74**   **Decorative Tray** *c.*1925, *Ill. above right*
With Suprematist painting in blue and yellow
No mark. Faience, painted over glaze, stencil.
Diameter (without handle) 30cm
Collection V.A.Dudakov and M.K.Kashuro

**75**   **Composition** 1928, *Ill. in col. p.126*
Oil on canvas, 100×55cm
Collection V.A.Dudakov and M.K.Kashuro

Anna Kagan: **Decorative Tray** *c.*1925
Cat.74

**KHLEBNIKOVA**, Vera Vladimirovna / 1891–1941
*Painter and graphic artist.* Studied at Art School, Kazan (1905–8), Art School, Kiev (1908–10), the studio of Yuon and Dudin in Moscow (1910), the OPKh School, St Petersburg, under Tsionglinsky, and the Académie Witte, Paris (1912) under Van Dongen. Lived in Italy and Switzerland (1913–16) and London. Symbolist and religious artist whose work was influenced by the style of Vrubel. Sister of the Futurist poet Velimir Khlebnikov. After his death (1922) married the artist Pyotr Miturich two years later. From 1919 participated in exhibitions including Union, Moscow. Produced decorative panels. Her works were shown in Moscow (1969, 1978), Astrakhan (1977) and Leningrad and Moscow (1978).

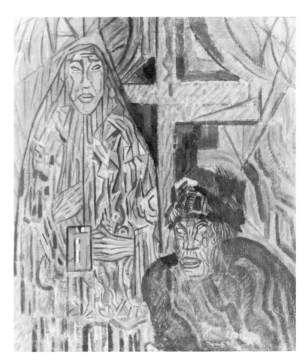

Vera Khlebnikova: **Blind Men** 1916–17
Cat.76

**76**  Blind Men 1916–17, *Ill. below left*
Oil on canvas, 92×82cm
Collection M.P.Miturich

**KHODASEVICH**, Valentina Mikhailovna / 1894–1970
*Painter, graphic artist and theatre designer.* Studied at the
studio of Rerberg, Moscow, the studio of Haberman, Munich
(1910–11), the Académie Witte, Paris (1911–12) under Van
Dongen, and the studio of Tatlin, Moscow (1912). From 1912
participated in exhibitions including the Salons, Knave of
Diamonds, Exhibition of Paintings of Leftist Tendencies.
Lived in St Petersburg from 1913. From 1919 worked for the
theatre. Lived in Germany in 1922 and travelled to London,
Paris and Italy in 1924. Designed stage productions in Milan
and Rome. Stayed in Sorrento with Maxim Gorky in 1928 and
then returned to Moscow.

**77**  Portrait of a Woman 1916, *Ill. p.30*
Oil on canvas, 160×115cm
Collection A.I.Shlepyanov

**KNIT**, Ludwig Frantsevich / 1894–1942?
*Graphic Artist.* Lived and worked in Baku. Produced posters
for BAKKAVROSTA. No information available after 1942.

**78**  Revolutionary Rider with Banner 1920, *Ill. p.18*
Studio of BAKKAVROSTA, Poster no.7
Lithograph poster in four colours
47.5×44.3, 73.8×52.4cm
Collection L.Kropivnitsky

**79**  'Female Moslem Workers' 1920, *Ill. below left*
Studio of BAKKAVROSTA, Poster no.8
Lithograph poster in four colours
37.4×39.6, 71.1×46.2cm
Collection L.Kropivnitsky

**80**  The Revolutionary Sailor 1920
Studio of BAKKAVROSTA, Poster no.10
Lithograph poster in three colours
40.5×45.5, 71×50.6cm
Collection L.Kropivnitsky

**KOBYLETSKAYA**, Zinaida Viktorovna / 1880–1957
*Ceramics painter and graphic artist.* Studied painting ceramics
at Drawing School of OPKh, St Petersburg (1910), and
factories in Denmark, Sweden and France (1910–12). Worked
at Imperial Ceramics Factory, St Petersburg (1912–14), the
painting section of the former Stieglitz School, and a factory
(1918–23). Painted a number of agitational ceramics. Worked
intermittently at the State Ceramics Factory and the
Leningrad Ceramics Factory (1917–32). Participated in
exhibitions including Exhibition of Russian Ceramics, Fifth
Exhibition of the Community of Artists, State Ceramics
Factory Exhibition and All-Union Exhibition of Soviet
Ceramics. From 1932 illustrator for the publishing section of
Academy of Sciences of the USSR, working on publications
including *Flora of the USSR* and *Flora of Tadjikistan*.

**81**  Yellow Tea Service with Emblems 1921
Teapot, milk jug, sugar bowl, two cups with saucers.
GFZ silver painted over glaze. Height of teapot 13.8cm;
cups 5.8cm
Collection T.Rubinshteyn

**KONCHALOVSKY**, Pyotr Petrovich / 1876–1956
*Painter and theatre designer.* Studied at studio of Raevska-
Ivanova, Kharkov, Stroganov Art and Technical Institute,
Moscow (from 1889), Académie Julian, Paris (1896–8) under
Laurens and Benjamin-Constant, and the St Petersburg
Academy of Arts (1898–1907) under Tvorozhnikov, Savinsky
and Kovalevsky. Moved to Moscow. From 1908 participated
in exhibitions including The Golden Fleece, Knave of
Diamonds, World of Art, Being, AKhRR. Founder and
President of Knave of Diamonds. Designs for operas by
Zimin (1912–14). Taught at SVOMAS (1918–21) and
VKhUTEMAS/VKhUTEIN (1926–9) One-man shows in Moscow
(1922, 1927–30) and Paris (1925).

**82**  Still Life with Samovar 1916, *Ill. in col. p.109*
Oil on canvas, 97×115cm
Collection Ye.B. and A.F.Chudnovsky

**83**  Still Life with Tray 1919, *Ill. p.29*
Oil on canvas, 92×107cm
Collection Ye.B. and A.F.Chudnovsky

**KONYONKOV**, Sergei Timofeevich / 1874–1971

*Sculptor.* Studied at MUZHVZ (1892–6) under Ivanov and Volnukhin, Moscow, and Academy of Art, St Petersburg (1899–1902). Visited Berlin, Dresden, Paris and Rome in 1897. Member of NOKh (from 1908), SRKh (from 1909), and World of Art (from 1917). Lived and worked in Moscow (1902–23). Travelled to Egypt and Greece (1912–13). Taught at SVOMAS, VKhUTEMAS and the studio of PROLETKULT (1918–22). President of Moscow Union of Sculptors and member of IZO Narkompros. Involved in Plan for Monumental Propaganda including the sculptural group *Stepan Razin* for walls of Kremlin. Lived and worked in New York (1924–45) and from 1945 in Moscow. Participated in many exhibitions in USSR and abroad, and wrote articles on art and books about his work. Memorial museum in honour of the artist, attached to Academy of Arts of USSR, Moscow.

**84**   Female Figure 1913, *Ill. below*
Wood, 60×30×30cm
Collection S.A.Shuster and Ye.V.Kryukova

Sergei Konyonkov:
**Female Figure** 1913
Cat.84

**KOROVIN**, Konstantin Alekseevich / 1861–1939

*Painter and theatre designer.* Studied at MUZHVZ (1875–83) under Pryanishnikov, Perov, Savrasov and Polyenov, and Academy of Arts (1882). From 1889 participated in exhibitions including TPKhV, World of Art, SRKh. Designed for private opera company of Savva Mamontov, Bolshoi Theatre, Moscow, and Marinsky and Aleksandrinsky Theatres, St Petersburg. Taught at MUZHVZ (1901–18). From 1910 chief designer at Moscow Imperial Theatres. From 1923 lived and worked in Paris. Exhibited in many countries.

**85**   Portrait of Fyodor Chaliapin with his Daughter Irina
1914, *Ill. below*
Oil on canvas, 84×67cm
Collection L.V.Morozova

Konstantin Korovin: **Portrait of Fyodor Chaliapin with his Daughter Irina** 1914
Cat.85

**86**   Winter 1915, *Ill. p.25*
Oil on canvas, 73×98cm
Collection V.Ya.Andreev

**87**   Portrait of a Woman *c.*1915, *Ill. p.13*
Oil on canvas, 87×66cm
Collection I.Yu.Gens and V.V.Katanyan

**88**   Hunting, Fishing 1916, *Ill. in col. p.85*
Oil on canvas, 132×85cm
Collection Ye.M.Nepalo

**KROPIVNITSKY**, Lev Yevgenyevich / Born 1922

*Painter and graphic artist.* Studied at MIII–MIDI (1939–41, 1945–6). From 1958 participated in over thirty exhibitions in Moscow. Also exhibited in Vienna (1975), Venice (1977), Washington (1977), London (1970s) and Paris (1978). Son of unofficial painter Yevgeny Kropivnitsky, exhibited also with Lianozovo group.

**89**  The Continuity of Creation 1959, *Ill. in col. p.142*
Oil on canvas, 141×76cm
Collection the artist

**KULBIN**, Nikolai Ivanovich / 1868–1917

*Painter, graphic artist, doctor and art critic.* Studied at Military Medical Academy, St Petersburg (until 1892), and was doctor of General Staff. No formal artistic education. Organiser and participant in exhibitions of Studio of Impressionists and Triangle (1908–11). Participated in exhibitions of Izdebsky's Salons, Dobychina's Byuro. Produced lithographic portraits of writers, painters and performers including Khlebnikov, Chukovsky, Kuzmin (1912). Participated in many exhibitions abroad, in France, Italy, Germany. Associated with Petrograd Futurists and Union of Youth exhibiting society.

**90**  Portrait of the Playwright and Director
Nikolai Yevreinov 1913–14, *Ill. below*
Watercolour on board, 90×62cm
Collection O.I.Rybakova

Nikolai Kulbin: **Portrait of the Playwright and Director**
**Nikolai Yevreinov** 1913–14
Cat.90

**KUPRIN**, Aleksandr Vasilyevich / 1880–1960

*Painter and graphic artist.* Studied Voronezh at the studio of painting and drawing under Solovyov and Ponomarev (1896–1902), studio of Dmitrieva-Kavkazsky, St Petersburg (1902–4), studio of Yuon and Dudin (1902–6), Moscow, MUZHVZ (1906–10) under Arkhipov, Korovin and Pasternak. From 1906 participated in exhibitions including Knave of Diamonds, OMKh. One of founders of Knave of Diamonds (1910). Taught at SVOMAS (1918–19), college, Nizhni Novgorod [now Gorki], VKhUTEMAS/VKhUTEIN (1922–30), and MTI (1931–9).

**91**  Female Model, contre-jour 1912
Oil on canvas, 105×86cm
Collection S.A.Shuster and Ye.V.Kryukova

**92**  Eastern Town 1917, *Ill. below*
Gouache and collaged coloured paper on paper, 61×89cm
Collection S.A.Shuster and Ye.V.Kryukova

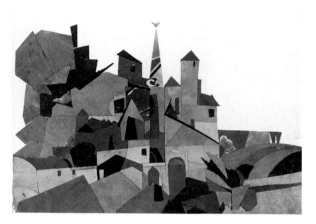

Aleksandr Kuprin: **Eastern Town** 1917
Cat.92

**KUSTODIEV**, Boris Mikhailovich / 1878–1927

*Painter, graphic artist, sculptor and theatre designer.* Studied in Astrakhan (1896–1903) under Vlasov, Higher Art School attached to Academy of Arts, St Petersburg (1896–1903) under Savinsky, Repin and Stelletsky. Visited France and Spain on grant from Academy of Arts in 1904. From 1904 participated in exhibitions including NOKh, World of Art, SRKh, Community of Artists. Member of SRKh (from 1907), World of Art (from 1910) and AKhRR (from 1923). Illustrations for satirical magazines *Zhupel* [Bugbear] and *Adskaya Pochta* [Infernal Post] (1905–7). Visited Italy, France, Germany and Switzerland (1907–17). Exhibited abroad and in USSR, including Petrograd (1920), Leningrad (1928), Moscow (1929, 1947, 1952), Leningrad (1959), Kiev (1960) Moscow (1968) Astrakhan (1978).

**93**  Autumn 1918, *Ill. overleaf*
Oil on canvas, 80×98cm
Collection I.A. and Ya.A.Rzhevsky

Boris Kustodiev: **Autumn** 1918
Cat.93

**94**    **Shrove-Tide** 1919, *Ill. in col. p.83*
Oil on canvas, 88×105cm
Collection I.A. and Ya.A.Rzhevsky

**KUZNETSOV**, Pavel Varfolomeevich / 1878–1968
*Painter, graphic artist and theatre designer.* Studied at School
of Saratov Society for the Encouragement of Fine Arts under
Konovalov and Baraki (1891–6), MUZhVZ (1897–1904) under
Arkhipov, Kasatkin, Pasternak, Serov and Korovin, and in
Paris (1905). From 1899 participated in exhibitions including
World of Art, Blue Rose, SRKh, MTKh. Leader of Blue Rose
group (1907), President of Four Arts society (1924–31), and
from 1906 member of Salon d'Automne, Paris. Worked on
Kirghiz series (1910–13). Taught at MUZhVZ and VKhUTEMAS
(1910–13), Stroganov Artistic Industrial Institute (1917–18),
MIII (1918–37), and MVKhPU (1945–8). In charge of the
painting section of IZO (1919–24).

**95**    **Kirghiz Family** 1910, *Ill. p.28*
Oil on canvas, 67.5×76cm
Collection S.A.Shuster and Ye.V.Kryukova

**96**    **Sheep Shearing** *c*.1912–13, *Ill. in col. p.97*
Oil on canvas, 105×105cm
Collection I.M.Ezrakh

**97**    **Miskhor** 1925, *Ill. in col. p.133*
Oil on canvas, 72×86cm
Collection S.A.Shuster and Ye.V.Kryukova

**98**    **Three Armenian Poets** 1930–1
Oil on canvas, 70×97cm
Collection S.A.Shuster and Ye.V.Kryukova

**99**    **Guarding the Socialist Motherland** *c*.1935, *Ill. p.10*
Tempera and gouache on canvas, 80.5×65.5cm
Collection S.A.Shuster and Ye.V.Kryukova

**LANSERE**, Yevgeny Yevgenyevich / 1875–1946
*Painter, monumental and graphic artist.* Studied at OPKh, St
Petersburg (1892–6) under Tsionglinsky and Lipgardt,
Académie Julian, Paris (1896–9) under Laurens and
Benjamin-Constant, and Académie Colarossi. From 1896
participated in exhibitions including World of Art, NOKh,
Academy of Arts, and from 1898 exhibited abroad. Member
of World of Art. Lived in St Petersburg until 1917, in
Dagestan (1917–20), in Tbilisi (1920–34) and in Moscow.
Travelled in Western Europe (1896–7, 1907, 1927). Visited
Japan (1902) and Turkey (1923). Worked for satirical anti-
Tsarist magazines *Zhupel* [Bugbear], *Adskaya Pochta*
[Infernal Post] and *Zritel* [The Spectator] (1905–8). Head
artist in ceramics and glass engraving factories, St Petersburg
and Ekaterinburg (1912–15). Also designed books and
monumental propaganda projects after the Revolution. From
1922 taught at Tbilisi Academy of Arts.

**100**    **Ust-Krestishche, Early Spring** 1917
Oil on canvas, 87.5×64.5cm
Collection Family of Ye.Ye.Lansere

**LAPSHIN**, Nikolai Fyodorovich / 1888–1942
*Graphic artist and painter.* Studied at Drawing School of
OPKh, St Petersburg, and the studio of Tsionglinsky and
Bernshteyn. From 1922 participated in exhibitions including
New Tendencies in Art, Petrograd Artists of all Tendencies,
Four Arts. Worked on agitational ceramics for Lomonosov
Porcelain Works and graphics. Exhibited abroad, in Leipzig
(1927), Cologne (1928), Winterthur (1929), Paris (1931).
Lived and worked in Leningrad.

**101**    **Suprematist Dish** 1923, *Ill. in col. p.123*
With Suprematist painting in brown and light blue
Body: GFZ 1923
On the base, inscription 'After design by Lapshin'.
Monogram 'NP 1900' in green ink.
Painted over glaze. Diameter 25cm
Collection V.N.Nemukhin

**LARIONOV**, Mikhail Fyodorovich / 1881–1964

*Painter, graphic artist and theatre designer.* Studied at MUZhVZ (1898–1908) under Levitan and Serov. In 1900 met Goncharova, his life-long companion. From 1906 participated in exhibitions including Salon d'Automne, World of Art, SRKh. In 1907 his 'primitive' period began and he founded Neo-primitivism. Organised The Wreath-Stephanos exhibition with Burlyuk in Moscow (1907), and participated in exhibitions including The Link in Kiev, The Golden Fleece (1908). Exhibited at Izdebsky's Salons in Odessa, Kiev, Riga and St Petersburg (1909–10) and with Knave of Diamonds (1910). Organised group exhibitions Donkey's Tail (1912), Target (1913), and No.4 (1914). Worked on series of *Soldiers* (1910–11). Founded Rayism together with Goncharova (1912). In 1915 left Russia, and worked with Diaghilev. Lived in Paris. Exhibited in Moscow, Leningrad and abroad.

**102**   **The Red Factory** *c.*1903
Oil on board, 38×44cm
Collection T.V.Rubinshteyn and V.A.Moroz

**103**   **The Walk** 1906, *Ill. p.28*
Oil on canvas, 65×44cm
Collection V.A.Dudakov and M.K.Kashuro

**104**   **Fishes** 1907, *Ill. in col. p.98*
Oil on canvas, 64×73cm
Collection Ye.B. and A.F.Chudnovsky

**105**   **Portrait of Natalia Goncharova** 1910, *Ill. in col. p.99*
Oil on canvas, 49.5×69.5cm
Collection V.S. and L.I.Semyonov

**LEBEDEV**, Vladimir Vasilyevich / 1891–1967

*Graphic artist and painter.* Studied at the studio of Titov, St Petersburg (1909), workshop of Rubo (1911), studio of Bernshteyn and Shervud (1912–14), and Academy of Arts (1912–16). From 1911 worked as illustrator for magazines *Galchonok* [Young Jackdaw], *Satirikon* and for *Novy Satirikon* [New Satyricon], *Argus* (1913–17). From 1912 participated in exhibitions. Lived and worked in St Petersburg/Leningrad. Member of avant-garde OBMOKhU from 1918. Taught at SVOMAS, Petrograd (1918–21). With Mayakovsky and Cheremnykh designed propaganda posters for the ROSTA windows (1920–1). Member of POSNOVIS/UNOVIS group (1921–2) and Four Arts group (from 1928). Art editor for OGIZ/DETGIZ, and working on children's books. Participated in exhibitions abroad including Paris (1925, 1931). One-man show in Leningrad (1928). Worked on posters for the TASS windows (1942–5).

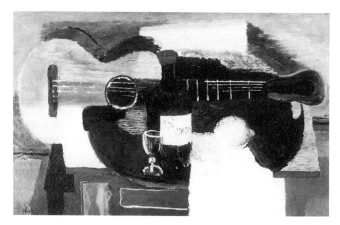

Vladimir Lebedev: **Guitar** 1930
Cat.106

**106**   **Guitar** 1930, *Ill. above*
Oil on canvas, 55×80cm
Collection I.M.Ezrakh

**107**   **Woman in Pink** *c.*1935, *Ill. p.39*
Oil on canvas, 71×54cm
Collection I.M.Ezrakh

**108**   **Seated Girl** 1939
Oil on canvas, 71×55cm
Collection N.N.Efron-Blokh

**LEBEDEVA**, Sarra Dmitrievna / 1892–1967

*Sculptor.* Studied at Drawing School of OPKh, St Petersburg, and the studio of Bernshteyn and Shervud (1910–14). Visited Berlin, Vienna, Paris, travelled in Italy (from 1914). Taught at SVOMAS, Petrograd (1918–20). From 1925 lived and worked in Moscow. Visited London (1925), and Berlin and Paris (1928). Member of ORS from 1926. From 1918 participated in exhibitions including World of Art, Association of New Tendencies, ORS. Exhibited abroad. One-person shows in Moscow (1968), Budapest (1968–9) and Moscow-Leningrad (1969–70).

**109**   **Bust of Vladimir Lenin** *c.*1923
Bronze, 38.5×28×28cm
Collection V.S. and L.I.Semyonov

**LENTULOV**, Aristarkh Vasilyevich / 1882–1943

*Painter, graphic artist and theatre designer.* Studied at Seliverstov Art College, Penza (1898–1900), Art School, Kiev (1900–4) under Pimonenko, the studio of Kardovsky, St Petersburg (1907–8), and in Paris under Le Fauconnier (1911). From 1905 participated in exhibitions in Penza, including The Wreath-Stephanos, The Link, Izdebsky's Salons, MTKh. One of organisers of Knave of Diamonds (1910) and participated in exhibitions of the World of Art (from 1911). Made theatre designs in Moscow (1916, 1918–26, 1930). Taught at SVOMAS, VKhUTEMAS/VKhUTEIN and MIII (1919–43). Member of AKhRR (from 1926), and OMKh (from 1928). Major retrospective Moscow, Leningrad (1987).

**110** Allegory of the Patriotic War of 1812 1914, *Ill. p.29*
Oil on canvas, 155.5×162.5cm
Collection V.S. and L.I.Semyonov

**111** Victory Battle 1914, *Ill. in col. p.17*
Oil on canvas, 137.5×183cm
Collection M.A.Lentulova

**112** Woman in Striped Dress (Portrait of M.P.Lentulova against a Background of Birch Trees) 1915
Oil, bronze and silver paint and collage on canvas, 116×104cm
Collection M.A.Lentulova

**113** Peace, Celebration, Liberation 1917, *Ill. in col. p.113*
Oil on canvas, 155×137cm
Collection S.A.Shuster and Ye.V.Kryukova

**114** Two Figures (Portrait of Anisimov and his Wife) 1919
Oil on canvas, 127.5×135.5cm
Collection V.S. and L.I.Semyonov

**LEVITAN**, Isaak Ilyich / 1860–1900

*Painter.* Studied at MUZhVZ (from 1873) under Savrasov and Polyenov. From 1877 participated in exhibitions including Student, TPKhV. Worked on series of landscapes of Volga River (1887–90). From 1898 taught at MUZhVZ. Exhibited in Munich, Paris and Berlin. His works regularly appeared at exhibitions in USSR and abroad.

**115** Izbas [traditional wooden houses] 1899, *Ill. in col. p.82*
Oil on canvas, 57.5×88cm
Collection V.Ya.Andreev

**MALEVICH**, Kazimir Severinovich / 1878–1935

*Painter, graphic artist and theatre, architectural and industrial designer.* Studied at Drawing School, Kiev (1895–6), MUZhVZ (1904–5), and the studio of Rerberg, Moscow (1905–10). From 1910 participated in exhibitions including Knave of Diamonds, Donkey's Tail, Union of Youth, Der Blaue Reiter, Tramway V, 0.10. Staged opera *Victory over the Sun* (libretto Kruchyonykh, music by Matiushin) and produced first Suprematist sketches for costumes and scenery (1913). First Suprematist paintings (1915), published pamphlet *From Cubism to Suprematism* (1915) and theoretical works on contemporary art. Head teacher at SVOMAS (1918), and in Vitebsk taught at Art School (1919–20), and founded UNOVIS group (1920). Taught at VKhUTEMAS (from 1922), director of GINKhUK (1923–7), and professor of Academy of Arts (from 1922). Designed Mayakovsky's *Mystery Bouffe*, directed by Meyerhold (1918). Worked on designs for ceramics and architectural models (from 1923). First one-man show in Moscow in 1919. Lived in Leningrad.

**116** The Flower Seller 1904, *Ill. in col. p.95*
Oil on canvas, 72×94cm
Collection Ye.B. and A.F.Chudnovsky

**117** Red Roofs 1906
Oil on board, 50×69cm
Collection T.V.Rubinshteyn and V.A.Moroz

**118** Three Figures 1913–28, *Ill. in col. p.119*
Oil on canvas, 37×27cm
Collection V.A.Dudakov and M.K.Kashuro

**119** Portrait of the Artist's Mother 1932
Oil on canvas, 41×36cm
Collection V.A.Dudakov and M.K.Kashuro

**120** Portrait of the Artist's Brother 1933, *Ill. in col. p.135*
Oil on canvas, 50×40cm
Collection V.A.Dudakov and M.K.Kashuro

**MASHKOV**, Ilya Ivanovich / 1881–1944

*Painter and graphic artist.* Studied at MUZhVZ(1900–9) under Korovin and Serov. Taught at own private studio (1904–17). Travelled in France, Germany, Austria, England, Spain and Italy (1908). From 1908 participated in exhibitions including New Society of Artists, The Golden Fleece, Izdebsky's Salons, World of Art. One of organisers of Knave of Diamonds group (1910). Taught at SVOMAS and VKhUTEMAS/VKhUTEIN (1918–30). Member of AKhRR (1924–32), and one of organisers of OMKh.

**121** Landscape with Small House 1911
Oil on canvas, 49×63cm
Collection S.A.Shuster and Ye.V.Kryukova

**122**    **Still Life with Poppies and Cornflowers** 1912–13
*Ill. in col. p.108*
Oil on canvas, 110×129cm
Collection I.A. and Ya.A.Rzhevsky

**123**    **Still Life with Pumpkin** 1913–14
Oil on canvas, 116×150cm
Collection Ye.B. and A.F.Chudnovsky

**124**    **Nude Models in the Studio** 1916, *Ill. below*
Oil on canvas, 147×156cm
Collection S.A.Shuster and Ye.V.Kryukova

Ilya Mashkov: **Nude Models in the Studio** 1916
Cat.124

**MATIUSHIN**, Mikhail Vasilyevich / 1861–1934
*Painter, musician, composer.* Studied at Moscow Conservatory
(1876–80), School of Society for the Encouragement of the
Arts, St Petersburg (1894–8), Academy of Arts (1902–5)
under Tsionglinsky, and the studio of Dobuzhinsky and Bakst
(1906–7). From 1908 participated in exhibitions including
Contemporary Tendencies in Art, Triangle, Union of Youth.
Organiser and member of Union of Youth (1910–14). Wrote
music for opera *Victory over the Sun* (1913), and for plays by
his wife, Elena Guro, artist and poet. Taught at SVOMAS/
VKHUTEMAS (1918–26), and was head of Department of
Organic Culture at GINKHUK (1924–7).

**125**    **The Pink House** *c.*1909, *Ill. in col. p.94*
Oil on canvas, 40×26cm
Collection V.A.Dudakov and M.K.Kashuro

**126**    **The Strip of Road** *c.*1913, *Ill. p.33*
Oil on canvas, 51×38cm
Collection T.V.Rubinshteyn and V.A.Moroz

**MATVEEV**, Aleksandr Terentievich / 1878–1960
*Sculptor.* Studied under Konovalov, Saratov at Drawing
School of Bogolyubov (1896–8), and MUZhVZ (1899–1902)
under Volnukhin and Trubetskoy. From 1900 participated in
exhibitions including MUZhVZ, World of Art, Blue Rose,
Knave of Diamonds, Donkey's Tail, Four Arts, Union of
Russian Artists, The Golden Fleece, The Wreath, Ten Years
of October Revolution, ORS. Worked in Mamontov's ceramics
workshop, Abramtsevo (1901–3), and Kikerin factory of
Vaulin (1907–12). Produced ten ceramic figures of nude
women including *Girl with Cup*, *Woman with Basin*, *Woman
with Shoes* for the State Ceramic Factory LFZ (1920s). Member
of World of Art (1910–24) and ORS (from 1926). Head of
sculptural department of TSUTRIShH (former Stieglitz), taught
at PGSKhUM (1918–20), and INZhSA named after Repin (1932–
40). Director of institute (1932–4), and professor at MGKhI
named after Surikov (1939–48). One-man shows in Moscow
(1958), and in Leningrad (1959–78).

**127**    **Girl with Cup** 1923
Bronze, 21.5×4.8×4cm
Collection D.V.Sarabyanov

**MAYAKOVSKY**, Vladimir Vladimirovich / 1893–1930
*Poet, playwright and artist.* Studied at preparatory classes of
Stroganov Institute (1908), in the studio of Kelin, Moscow
(1910) and MUZhVZ (1911–14). From 1912 participated in
exhibitions including Union of Youth, Artistic Association,
MUZhVZ, 1915. Illustrated Futurist publications including
*Rzhanoe Slovo* [Rye Word], *Mystery Bouffe*. Produced

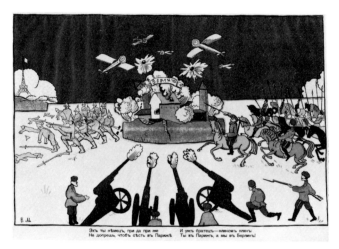

Vladimir Mayakovsky: 'Come Germans, come, come.
**You will never reach Paris.**
**And, my friend as you go to Paris, we go to Berlin.'** 1914
Cat.130

propaganda posters and texts for the publishers Modern Lubok during the First World War, and after the October Revolution at the time of the Civil War devised stencilled propaganda and public information posters which were shown throughout the country in the windows of ROSTA. Member of Left Front of the Arts, LEF (1923–5) and Novy LEF (1927–8). During NEP, worked with Rodchenko in writing copy for adverts for State stores and industries.

**128–131**  Patriotic Broadsheets [lubki] 1914
'A red-haired uncouth German flew over Warsaw, but a Cossack, Danilo the Savage, pierced a hole in him with his bayonet and his wife, Pauline, now sews pants for him out of the Zeppelin'
38×56cm

129  Patriotic Poster against the Austrians, *Ill. p.32*
38×56cm

130  'Come Germans, come, come. You will never reach Paris. And, my friend as you go to Paris, we go to Berlin', *Ill. previous page*
38×55.5cm

131  Patriotic Poster against the Turks
56×36cm
Lithographs, Collection V.V.Katanyan

**132**  Portrait of Lily Brik 1916, *Ill. p.32*
Charcoal and pencil on board, 45×30cm
Collection V.V.Katanyan

**133**  Portrait of Osip Brik 1916, *Ill. below*
Pencil and Indian ink on paper, 23.5×29.5cm
Collection V.V.Katanyan

**134**  Self Portrait *c.*1915, *Ill. in col. p.115*
Oil on board, 50.5×31cm
Collection V.V.Katanyan

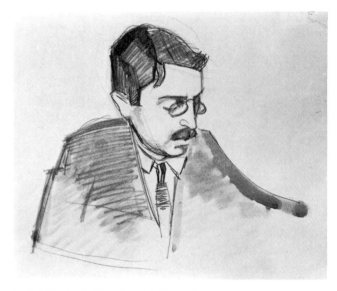

Vladimir Mayakovsky: **Portrait of Osip Brik** 1916
Cat.133

**MITURICH**, Pyotr Vasilyevich / 1887–1956
*Graphic artist, painter and illustrator.* Studied at Art School, Kiev (1906–9), and Academy of Arts, St Petersburg (1906–16) under Samokish. From 1915 participated in exhibitions including World of Art, New Tendencies, Four Arts. Created moving apparatus (1916). Designed decorations for public holidays in Petrograd (1918). Emissary on educational matters for the North (1918). Close friend with Futurist poet Velimir Khlebnikov, illustrated some of his poems (1920–2); later married Vera Khlebnikova, his sister. From 1923 lived and worked in Moscow. Member of group Four Arts (1925–9). Taught at VKhUTEMAS/VKhUTEIN (1923–30) and Architectural Workshops (from 1930). One-man shows in Moscow (1923, 1988).

**135**  Graphic Dictionary (A Celestial Alphabet) 1919
*Ill. below*
Stiff paper, 170 cubes 6×6×6, 4 cubes 8×8×8cm
Collection M.P.Miturich

Pyotr Miturich: **Graphic Dictionary (A Celestial Alphabet)** 1919
Cat.135

**MOOR** [ORLOV], Dmitri Stakhievich / 1883–1946
*Graphic and poster artist.* Studied at the studio of Kelin (1910). Worked for magazine *Budilnik* [Alarm Clock]. One of creators of ROSTA windows. Produced illustrations for newspapers *Izvestiya* (from 1919), *Pravda* (from 1920), and magazines *Krasnoarmeets* [Red Army Soldier] (from 1922), *Krokodil* [Crocodile]. Art director of magazines *Bezbozhnik* [Atheist] and *Bezbozhnik u Stanka* [The Atheist at the Workbench] (1923–8). Designed decorations for political festivals in Moscow (1918). From 1918 participated in exhibitions including shows in Paris (1925), Berlin (1927) and Danzig (1930). Member of group October (1928). Taught at VKhUTEMAS/VKhUTEIN, Moscow (1922–30).

**136**  'Take a Solemn Oath when Enlisting in the Red Army'
1918, *Ill. p.36*
Moscow
Lithograph poster in four colours
91.5×66.3, 107.2×71cm
Collection L.Kropivnitsky

**137** 'October 1917. October 1920' 1920, *Ill. in col. p.122*
'Long Live the Universal October'
Izd. Politupr. RVSR, Moscow
Lithograph poster in two colours
61.4×101.7, 69×106.6cm
Collection L.Kropivnitsky

**138** 'Help!' 1921, *Ill. below*
Moscow
Made at time of serious famine in Volga region
Lithograph poster
102.8×63.6, 106.5×71cm
Collection L.Kropivnitsky

**139** 'Be on Guard' *c.*1921
Gosizdat, Moscow
Lithograph poster in three colours
74.8×64.5, 107.1×69.8cm
Collection L.Kropivnitsky

**140** 'To the Peoples of the Caucasus' *c.*1921, *Ill. in col. p.122*
Izd. Politupr. RVSR, Moscow
Lithograph poster in four colours
55.4×99.4, 69.3×106.7cm
Collection L.Kropivnitsky

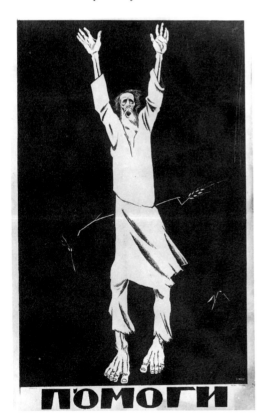

Dmitri Moor: 'Help!' 1921
Cat.138

**NEIZVESTNY**, Ernst Iosifovich / Born 1925
*Sculptor and graphic artist.* Studied at Academy of Arts, Riga (1945–7), and MGKhI named after Surikov, Moscow (from 1947) under Matveev and Manizer. From 1956 participated in exhibitions including House of Friendship, Moscow, 30 Years of MOSKhA. Left USSR in 1975 and now lives in USA. Exhibited in Yugoslavia, England (1965), France (1966), Switzerland (1974), Austria (1975), The Netherlands (1976), Zurich, Rome, Lugano, Vienna. One-man shows in Belgrade, Moscow, London, Tel-Aviv (1973), New York.

**141** Torso 1968, *Ill. p.39*
Bronze, 20×14×13cm
Collection V.A.Dudakov and M.K.Kashuro

**NEMUKHIN**, Vladimir Nikolaevich / Born 1925
*Painter and graphic artist.* Studied at the studio of Yuon, Moscow (1943–6), and under Sokolov, Malevich's assistant. One of leaders of Unofficial Art movement. From 1952 participated in exhibitions. Organiser and participant in exhibitions of City Committee of Graphic Artists of Moscow. Exhibited in USA (1967), France (1976), England (1977), Japan (1978). One-man show in New York (1984).

**142** A Blue Day 1959, *Ill. in col. p.140*
Oil on canvas, 108×156cm
Collection Ye.M.Nutovich

**NIKRITIN**, Solomon Borisovich / 1898–1965
*Painter, graphic artist and theatre designer.* Studied at Art School, Kiev (1909–14), student of Pasternak and Yakovlev, Petrograd (1914–17), at the studio of Ekster, Kiev (1917–20),

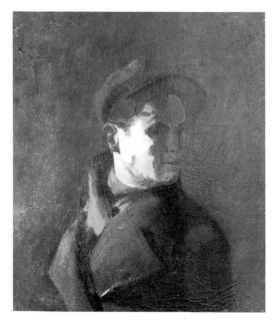

Solomon Nikritin: **Self Portrait** *c.*1928
Cat.143

and vкhuтемаs, Moscow (1920–2). From 1922 participated in exhibitions including Electroorganism, Method, акhrr. Co-worker of experimental theatre of 'Projectionists' (1923–4). Head of analytical section of Museum of Pictorial Culture (1925–9). Designer of agricultural exhibitions (1936–41).

**143**   Self Portrait *c.*1928, *Ill. previous page*
Oil on canvas on board, 67 × 57cm
Collection S.A.Shuster and Ye.V.Kryukova

**144**   The Old and the New, sketch 1934, *Ill. in col. p.136*
Gouache on paper, 40 × 58cm
Collection S.A.Shuster and Ye. V.Kryukova

**OSMYORKIN**, Aleksandr Aleksandrovich / 1892–1953
*Painter.* Studied at Art School, Kiev (1909–11) under Pimonenko, and the studio of Mashkov, Moscow (1912–13). From 1913 participated in exhibitions including Yelizavetgrad, Knave of Diamonds, Free Art, World of Art, акhrr. Taught at vкhuтемаs/vкhuтеin, Moscow (1918–30), Academy of Arts, Leningrad (1932–7) and мiii/мgкhi (1937–48). Member of акhrr, омкh, and Being.

**145**   Nude against a Background of Persian Printed Cloth
1915, *Ill. p.29*
Oil on canvas, 85 × 69cm
Collection V.A.Dudakov and M.K.Kashuro

**PASTERNAK**, Leonid Osipovich / 1862–1945
*Painter and graphic artist.* Studied at Drawing School, Odessa (1879–81), the workshop of Sorokin, Moscow, Moscow University (1881–5), and Academy of Arts, Munich (1886–7) under Gerterich and Litzenmeyer. From 1888 participated in exhibitions including мol.kh, 36, World of Art, srkh. Member of тркhv and srkh. From 1889 lived in Moscow. Taught at мuzhvz (1894–1917). Visited Germany, Italy (1904), Berlin (1906), The Netherlands, Belgium, England (1908) and Venice (1912). From 1921 lived in Berlin, Munich and Oxford. Father of writer, Boris Pasternak.

**146**   Portrait of an old Man 1909
Pastel on paper, 40 × 30cm
Collection I.K.Korolyuk

**147**   Josephine with her Mother Hulling Berries 1913
*Ill. in col. p.84*
Pastel on paper, 53.5 × 40.5cm
Collection N.N.Efron-Blokh

**148**   Portrait of K.F.Lemercier 1918, *Ill. right*
Pastel on paper, 65 × 50cm
Collection N.N.Efron-Blokh

**PETROV-VODKIN**, Kuzma Sergeevich / 1878–1939
*Painter, graphic artist and writer.* Studied at School of Drawing and Painting, Samara (1893–5) under Burov, Central Stieglitz School (1895–7), мuzhvz (1897–1904) under Kasatkin and Serov (1897–1904), Ažbé's studio, Munich (1901), and in Paris (1905–8). Travelled to Italy, Greece, France and Africa. From 1906 participated in exhibitions including Salon d'Automne, Salon, srkh, The Golden Fleece, Union of Youth, World of Art. Became leading figure among Petrograd Symbolists. Taught at Yelizaveta Zvantseva's school, St Petersburg (1910–15), svomas, Petrograd (1918–21) and Academy of Arts (1921–33). Member of Four Arts group from 1925. During 1920s developed a form of mystical realism often with revolutionary subject-matter. Wrote *The Woman of Samarkand, Khlynovsk* and *Prostranstvo Evklida* [Euclid's Space].

**149**   Monumental Head 1911, *Ill. in col. p.91*
Oil on canvas, 132 × 96cm
Collection Ye.B. and A.F.Chudnovsky

**150**   Still Life with Violin 1921, *Ill. in col. p.128*
Oil on canvas, 37.5 × 48cm
Collection G.P.Belyakov

**151**   Portrait of the Artist's Wife (Maria Fyodorovna) 1922
Oil on canvas, 65 × 46cm
Collection V.A.Dudakov and M.K.Kashuro

Leonid Pasternak: **Portrait of K.F.Lemercier** 1918
Cat.148

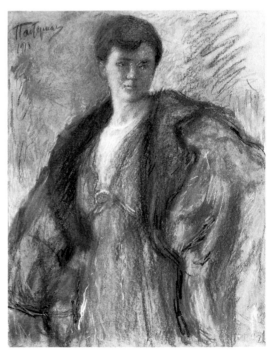

**152** The Crucifixion *c*.1923, *Ill. below*
Oil on canvas, 54×40cm
Collection N.N.Efron-Blokh

**153** At the Height 1925, *Ill. p.30*
Oil on canvas, 53.5×40.5cm
Collection A.K.Gordeeva

Niko Pirosmani: **Two Georgians by a Wine Jar** *c*.1910
Cat.155

Kuzma Petrov-Vodkin: **The Crucifixion** *c*.1923
Cat.152

## PIROSMANASHVILI [PIROSMANI], Niko
[Nikolai Aslanovich] / 1862–1918

*Signpainter and artist.* No formal art education. Lived and worked in Tbilisi, Georgia. Decorated walls of inns and taverns, painted genre pictures, landscapes and still lifes, many of them were used as commercial signs. In 1912 discovered by the Zdanevich brothers and Le-Dantu and began to exhibit in Moscow, St Petersburg and Paris. In 1913 participated in exhibition Target. Was also championed by Larionov and Shevchenko. Died in penury, the site of his grave is not known.

**154** The Russo-Japanese War *c*.1906, *Ill. in col. p.96*
Oil on oilcloth, 107×157cm
Collection I.G.Sanovich

**155** Two Georgians by a Wine Jar *c*.1910
Oil on oilcloth, 101×216cm
Collection I.G.Sanovich

**156** Portrait of I.Zdanevich 1913, *Ill. p.31*
Oil on canvas, 150×120cm
Collection S.A.Shuster and Ye.V.Kryukova

## POPKOV, Viktor Yefimovich / 1932–74
*Painter.* Studied at Arts and Graphics Pedagogical College, Moscow, and MGKhI (1953–8). Exhibited from 1956. One-man show in Moscow (1976). Lived and worked in Moscow. Leader of the new 'Severe Style' in realism during 1960s.

**157** Sketch for **'Grandma Anisya was a Good Person'** 1973
*Ill. in col. p.143*
Oil on hardboard, 70×100.5cm
Collection V.S. and L.I.Semyonov

## POPOVA, Lyubov Sergeevna / 1889–1924
*Painter, theatre artist and industrial designer.* Student of Zhukovsky and at studio of Yuon and Dudin (1907–8). Studied medieval painting and architecture of Pskov and Vologda (1910–11), and works of Giotto in Italy (1910). Studied at Tatlin's studio (1912) under Zdanevich and Bart, and La Palette, Paris (1912–13) under Le Fauconnier and Metzinger, where she met Pestel and Udaltsova. Worked in Tatlin's studio with Vesnin (1913–15). From 1914 participated in exhibitions including Knave of Diamonds, Tramway V, 0.01, Shop, 5×5=25. Member of Supremus group (1916). Taught at SVOMAS/VKhUTEMAS from 1918. Member of INKhUK from 1920. One of leaders of Constructivism and Productivist art. Stopped painting 1921 to concentrate on design. Worked for theatre with Meyerhold from 1922, and with Stepanova designed fabrics for First State Textile Factory, Moscow. (1923–4).

**158**  Guitar 1914, *Ill. in col. p.15*
Oil on canvas, 71 × 53.5cm
Collection D.V.Sarabyanov

**159**  Pictorial Architectonics 1916, *Ill. in col. p.117*
Oil on canvas, 106 × 88.5cm
Collection D.V.Sarabyanov

**160**  Composition 1917
Linocut and gouache on paper, 35 × 26cm
Collection A.P.Gozak

**161**  Composition 1917–19, *Ill. p.34*
Watercolour and gouache on paper, 34.5 × 27cm
Collection A.P.Gozak

**162**  Composition 1917–19, *Ill. below*
Collage on paper, 42 × 28.5cm
Collection A.P.Gozak

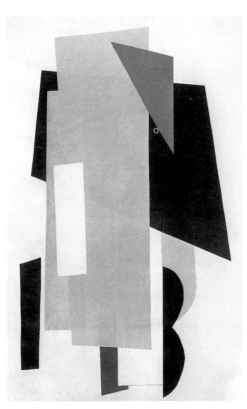

Lyubov Popova: **Composition** 1917–19
Cat.162

**PUNI**, Ivan Albertovich [Jean Pougny] / 1894–1956
*Painter and graphic artist.* Studied at private art school,
St Petersburg (1900–8), and Académie Julian, Paris (1910).
Travelled in Italy (1912). From 1911 participated in
exhibitions including Union of Youth, Salon des
Indépendants, Tramway V, 0.10. In 1913 married Ksenia
Boguslavskaya, painter, co-author of *Suprematist Manifesto*
with Malevich (1915). Taught at svomas, Petrograd (1918)
and Art School, Vitebsk (1919). In 1920 emigrated to Berlin.
One-man show at Galerie Der Sturm (1921). From 1924 lived
in Paris. One-man show at Galerie Barbazanges, Paris (1925).

**163**  Top Hat with Playing Cards 1917, *Ill. in col. p.114*
Oil on canvas, 64 × 44cm
Collection O.I.Rybakova

**164**  Cakes *c.*1917, *Ill. p.33*
Oil on canvas, 38 × 46cm
Collection O.I.Rybakova

**165**  Still Life with Bottle and Pears 1923, *Ill. below*
Oil on canvas, 64 × 44cm
Collection V.A.Dudakov and M.K.Kashuro

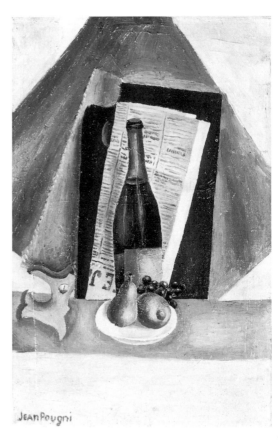

Ivan Puni: **Still Life with Bottle and Pears** 1923
Cat.165

**RABIN**, Oskar Yakovlevich / Born 1928
*Painter and graphic artist.* Studied at Academy of Arts, Riga (1946–8), MGKhI, Moscow, and the studio of Ye.Kropivnitsky. Leader of movement of Non-conformists. Participated in exhibitions in Moscow from 1957 showing in private apartments as well as in exhibition halls. Lived in Moscow until 1978 and moved to Paris. Exhibited in London (1963) and Paris. One-man shows in London (1965), Paris (1977, 1984), Oslo (1982), Vienna (1983), New York (1985) and Oslo (1985).

**166**  **Unexpected Happiness** 1964, *Ill. below*
Oil on canvas, 71.5×91cm
Collection Ye.M.Nutovich

Oskar Rabin : **Unexpected Happiness** 1964
Cat.166

**RADAKOV**, Alexei Aleksandrovich / 1877–1942
*Graphic artist.* Studied at Moscow School of Painting, Sculpture and Architecture and Stieglitz School of Technical Draughtsmanship, St Petersburg. Before the Revolution contributed to the journal *Novy Satirikon* as caricaturist, illustrator and co-editor. Travelled to Paris, London, Madrid and Berlin. Worked in the studios of Steinlen and Forain. Active as political poster designer after the Revolution and contributed to satirical magazines.

**167**  **'Can't Read', 'Can Read' [Before and After]** 1920
*Ill. above right*
Gosizdat, St Petersburg
Lithograph poster in four colours, each subject 30.6×49.3, sheet 80.2×57.2cm
Collection L.Kropivnitsky

Alexei Radakov: **'Can't Read, Can Read'**
**[Before and After]** 1920
Cat.167

**RODCHENKO**, Aleksandr Mikhailovich / 1891–1956
*Painter, graphic artist, photo-artist and designer.* Studied at Art School, Kazan (1910–14) under Feshin and Stroganov Art Industrial Institute, Moscow (1914–16). From 1913 participated in exhibitions including The Store, OBMOKhU, 5×5=25. Decorated Café Pittoresk with Tatlin and Yakulov (1917). Member of IZO (1918), OBMOKhU and INKhUK (1920–21) and President of INKhUK (1921). Taught at VKhUTEMAS/VKhUTEIN (1920–30). Worked for theatre (from 1918) and designed advertisements with Mayakovsky (from 1923). Worked for journals LEF (1923–5), *Novy LEF* [New LEF] (1927–8) and *SSSR na Stroyke* [USSR in Construction] (1933–41), and for film (1927–30). Pioneer of Soviet design and awarded four silver medals at International Exhibition of Decorative Arts [Exposition International des Arts Décoratifs] in Paris (1925). Stopped painting in 1921 to concentrate on design; resumed realist paintings in 1930s when he received very few official commissions.

**168**  **Portrait of N.A.R.** [Nadezhda, Rodchenko's sister-in-law, with her son] 1915, *Ill. overleaf*
Oil on cardboard, 61×51cm
Collection Family of A.Rodchenko and V.Stepanova

**169**  **Non-objective Composition** from the series 'Movement of Projected Planes' 1918, *Ill. in col. p.118*
Oil on plywood, 72×32cm
Collection Family of A. Rodchenko and V.Stepanova

**170** **Construction** from the series 'Lines' 1919, *Ill. p.35*
Oil on canvas, 84×65cm
Collection Family of A. Rodchenko and V.Stepanova

**171** **DOBROLET** [The State Merchant Air Service of the time of
the New Economic Policy [NEP]] 'Buy Shares in it and
Support it' 1923
Lithograph poster in two colours
101.5×67.5, 104.5×71.5cm
Collection Family of A. Rodchenko and V.Stepanova

**172** **'Three Hills Beer'** 1925, *Ill. right*
Text by Vladimir Mayakovsky
Typography Mosselprom, Moscow
Lithograph poster in four colours
68.8×44.2, 70.5×48.5cm
Collection Family of A. Rodchenko and V.Stepanova

**173** **'Battleship Potemkin'** 1925
Poster for Eisenstein's film
Typography, 'The Spark of the Revolution', Moscow
Lithograph poster in five colours, 60×95, 69×106.7cm
Collection Family of A. Rodchenko and V.Stepanova

**174** **Acrobat** 1948, *Ill. in col. p.138*
Oil on canvas, 85×57.5cm
Collection Family of A. Rodchenko and V.Stepanova

Aleksandr Rodchenko: **Portrait of N.A.R.** 1915
Cat.168

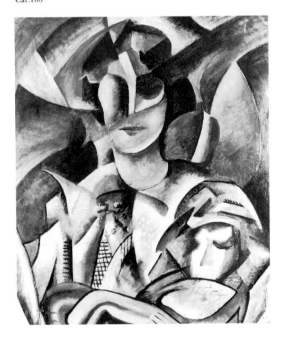

Aleksandr Rodchenko: **'Three Hills Beer'** 1925
Cat.172

**ROERICH**, Nikolai Konstantinovich / 1874–1947
*Painter, graphic artist, theatre designer and man of letters.*
Studied at Law Faculty, St Petersburg University and
Academy of Arts (1893–8) under Kuindji, and studio of
Cormon in Paris (1900). From 1899 participated in
exhibitions including Spring, World of Art, SRKh. President
of World of Art (from 1910). Director of Drawing School of
OPKh. Designed for theatre and worked for Diaghilev's Ballets
Russes in Paris and London (1908–14). Left Soviet Union in
1918. Lived in USA (1920–2), and in India (from 1923).
Exhibited abroad.

**175** **Pskovo-Pechersky Monastery** 1907, *Ill. p.26*
Gouache, pastel and pencil on paper, 63×81cm
Collection V.A.Dudakov and M.K.Kashuro

**176** **The Siege of Kazan** 1914
Indian ink and gouache on paper, 77×80cm
Collection A.M. and I.G.Shchusev

**ROITER**, Andrei Vladimirovich / Born 1960

*Painter*. Participated in exhibitions of Organisation of Graphics Committee of Moscow since 1977. Since 1982 produced series of conceptual and symbolic works. Participated in thirty exhibitions in USSR and abroad, including in USA (1987), The Netherlands (1988), West Germany, Switzerland (1988). Member of Hermitage group, Moscow (1987).

**177 One Cup of Tea** 1987, *Ill. p.19*
Mixed media on hardboard, 80×120cm
Collection the artist

**178 Morning Exercise** 1987
Mixed media on hardboard, 120×80cm
Collection the artist

**179 Pupil** 1987, *Ill. below*
Oil on canvas, 90×120cm
Collection the artist

Andrei Roiter: **Pupil** 1987
Cat.179

**SAMOKHVALOV**, Aleksandr Nikolaevich / 1894–1971

*Painter, graphic artist, sculptor and theatre designer*. Studied at Bezhetsk Drawing School under Kostenko, Goldblatt's school, St Petersburg (1913), Academy of Arts, Petrograd (1914–18), and SVOMAS/VKhUTEMAS (1920–3) under Kardovsky, Savinsky and Petrov-Vodkin. From 1917 participated in exhibitions including World of Art, Community of Artists, Heat-colour, Circle of Artists. From 1923 worked on posters, painted ceramics and illustrated books. Designed monument to Lenin and Sverdlov. Member of Circle of Artists (1926) and October group (1930).

**180 Vasilyevsky Island** *c.*1926, *Ill. above right*
Oil on canvas, 57×49cm
Collection N.Ye. and A.I.Shlepyanov

Aleksandr Samokhvalov: **Vasilyevsky Island** *c.*1926
Cat.180

**SAPUNOV**, Nikolai Nikolaevich / 1880–1912

*Painter and theatre designer*. Studied at MUZhVZ (1893–1901) under Levitan, and Academy of Arts (1898–1901) under Kiselyov. From 1904 participated in exhibitions including Crimson Rose, World of Art, Blue Rose, MTKh. Painted sets for Bolshoi Theatre, Moscow based on designs by Korovin (1901–2). Set designs for Moscow Arts Theatre (from 1904), Meyerhold's studio and theatres of Vera Komissarzhevskaya and Aleksandr Tairov.

**181 Dance** *c.*1912, *Ill. in col. p.87*
Tempera on canvas, 77×104cm
Collection V.A.Dudakov and M.K.Kashuro

**SARIAN**, Martiros Sergeevich / 1880–1972

*Painter, graphic artist and theatre designer*. Studied at MUZhVZ under Serov and Korovin. From 1902 participated in exhibitions including SRKh, The Golden Fleece, World of Art. With Kuznetsov leading member of Blue Rose group. Travelled in Turkey (1910), Egypt (1911) and Iran (1913). Lived and worked in Yerevan, and in Paris (1926–8). One-man show in Paris. Member of Four Arts group (1925–9). Illustrated books and worked for theatre. Taught at Institute of Theatrical Art, Yerevan (1946–52).

**182 Landscape with Wild Goats** 1907, *Ill. p.27*
Tempera on board, 35×53cm
Collection S.A.Shuster and Ye.V.Kryukova

**183 Still Life with Peonies** 1916
Tempera on canvas, 72×67cm
Collection N.N.Efron-Blokh

**SEREBRIAKOVA**, Zinaida Yevgenyevna / 1884–1967
*Painter and graphic artist.* Studied at studio of Tenisheva, St Petersburg (1901) under Repin and workshop of Braz (1903–5). From 1910 participated in exhibitions including World of Art. Member of World of Art. Visited Italy (1902–3), Paris (1905), Switzerland (1914) and Morocco (1928, 1932). Lived in St Petersburg, and in Kharkov (1981–20). In 1924 moved to Paris. Exhibited abroad.

**184**  **Sleeping Peasant Woman** 1917, *Ill. in col. p.125*
Oil on canvas, 77.5×138cm
Collection O.I.Rybakova

**185**  **Self Portrait with Children** 1917–18
Watercolour on board, 57×47cm
Collection Ye.B. and A.F.Chudnovsky

**186**  **Portrait of Sergei Ernst** 1922, *Ill. below*
Tempera on paper, 55×44cm
Collection I.A. and Ya.A.Rzhevsky

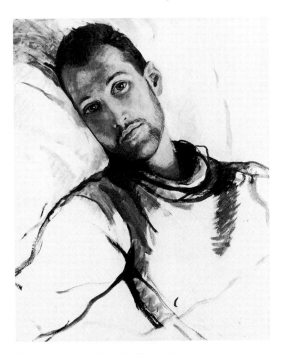

Zinaida Serebriakova: **Portrait of Sergei Ernst** 1922
Cat.186

**SEROV**, Valentin Aleksandrovich / 1865—1911
*Painter, graphic artist, sculptor and theatre designer.* Studied in Paris (1873–4, 1878–80) under Repin, at Academy of Arts, St Petersburg (1880–5) under Chistyakov, and in Munich and Paris (until 1875). From 1890 participated in exhibitions including TPKhV, MTKh, World of Art, SRKh. Visited The Netherlands, Belgium, Germany, Italy, France, Greece and Spain. Member of TPKhV (1894–9) and World of Art (from 1899). Designed sets for Mamontov's opera company, and worked for Marinsky Theatre (1908) and Diaghilev. Taught at MUZhVZ (1897–1909). One-man show in 1914.

**187**  **The Rape of Europa** 1910, *Ill. below*
Ceramic, white, cast 1915, 24×29×22cm
Collection V.A. Dudakov and M.K.Kashuro

Valentin Serov: **The Rape of Europa** 1910
Cat.187

**188**  **Diana and Actaeon**, sketch for a wall painting in the house of V.V.Nosov in Moscow 1911, *Ill. p.26*
Watercolour, pencil and charcoal on paper mounted on board, 62×49cm
Collection A.V.Smolyannikov

**SHCHEKOTIKHINA-POTOTSKAYA**
Aleksandra Vasilyevna / 1892–1967
*Theatre designer, ceramics painter and sculptor.* Studied at Drawing School of OPKh (1908–15), St Petersburg under Roerich, Bilibin, whom she married, Tsionglinsky and Shchuko. Visited Greece, Italy and France (1913). In Paris worked at studios of Denis, Vallotton and Sérusier (1913). Designed sets and costumes for theatre (1912–20) including costumes for Diaghilev's production of Stravinsky's *Rite of Spring* (1913). From 1913 participated in exhibitions including World of Art, Community of Artists, House of Arts, State Ceramics Factory. Worked at State Ceramics Factory as painter and produced agitational ceramics (1918–23). Lived in Paris (1925–36). Worked at Leningrad Ceramics Factory (1936–53). Was one of the most outstanding ceramic artists in USSR. Produced several models for sculptures including *Snow Maiden*. One-woman shows in Paris (1926) and Leningrad (1955).

**189**  **Plate 'The Pupil'** 1923
'GFZ 1923'. On base inscription 'To a design by Shchekotikhina' and signature of factory artist N.Sverchkov Painted over glaze. Diameter 22cm
Collection T.Rubinshteyn

**190**   **Dish 'Card Game'** 1923, *Ill. in col. p.123*
A Baltic sailor, a merchant and a peasant seated at a garden
table. On the table, a plate with fish, vegetables and cards.
In the background, buildings and the cupola of churches.
Body: 'Nikolai II 1907'
'GFZ 1923' no.151/3. 'After a design by Shchekotikhina' and
monogram 'MK' (M.Kirillova, the factory artist)
Painted over glaze. Diameter 36cm
Collection V.A.Dudakov and M.K.Kashuro

**SHEVCHENKO**, Aleksandr Vasilyevich / 1883–1948
*Painter and graphic artist*. Studied at Stroganov Artistic
Industrial Institute, Moscow (1899–1907), the studio of
Carrière at Académie Julian, Paris (1905–6) under Dinet and
Laurens, and MUZhVZ (1907–10) under Korovin. Visited
England, Spain, Egypt and Turkey. From 1912 participated
in exhibitions including Donkey's Tail, No.4, World of Art.
In 1913 wrote *Neo-Primitivism*. With Larionov, important
Neo-primitivist and Rayist artist. Member of INKhUK (1920),
MTKh, group Makovets (1922–5) and OMKh (1928–9). Founder
of the Corporation of Painters (1926–8). Taught at
VKhUTEMAS/VKhUTEIN (1920–8) and Textile Institute, Moscow
(from 1940). Lived in Moscow.

**191**   **Idleness and Shadow** 1914, *Ill. in col. p.101*
Oil on canvas, 67×71cm
Collection I.G.Sanovich

**192**   **Tsepora the Horsewoman** 1914, *Ill. below*
Oil on canvas, 78×70cm
Collection Ye.B. and A.F.Chudnovsky

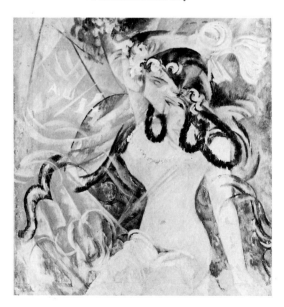

Aleksandr Shevchenko: **Tsepora the Horsewoman** 1914
Cat.192

**SHTERENBERG**, David Petrovich / 1881–1948
*Painter and graphic artist*. Studied at Ecole des Beaux-Arts
and Académie Witte, Paris under Martin, Van Dongen and
Anglade. From 1912 participated in exhibitions including
Salon d'Automne, Salon des Indépendants. In 1917 showed
with Matisse, Ozenfant and Utrillo in Paris, and returned to
Russia. Commissar for Arts (1917–18) and head of IZO (1918–
20). In 1922 joined Exhibition of Three with Altman and
Chagall in Berlin. Founder and President of OST (1925–30).
Taught at VKhUTEMAS/VKhUTEIN (1920–30).

**193**   **Still Life with Pomegranates** (oval) 1917, *Ill. in col. p.120*
Oil on canvas, 63×52cm
Collection S.A.Shuster and Ye.V.Kryukova

**194**   **Pink Vase with Fruit** 1924
Oil on hardboard, 116×75cm
Collection Family of D.P.Shterenberg

**195**   **Yellow Cup** *c.*1925
Oil on canvas, 50×70cm
Collection S.A.Shuster and Ye.V.Kryukova

**196**   **Photograph on the Wall** *c.*1925, *Ill. below*
Oil on canvas, 60×39cm
Collection Ye.B. and A.F.Chudnovsky

David Shterenberg: **Photograph on the Wall** *c.*1925
Cat.196

**SHVARTSMAN**, Mikhail Matveevich / Born 1926
*Painter, graphic artist, cinema designer and monumental artist.*
Studied at Moscow Higher Art College (former Stroganov
Institute). Participated in exhibitions from 1956 in USSR
including Town Committee of Graphic Artists of Moscow
and galleries in USSR, and abroad in England, France, USA,
Italy and Belgium.

**197**  **Hieratic Order of Hopes** 1978–87, *Ill. below*
Tempera on board, 130×100cm
Collection the artist

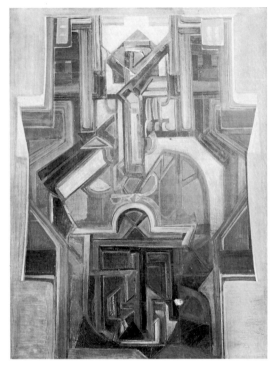

Mikhail Shvartsman: **Hieratic Order of Hopes** 1978–87
Cat.197

**SIMAKOV**, Ivan Vasilyevich / 1877–1925
*Painter, graphic artist, designer of book plates and theatre
designer.* His works appeared in exhibitions of Petrograd
Society of Artists, Society of Russian Watercolourists,
Fellowship of Artists, St Petersburg Book Plates group, AKhRR
and Theatrical Design of the Last Ten Years.

**198**  **'Remember the Starving'** 1921, *Ill. above right*
Gosizdat, St Petersburg
Lithograph poster in five colours
60.5×53.4, 80.3×61cm
Collection L.Kropivnitsky

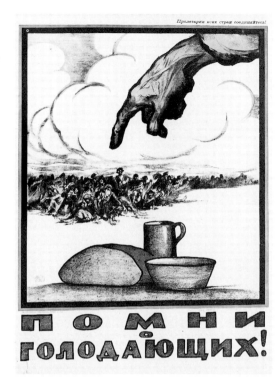

Ivan Simakov: **'Remember the Starving'** 1921
Cat.198

**SOFRONOVA**, Antonina Fyodorovna / 1892–1966
*Painter and graphic artist.* Studied at studio of Rerberg,
Moscow (1910–13) and studio of Mashkov, Moscow (1913–
14). Participated in exhibitions from 1914 including Knave of
Diamonds, World of Art, MTKh. Taught at studio, Orel
(1920), SVOMAS, Tver (1920–1). Member of the organisation
Thirteen (1931).

**199**  **Self Portrait** 1921, *Ill. in col. p.124*
Oil on canvas, 57×53cm
Collection T.V.Rubinshteyn and V.A.Moroz

**STEPANOVA**, Varvara Fyodorovna / 1894–1958
*Painter, graphic artist and designer.* Studied at Art School,
Kazan (1910–11), where she met Rodchenko, also at studios
of Mashkov and Yuon, Moscow (1912) and Stroganov Artistic
Industrial Institute (1913–14). From 1914 participated in
exhibitions. Member of collegium of IZO (1918) and of INKhUK
(from 1920). Also member of group of Constructivists and
participated in exhibition 5×5=25 (1921). Stopped painting
to concentrate on design. Designed costumes for Meyerhold's
*Tarelkin's Death* (1922) as well as other theatrical productions.
With Popova, designed fabrics (1923–4) and designed for
magazines *LEF*, *Novy LEF* (New LEF] (1923–8), and *SSSR
na Stroyke* [USSR in Construction] (from 1930). Taught at
VKhUTEMAS (1924–5). Married to Rodchenko.

**200 Draughts Players** 1920, *Ill. in col. p.121*
Oil on plywood, 78×62cm
Collection Family of A.Rodchenko and V.Stepanova

**201 Muzhik** [peasant woman] 1921, *Ill. p.35*
Oil on plywood, 100×65cm
Collection Family of A.Rodchenko and V.Stepanova

**SUDEIKIN**, Sergei Yuryevich / 1882–1946
*Painter, graphic artist and theatre designer.* Studied at MUZhVZ (1897–1909) under Korovin, and Academy of Arts (1909–11). Participated in exhibitions from 1911, including Crimson Rose, Blue Rose, SRKh, World of Art, The Golden Fleece. Worked for Mamontov's private opera (1890s) and in Paris from 1912. Worked for Diaghilev's *Ballets Russes*, notably *L'après-midi d'un faune* based on Bakst's sketches. From 1920 lived in France and from 1923 in USA.

**202 The Big Wheel** 1910, *Ill. p.27*
Tempera on board, 65×70cm
Collection V.A.Dudakov and M.K.Kashuro

**203 Cabaret** 1915, *Ill. in col. p.110*
Tempera on board, 45×70cm
Collection V.A.Dudakov and M.K.Kashuro

**204 Still Life with Figure of Buddha** *c.*1915
Oil on canvas, 79×58cm
Collection I.M.Ezrakh

**SUETIN**, Nikolai Mikhailovich / 1897–1954
*Painter, graphic artist, designer and ceramics painter.* Studied at Higher Art Institute, Vitebsk (1918–22) under Malevich. Member of group UNOVIS. Participated in exhibitions from 1920 including UNOVIS. Lived in Petrograd from 1923 and worked at State Ceramics Factory. Member of GINKhUK (1923–6). Worked at experimental laboratory, Institute of Art History (1927–30). Chief artist at artistic laboratory, Leningrad Ceramics Factory (from 1932). Also worked as book illustrator and exhibition designer. One of leading Suprematist artists. Chief artist and designer of USSR pavilions for the World Exhibitions in Paris (1937) and New York (1939).

**205 Suprematist Plate** Late 1920s–early 1930s
'GFZ' no date
Painted over glaze, stencil. Diameter 18cm
Collection O.Severtsevaya

**206 Suprematist Dish** Late 1920s–early 1930s, *Ill. in col. p.123*
'GFZ' no date
Painted over glaze, stencil. Diameter 17.9cm
Collection O.Severtsevaya

**TATLIN**, Vladimir Yevgrafovich / 1885–1953
*Painter, architect, designer.* Studied at MUZhVZ under Serov (1902–4) and Korovin (1909–10), and Art College, Penza (1904–10) under Goryushkin-Sorokopudov and Afanasyev. Sailor, travelling to Bulgaria, Greece, Turkey, the Near East and North Africa (1902–4). From 1910 participated in exhibitions including Donkey's Tail, Union of Youth, Knave of Diamonds, The Store. Popova, Vesnin and Udaltsova, future Constructivists, worked in his studio 'The Tower' (1912–15). Worked as artistic director for Glinka's opera *A Life for the Tsar* and play *Tsar Maximilian* (1912–13). Central figure of Constructivist movement and produced reliefs and counter-reliefs (from 1914). Exhibited at Tramway V and 0.10. Head of IZO, Moscow (1918–19), taught at SVOMAS, Moscow (1918–20) and Petrograd (1919–24). Created monument for Third International (1919). Founder and member of GINKhUK, Petrograd (1923). Taught basis of design and worked as artist-constructor. Taught at department of theatre, cinema and photography, Kiev Art School (1925–7), and VKhUTEIN, Moscow (1927–30). Worked on the 'Letatlin' human-powered flight machine (1930–2). Worked on theatre designs in Ukraine. During later 1930s his work changed towards sombre, expressive realist painting.

**207 Bouquet** 1940, *Ill. in col. p.139*
Oil on wood, 39.5×33.8cm
Collection T.V.Rubinshteyn and V.A.Moroz

**208 Portrait of a Man** 1930s, *Ill. p.38*
Oil on panel, 47×34cm
Collection Ye.B. and A.F.Chudnovsky

**TSAPLIN**, Dmitri Filippovich / 1890–1967
*Sculptor.* Studied at VKhUTEMAS, Saratov (1919). After service in Red Army began to work as sculptor (1923). Participated in exhibitions from 1924, including one-man shows in Saratov and Moscow, exhibitions of ORS, AKhRR. In 1927 went to France and Spain. From 1935 lived and worked in Russia. Many exhibitions abroad. One-man shows in Paris, Madrid, London and Moscow.

**209 Harpist** 1930s, *Ill. overleaf*
Stone, 55×25×25cm
Collection V.S. and L.I.Semyonov

Dmitri Tsaplin: Harpist 1930s
Cat.209

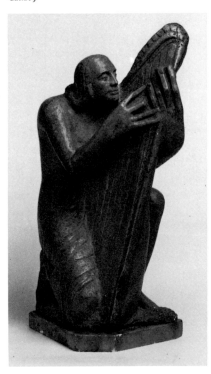

**TSELKOV**, Oleg Nikolaevich / Born 1934
*Painter and graphic artist.* Studied at Moscow Secondary Art School (until 1953), Art Institute, Minsk (1953–4), Academy of Arts, Leningrad (1954–5), and Leningrad Institute of Theatre and Cinema (1955–8). From 1956 participated in exhibitions in USSR including Exhibition of Youth in Moscow, Union of Artists and abroad in Paris (1976), Venice (1977), Washington, Antwerp, Paris, Tokyo, Turin (all in 1978), New York (1979), Paris (1980). One-man shows in Moscow (1965, 1970), New York (1979, 1981) and Paris (1982). Emigrated to Paris (1977).

**210**   **Group Portrait with Medal** 1969, *Ill. in col. p.145*
Oil on canvas on panel, 75.5×152cm
Collection Ye.M.Nutovich

**TYSHLER**, Aleksandr Grigoryevich / 1898–1980
*Painter, graphic artist and theatre designer.* Studied at Art School, Kiev (1912–17) under Prakhov, Monastyrsky and Seleznyov, and studio of Ekster, Kiev (1917–18). Participated in exhibitions from 1920 including Projectionists, OST. From 1921 lived in Moscow. Studied at VKhUTEMAS (1921) under Favorsky. From *c.*1925 moved away from abstract painting towards the form of poetical Surrealism by which he has become known. From 1927 designed productions for Byelorussian Jewish Theatre, Minsk and Kharkov Jewish Theatre. Exhibited in Dresden (1926) and Leipzig (1927), and one-man shows in Moscow in 1965 and 1978.

**211**   **Colour-dynamic Tension in Space** 1924, *Ill. below*
Oil on canvas, 133×89cm
Collection Family of I.Selvinsky

**212**   **Sports Parade** 1929, *Ill. in col. p.132*
Oil on canvas, 80.2×67.5cm
Collection V.S. and L.I.Semyonov

Aleksandr Tyshler: **Colour-Dynamic Tension in Space** 1924
Cat.211

**UDALTSOVA**, Nadezhda Andreevna / 1886–1961

*Painter.* Studied at MUZhVZ (1905–9), studio of Yuon, Moscow (1906–7) under Dudin and Ulyanov, studio of Kish, Moscow (1909) La Palette, Paris (1912–13) under Metzinger, Le Fauconnier and Segonzac, and Tatlin's studio 'The Tower', Moscow (1913). From 1914 participated in exhibitions including Knave of Diamonds, Tramway V, 0.10. Member of group Supremus (1916), IZO (1918) and INKhUK (1921). Taught at VKhUTEMAS/VKhUTEIN (1921–30). Travelled in the Urals and Altai with her husband, Aleksandr Drevin, where they both made a number of paintings (1930–1).

**213**   **Composition** (double-sided) 1916, *Ill. p.34*
Gouache on paper, 21×23cm
Collection A.A. and Ye.A.Drevin

**214**   **Composition** 1916, *Ill. in col. p.116*
Gouache on paper, 41×30cm
Collection A.A. and Ye.A.Drevin

**215**   **Composition** 1916
Gouache on paper, 31×23cm
Collection A.A. and Ye.A.Drevin

**USPENSKY**, Aleksei Aleksandrovich / 1892–1941

*Painter, graphic artist and scene-painter.* Studied at private studios in St Petersburg. Exhibited at Soviet Theatre Design (1922) and Exhibition of Paintings by Petrograd Artists of all Tendencies (1923). Taught at Studio of Line Engraving with Yermolaeva (from 1923) and worked as scene-painter.

**216**   **Bridges** Late 1910s
Tempera and watercolour on paper, 54×76cm
Collection O.I.Rybakova

**UTKIN**, Pyotr Savvich / 1877–1934

*Painter and graphic artist.* Studied at School of Saratov Society for the Encouragement of Fine Arts (1892–7) under Konovalov, and at MUZhVZ (1897–1905) under Levitan, Serov and Korovin. From 1904 participated in exhibitions including Crimson Rose, Blue Rose, SKRh, World of Art, The Golden Fleece. Produced decorative works for Zhukovsky villa, Crimea, with Matveev, Kuznetsov (1909–18). From 1918 taught in Saratov and from 1933 at Academy of Arts. Many of his works lost.

**217**   **Night** 1904, *Ill. in col. p.90*
Tempera on canvas, 103×124cm
Collection V.A.Dudakov and M.K.Kashuro

**VASNETSOV**, Viktor Mikhailovich / 1848–1926

*Painter, graphic artist, monumental artist and theatre designer.* Studied at religious seminary, Vyatka, Drawing School OPKh, St Petersburg (1867–8) under Kramskoy, and Academy of Arts (1868–74) under Chistyakov, Basin, Vereshchagin and Vorobyov. Member of TPKhV. Participated in exhibitions from 1869 including Acadmy of Arts, TPKhV. From 1878 lived in Moscow. Travelled in France (1876–7). Produced works based on folkloric themes including *Tsarevich Ivan on the Grey Wolf, The Snow Maiden, Bogatyrs* [Russian heroes]. Executed wall paintings for Vladimir Cathedral, Kiev. Designed church at artists' colony of Abramtsevo (1881–2) and his own house in Moscow (now V.M.Vasnetsov Museum). Founded art museum in Vyatka.

**218**   **The Last Song** 1881, *Ill. p.25*
Oil on canvas, 37×30cm
Collection G.P.Belyakov

**219**   **Ivan the Terrible**, study 1884, *Ill. in col. p.81*
Oil on canvas, 66×49.3cm
Collection V.Ya.Andreev

**220**   **The Flying Carpet** 1901-15, *Ill. below*
Gouache and pastel on board, 57×43.5cm
Collection G.P.Belyakov

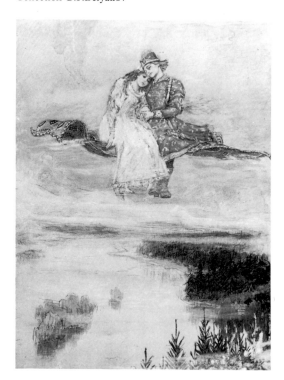

Viktor Vasnetsov: **The Flying Carpet** 1901–15
Cat.220

**VEISBERG** [WEISBERG], Vladimir Grigoryevich / 1924–85
*Painter.* Studied at studio of Unions, Moscow (1943–8), and studios of Mashkov and Osmyorkin. Participated in exhibitions from 1956 including Exhibition of the Nine (Moscow), Exhibition of the Eight (Leningrad). One-man shows in Paris (1984) and Moscow (1987). Taught in studio of Union of Architects of the USSR. Lived and worked in Moscow.

**221**   **Portrait of an Actress** 1960, *Ill. below*
Oil on canvas, 100×62cm
Collection Ye.M.Nutovich

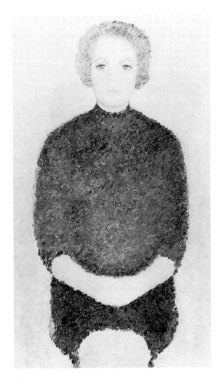

Vladimir Veisberg: **Portrait of an Actress** 1960
Cat.221

**VESNIN**, Aleksandr Aleksandrovich / 1883–1959
*Painter, architect, theatre designer and graphic artist.* Studied at Institute of Civil Engineers, St Petersburg (1909–12), studio of Yuon, Moscow (1907–10) and studio of Tsionglinsky, St Petersburg (1909–11). From 1909 participated in exhibitions. Worked in Tatlin's studio, Moscow (1912–14). Visited Italy (1913–14). Designed decorations for Red Square for 1 May 1918 with Viktor Vesnin. Member of INKhUK (from 1921). Taught at VKhUTEMAS (1921–5), and Moscow Architectural Institute (from 1930). In 1921 participated in exhibition of Constructivists, 5×5=25 and was one of leaders of Constructivist movement. From this time, stopped painting and devoted himself entirely to design and architecture. Member of architectural group OSA and

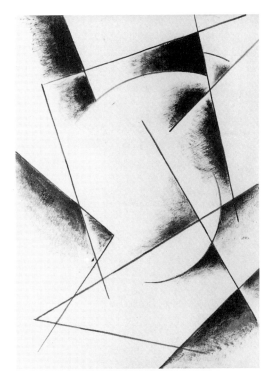

Aleksandr Vesnin: **Composition** 1921
Cat.222

editor of journal *Sovremennaya Arkhitektura* [Contemporary Architecture]. Together with his brothers designed first Soviet bank notes (1918). Worked for Tairov's Kamerny [Chamber] Theatre (1922–3). Designed building for newspaper *Leningradskaya Pravda* [Leningrad Pravda], Moscow (1924), department store at Krasnaya Presnaya, Moscow (1927). Brother of Leonid and Viktor Vesnin.

**222**   **Composition** 1921, *Ill. above*
Gouache on paper, 28×20cm
Collection D.V.Sarabyanov

**VILDE**, Rudolf Fyodorovich [VILDE VON VIDELMAN] / 1887–1942
*Draughtsman, ceramics artist/designer.* Studied at drawing school of Prokhorov Three Hills Factory, Moscow, and TSUTRISh, St Petersburg (1894–9). Travelled in France, Germany and Italy on a grant (1899–1902). From 1902 participated in exhibitions including Society of Russian Watercolourists, Seventh Exhibition of Community of Artists, Artists of Russian Republic over a Period of 15 Years. Draughtsman at Imperial Ceramics Factory (from 1905), and head of painting studios of State Ceramics Factory and Leningrad Ceramics Factory. Worked on agitational ceramics (1918–23).

**223** Plate **'Long Live the 8th Congress of Soviets'** 1920
On side, inscription 'Long live the 8th Congress of Soviets
1920' in black paint. On dish, multi-coloured painting,
large flowers and leaves.
Body: IFZ 'Nikolai II'
'GFZ 1920'
Painted over glaze. Diameter, 24cm
Collection V.A.Dudakov and M.K.Kashuro

**VOLKOV**, Aleksandr Nikolaevich / 1886–1957
*Painter and graphic artist.* Studied at Faculty of Natural
Sciences, St Petersburg University (1906–8), Academy of Arts
(1908–10) under Makovsky, in private school of Bernshteyn
(1910–12) under Bilibin, Roerich and Shervud, and at Art
School, Kiev (1912–16) under Krichevsky and Menk. Was
strongly influenced by work of Vrubel. From 1916 lived and
worked in Tashkent. From 1916 taught at Art College,
Tashkent. Director of PROLETKULT Theatre (1922) and
Central State Museum of Art of Asia (1919). Participated in
exhibitions from 1920. Member of AKhRR (1928–32) and
society Masters of the New East (from 1928).

**224** Musicians 1921, *Ill. below*
Oil on canvas, 56×89cm
Collection V.A.Dudakov and M.K.Kashuro

Aleksandr Volkov: **Musicians** 1921
Cat.224

**225** Farewell 1921
Tempera on board, 76×76cm
Collection T.V.Rubinshteyn and V.A.Moroz

**226** **In the Wagon** 1925, *Ill. in col. p.131*
Oil on canvas, 113×113cm
Collection V.S. and L.I.Semyonov

**VRUBEL**, Mikhail Aleksandrovich / 1856–1910
*Painter, graphic artist, sculptor and theatre designer.* Studied at
Drawing School of OPKh, St Petersburg (1867–9), Faculty of
Law, St Petersburg University (1874–9), Academy of Arts
(1880–4) under Chistyakov, and took watercolour lessons
from Repin. Worked in Kiev for restoration and new wall
paintings of 12th-century church of St Kyril (1884–9).
Sketches for wall paintings in Cathedral of St Vladimir,
Kiev. Visited Rome, Milan, Venice and Paris. Illustrations for
works of Lermontov. Responsible for decoration of
Mamontov's private opera. Also worked in sculpture and
ceramics workshop, Abramtsevo (1889–90). Designed
Mamontov's house in Moscow. Participated in exhibitions 36,
World of Art. Died in St Petersburg. Exhibited in Vienna
(1901), Paris (1906), Venice (1907). One-man shows in Kiev
(1910), Moscow (1921), Kiev, Leningrad, Moscow (all in
1956) and Abramtsevo (1965).

**227** **Virgin and Child** 1880s
Oil on canvas, 65×39cm
Collection A.Ye.Stychkin

**228** **Portrait of A.G.Rubinshteyn** 1889, *Ill. p.24*
Black chalk (formed of ground charcoal and soft clay)
on board, 82×57cm
Collection Ye.M.Nepalo

**229** **The Fall of Tamara** Late 1890s–early 1900s
Watercolour, Indian ink and pencil on paper, 22×22cm
Collection A.Ye.Stychkin

**230** **Magician** 1900
Majolica, painted, 42×22×22cm
Collection V.A.Dudakov and M.K.Kashuro

**231** **The Demon Cast Down** Early 1900s, *Ill. below*
Pencil and Indian ink on paper, 22×50cm
Collection A.M. and I.G.Shchusev

Mikhail Vrubel: **The Demon Cast Down** Early 1900s
Cat.231

**YAKOVLEV**, Aleksandr Yevgenyevich / 1887–1938
*Painter.* Studied at Academy of Arts (1904–13) under Kardovsky. From 1909 participated in exhibitions including Union of Russian Artists, World of Art. Travelled and worked in Italy, Spain (1913–15), Mongolia, China and Japan (1917–18). From 1920 lived in Paris.

**232**    Mannequin *c.*1916, *Ill. in col. p.106*
Oil on canvas, 98×70cm
Collection N.N.Efron-Blokh

**YAKULOV**, Georgy Bogdanovich / 1884–1928
*Painter, graphic artist and theatre designer.* Studied at Lazarev Institute of Eastern Languages, Moscow (1894–1900), studio of Yuon, and MUZHVZ (1901–2). From 1906 participated in exhibitions including MTKh, The Wreath, World of Art, OBMOKhU. Travelled in Italy and France (1908, 1911–13) Signed Futurist Manifesto in 1914. Designed interior of Café Pittoresk, Moscow with Tatlin and Rodchenko (1917). From 1918 worked for theatres including Tairov's Kamerny Theatre. Designed Prokofiev's *Pas d'Acier* for Diaghilev's Ballets Russes (1927). Taught at SVOMAS (1918–19), and then at VKhUTEMAS.

**233**    Portrait of the Composer A.Lurye
Sketch for book cover **'Carved Patterns'** 1918, *Ill. below*
Gouache on canvas 38×30cm
Collection S.A.Shuster and Ye.V.Kryukova

Georgy Yakulov: **Portrait of the Composer A.Lurye** 1918
Cat.233

**234**    Portrait of the Actress Alisya Koonen 1920
Oil on panel, 156×132cm
Collection V.S. and L.I.Semyonov

**235**    Panel on the theme of E.T.A.Hoffmann's *Princess Brambilla* 1920, *Ill. below*
Oil on canvas, 125×236cm
Collection V.A.Dudakov and M.K.Kashuro

Georgy Yakulov: **Panel on the Theme of E.T.A. Hoffmann's** *Princess Brambilla* 1920
Cat.235

**ZADKINE**, Osip / 1890–1967
*Sculptor.* Born in Smolensk. Studied in England from 1905 first in Sunderland, then London. In 1909 moved to Paris. From 1911 participated in exhibitions including Salon des Indépendants, Salon d'Automne. Exhibited with Modigliani and Kisling in Paris (1918), and one-man show at Galerie Barbazanges (1921). Participated in many exhibitions abroad.

**236**    Ceramic Sculpture 1908
Ceramic, painted, fired, 30×16×15cm
Collection V.A.Dudakov and M.K.Kashuro

**ZAKHAROV**, Vadim Arisovich / Born 1959
*Painter.* Studied at Faculty of Art and Graphics, Moscow State Pedagogical Institute from 1977. Member of Hermitage group (1987). Lives and works in Moscow. Exhibited since 1978 in USSR, and abroad in New York (1983), Washington (1985), New York (1987), Madrid (1988) and Berne (1988).

**237**    A-6 1985, *Ill. p.40*
Oil on canvas, 220×320cm
Collection the artist

**ZALTSMAN**, Pavel Yakovlevich / 1912–85
*Painter, graphic artist and theatre and film designer.* Studied at
First Artistic Studio, Leningrad, and State Institute for
History of Art. Illustrated for magazines *Rezets* [Chisel],
*Stroyka* [Building], *Yunyy Proletariy* [Young Proletariat], and
designed for cinema. Worked at School of Analytical Art of
Filonov (1930). From 1943 lived and worked in Kazakhstan.
Exhibited from early 1930s. Taught at Art School, Alma Ata,
and Kazakh State University.

**238**  Group with Self Portrait 1937, *Ill. in col. p.137*
Oil on canvas, 55.5×65.5cm
Collection Ye.P.Zaltsman

**ZDANEVICH**, Kyril Mikhailovich / 1882–1970
*Graphic artist, painter and theatre designer.* Studied at School
of Painting and Sculpture, Tbilisi (early 1900s) under
Sklifasovsky, Academy of Arts (1911) and in Paris (1912–14).
From 1912 participated in exhibitions including Donkey's
Tail, Target. Worked at Tatlin's studio, 'The Tower' (1913–
15). Lived in Tbilisi (1917–25) and then in Moscow.
Discovered work of Georgian primitive artist, Pirosmani.
Participated in decoration of Khimerioni tavern, and designed
and illustrated Futurist poetry, including works of
Mayakovsky, Kruchyonykh. Co-author of declarations and
publications on Futurists with his brother I.Zdanevich.

**239**  Orchestral Self Portrait (V.Gudiashvili, Kara-Dervish,
K.Zdanevich, V.Zdanevich, A.Kruchyonykh) *c.*1917
*Ill. in col. p.103*
Watercolour on paper, 76.5×153cm
Collection S.A.Shuster and Ye.V.Kryukova

**ZHEGIN**, Lev Fyodorovich / 1892–1969
*Painter and graphic artist.* Studied in Moscow at studio of
Yuon and Dudin, MUZHVZ (1911–18) and SVOMAS (1918–19).
Son of architect Shekhtel. Lived in Moscow. Founder-
member of society Makovets (1922–6) and group Way of
Painting (1927–30). Participated in exhibitions from 1914.
Together with Chekrigin illustrated first book of
Mayakovsky's poetry, *I* (1913). Designed for festivals and
public holidays (1918). Exhibited in Berlin (1922), Venice
(1924, 1928), Paris (1925, 1928) and London (1928). One-man
shows in Moscow (1967, 1970). Author of book on medieval
Russian painting. Taught printing (1920–5).

**240**  Family 1920, *Ill. above right*
Charcoal on paper, 59×66cm
Collection V.A.Dudakov and M.K.Kashuro

**241**  In Memory of V.N.Chekrigin 1922
Charcoal on paper, 55×60cm
Collection I.G.Sanovich

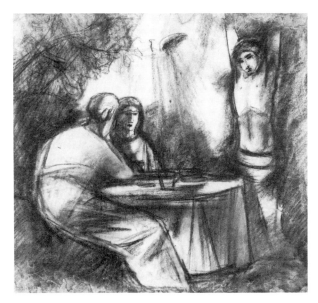

Lev Zhegin: **Family** 1920
Cat.240

Unknown artist
**242**  The Union of Town and Countryside in Azerbaijan
*c.*1919, *Ill. p.22*
Sketch for a poster
Watercolour on paper, 30.5×58cm
Collection L.Kropivnitsky

Unknown artist
**243**  'Comrades, We Shall Celebrate Red October
with the Rifle and the Hammer' *c.*1920, *Ill. in col. p.112*
Izd. Politupr. RVSR, Moscow
Lithograph poster, 67.2×61.7, 89×71.8cm
Collection L.Kropivnitsky

Unknown artist
**244**  'From America to Starving Russia' 1922, *Ill. below*
Made at time of serious famine in Volga region
Moscow
Lithograph poster, 59.8×90.4, 61.7×93cm
Collection L.Kropivnitsky

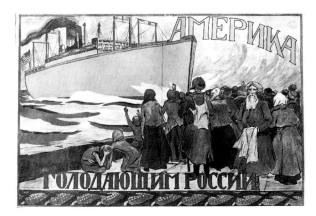

Unknown artist: **'From America to Starving Russia'** 1922
Cat. 244

Unknown artist
**245 Plate 'Long Live the Third International'** *c*.1923
*Ill. p.37*
'GFZ', no date
Painted over glaze, gilded. Diameter 22cm
Collection V.Andreev

Unknown artist
**246 Jug** *c*.1924, *Ill. below*
Mark of the ceramic faculty of VKhUTEMAS
Moscow and 'GFZ' with stamp, no date.
Painted over glaze. Height 17.3cm
Collection V.A.Dudakov and M.K.Kashuro

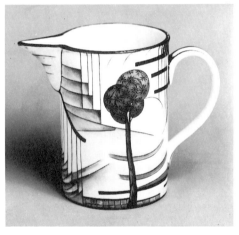

Unknown artist: **Jug** *c*.1924
Cat.246

Unknown artist
**247 Suprematist Cup and Saucer** Late 1920s, *Ill. below*
No mark.
Painted over glaze. Height of cup 5.8cm;
diameter of saucer 14.3cm
Collection V.A.Dudakov and M.K.Kashuro

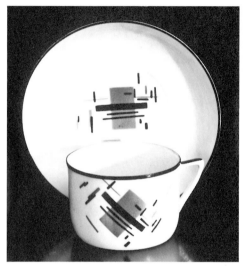

Unknown artist: **Suprematist Cup and Saucer** Late 1920s
Cat.247

# SELECTED BIBLIOGRAPHY

Recent publications in English

Nina Baburina, *The Soviet Political Poster 1917–1980 from the USSR Lenin Library Collection*, Harmondsworth, Penguin, 1985

Alan Bird, *A History of Russian Painting*, Oxford, Phaidon, 1987

John Bowlt (Ed), *Russian Art of the Avant-garde: theory and criticism 1902–1934* (revised edition), London, Thames & Hudson, 1988

Matthew Cullerne Bown, *Contemporary Russian Art*, Oxford, Phaidon, 1989

David Elliott, *'New Worlds': Russian Art and Society 1900–1937*, London, Thames & Hudson 1986

Camilla Gray, *The Russian Experiment in Art 1863–1922* (revised edition), London, Thames & Hudson 1986

Igor Golomshtok and Alexander Glezer, *Unofficial Art in the Soviet Union*, London, Secker & Warburg, 1977

V.Leniashin (Ed), *Soviet Art 1920s and 1930s from the Russian Museum Leningrad*, Harmondsworth, Penguin, 1988

Oxford, Museum of Modern Art, *Art into Production: Soviet Textiles, Fashion and Ceramics 1917–1935* (catalogue), 1984

Angelika Rudenstine, *Russian Avant-garde Art: The Costakis collection*, London, Thames & Hudson, 1981

Konstantin Rudnitsky, *Russian and Soviet Theatre: Tradition and the Avant-garde*, London, Thames & Hudson, 1988

Paul Sjeklocha and Igor Mead, *Unofficial Art in the Soviet Union*, Berkeley and Los Angeles, University of California Press, 1967

Clive Vaughan-Jones, *Soviet Socialist Realism*, London, Macmillan, 1976

Vienna, Austrian Museum of Applied Arts in association with Mücsarnok, Budapest, *Art and Revolution, Russian and Soviet Art. 1910–1932* (exhibition catalogue), Vienna, Löcker Verlag, 1988

Washington, *Russian and Soviet Painting 1900–1930* (exhibition catalogue), Washington, Smithsonian Institute Press, 1988

Stephen White, *The Bolshevik Poster*, London, New Haven, Yale University Press, 1988

Isaak Levitan: **Izbas** [traditional wooden houses] 1899
Cat.115

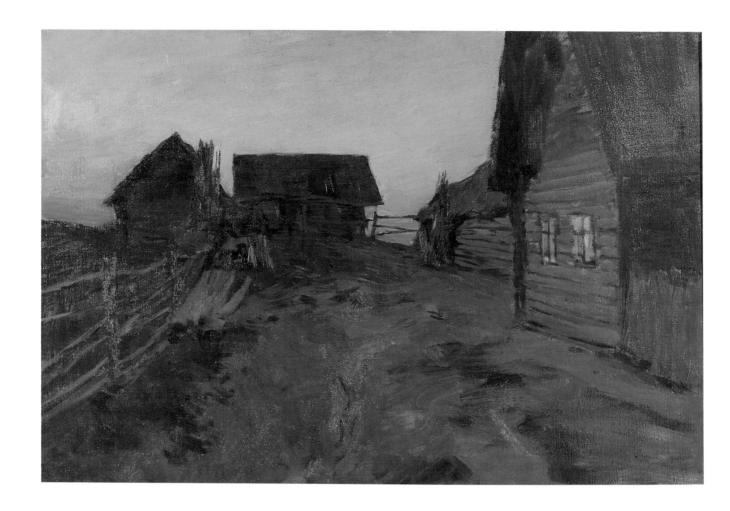

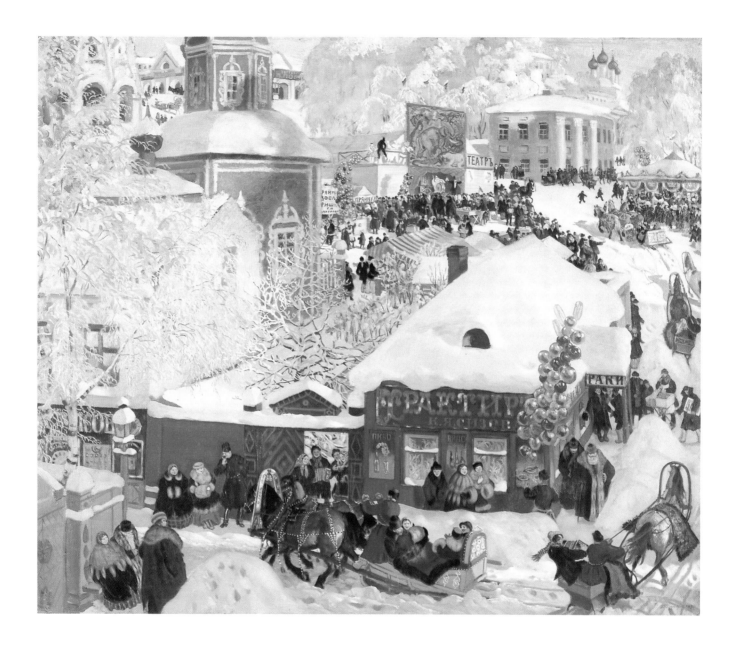

Alexandre Benois: **Versailles** 1906
Cat.9

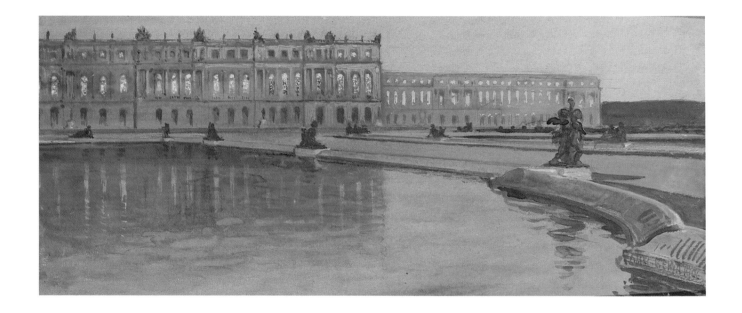

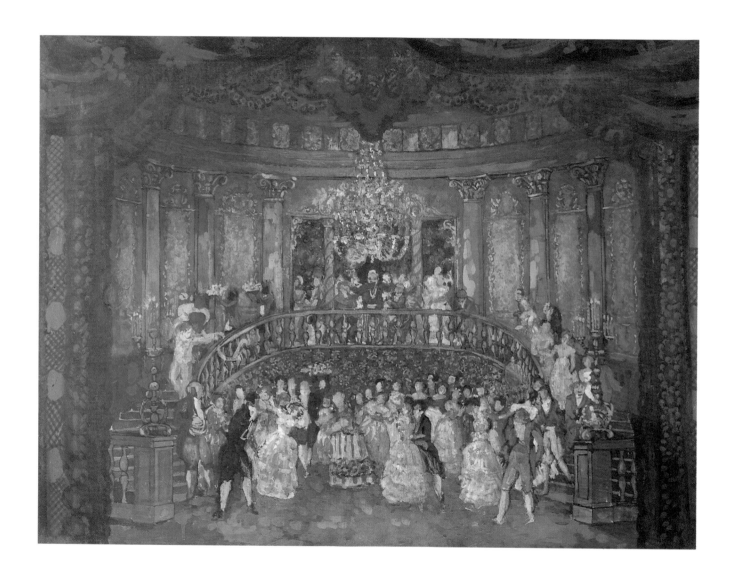

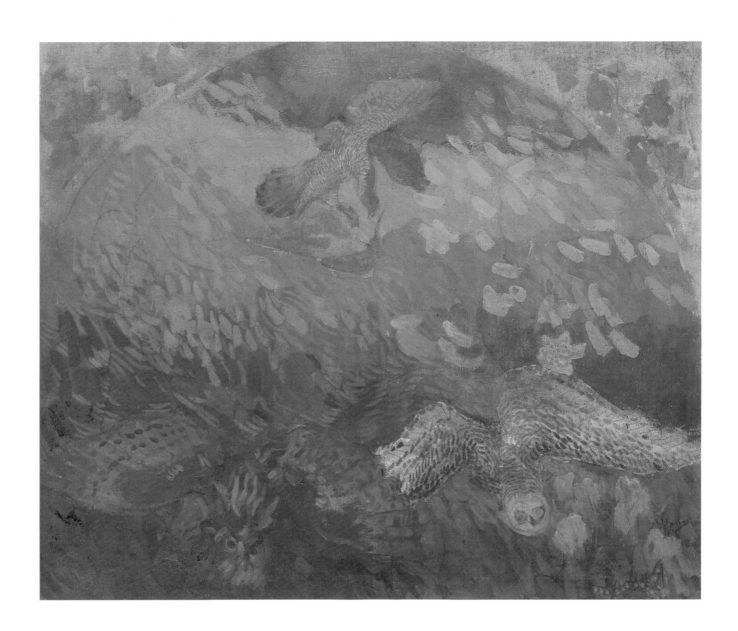

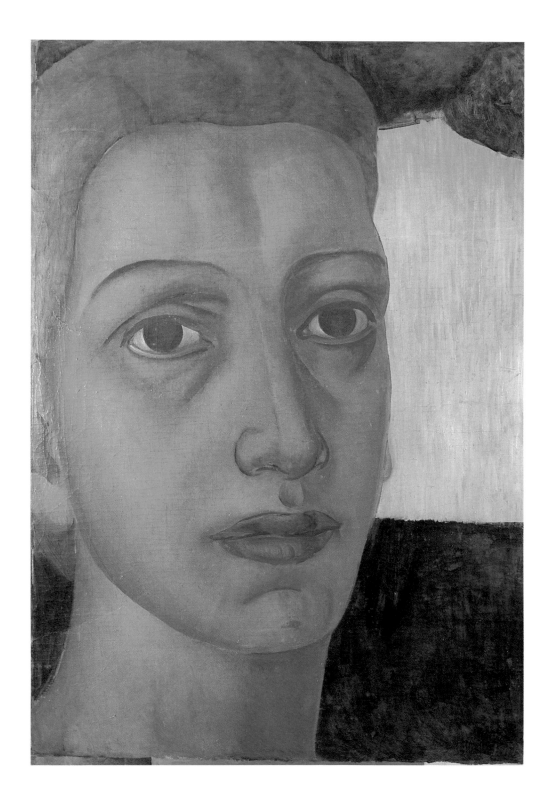

Aleksei Jawlensky: **Still Life** 1902
Cat.71

Mikhail Matiushin: **The Pink House** *c*.1909
Cat.125

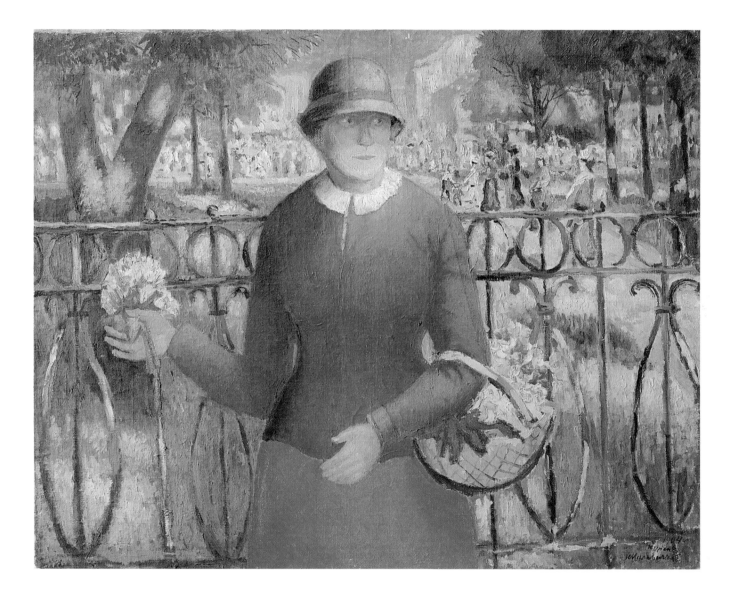

Niko Pirosmanashvili (Pirosmani): **The Russo-Japanese War** *c*.1906
Cat.154

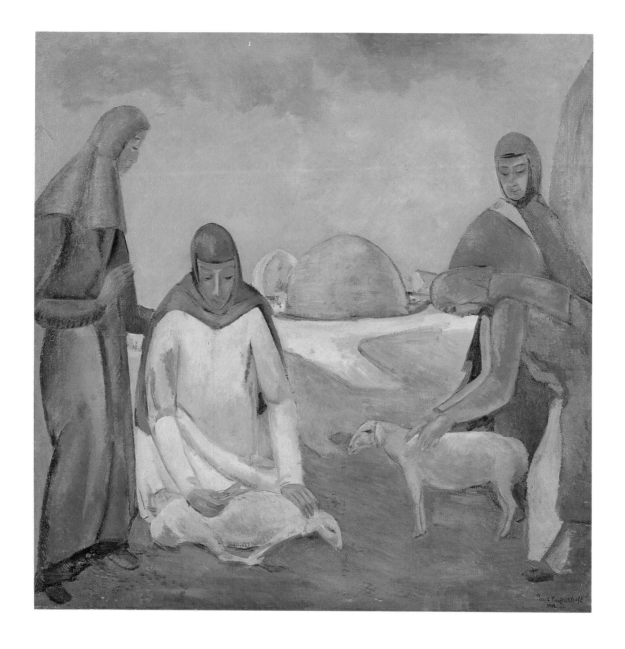

Mikhail Larionov: **Fishes** 1907
Cat.104

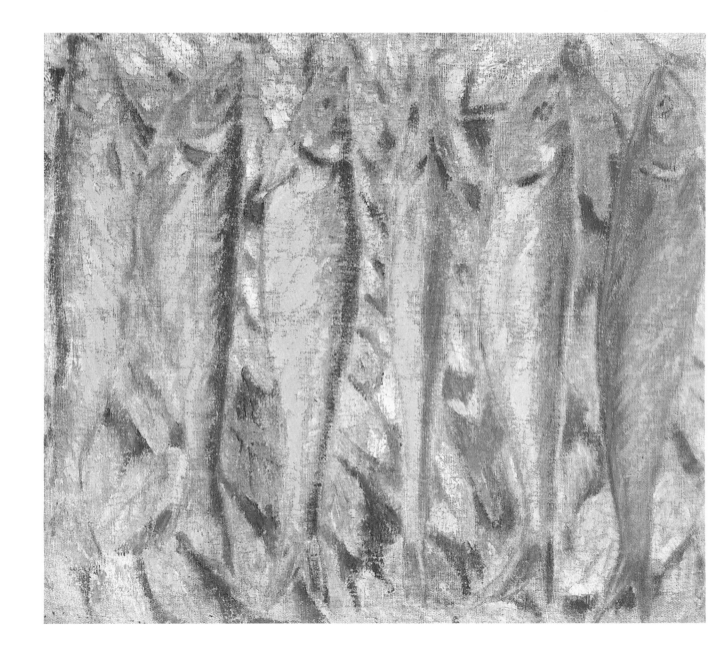

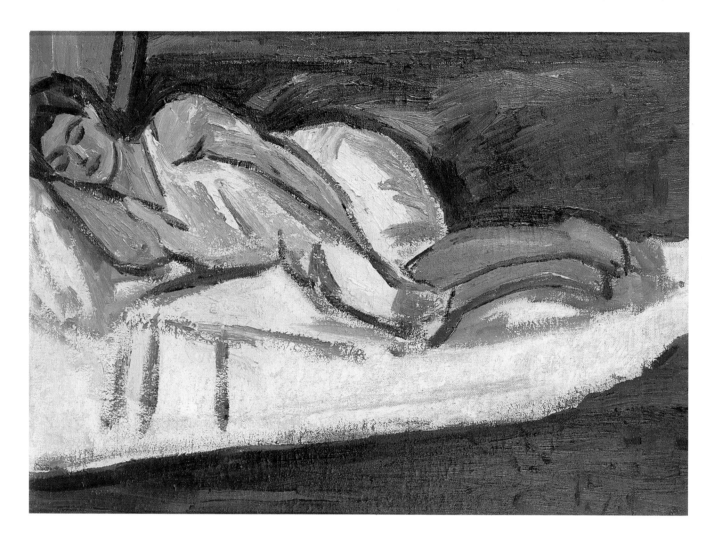

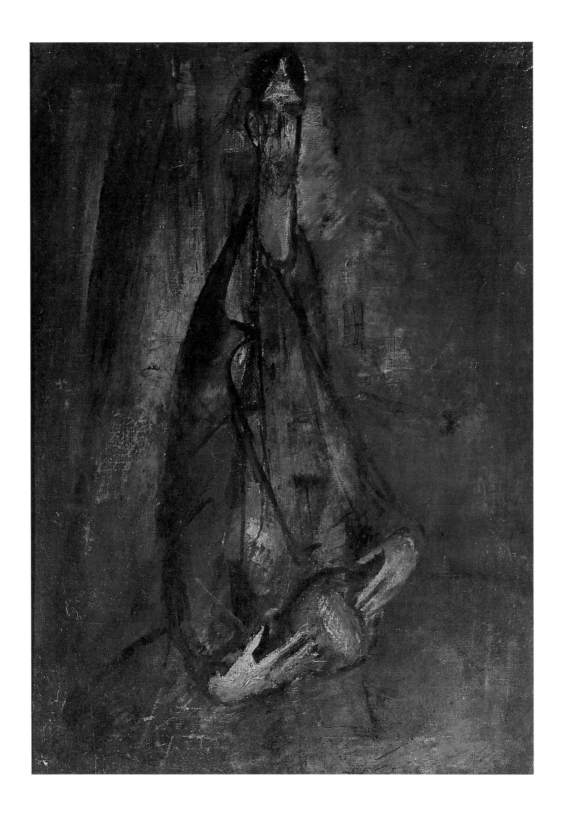

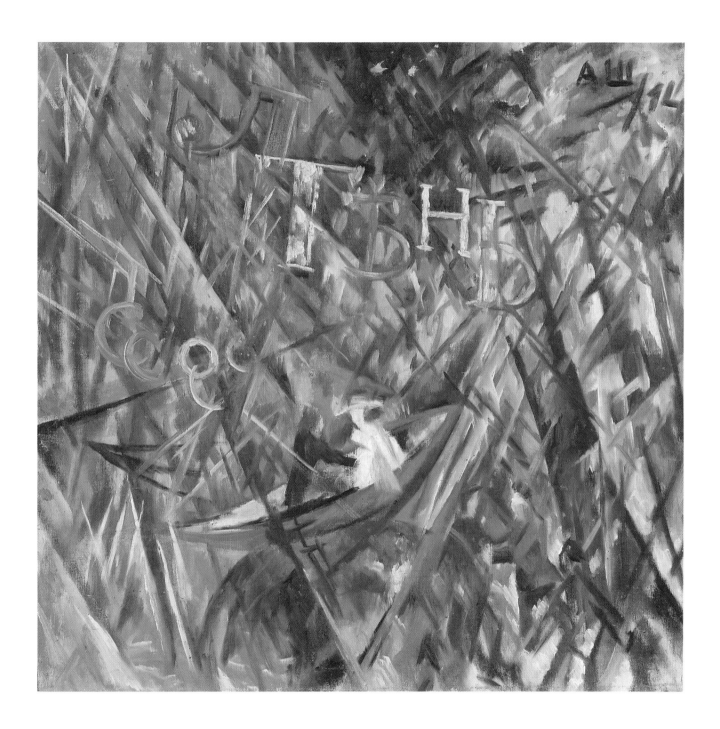

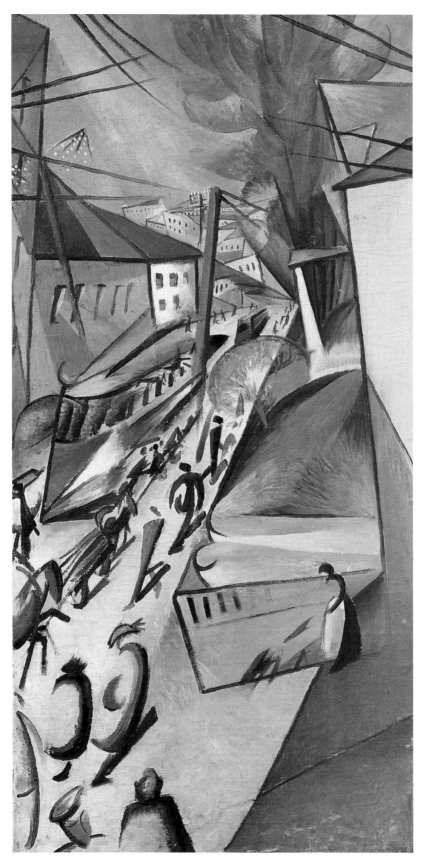

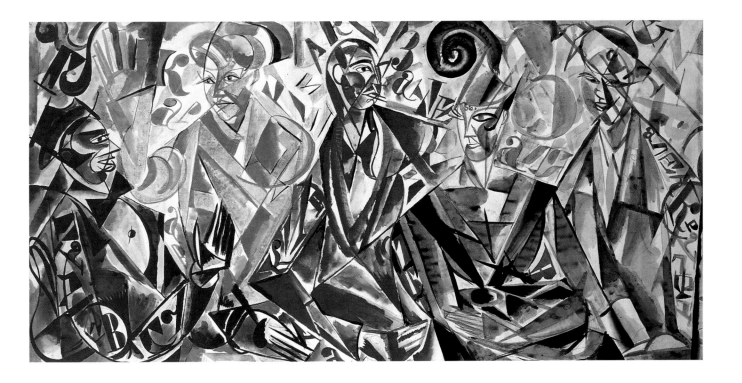

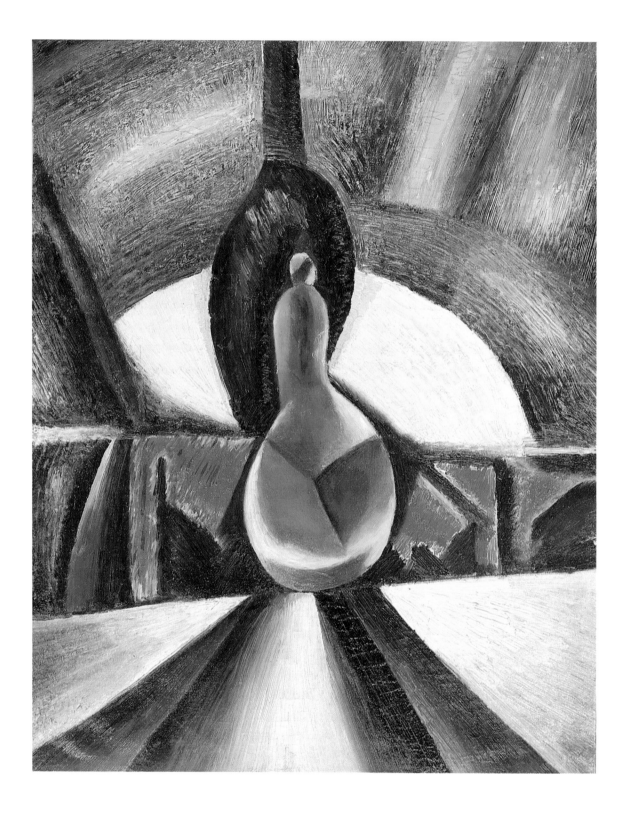

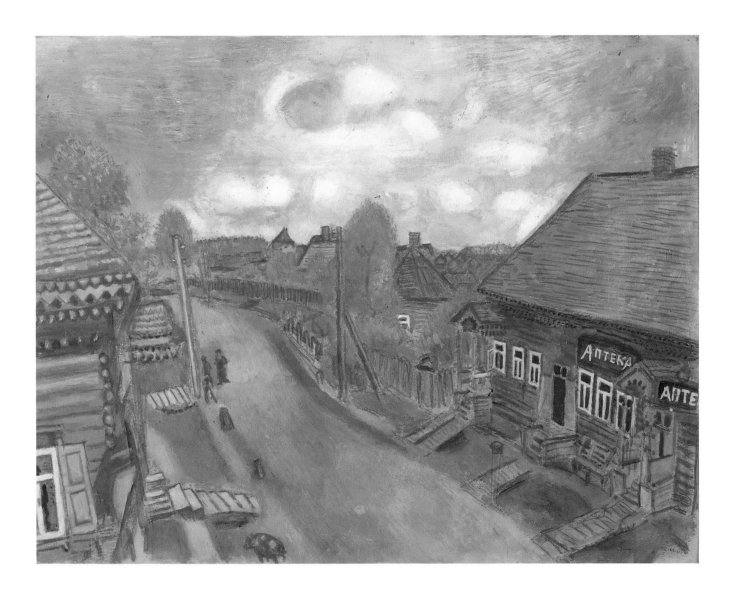

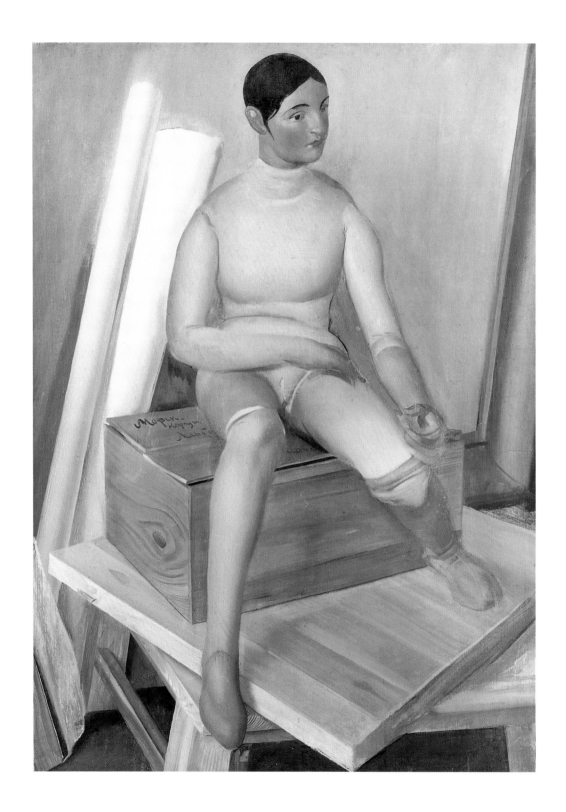

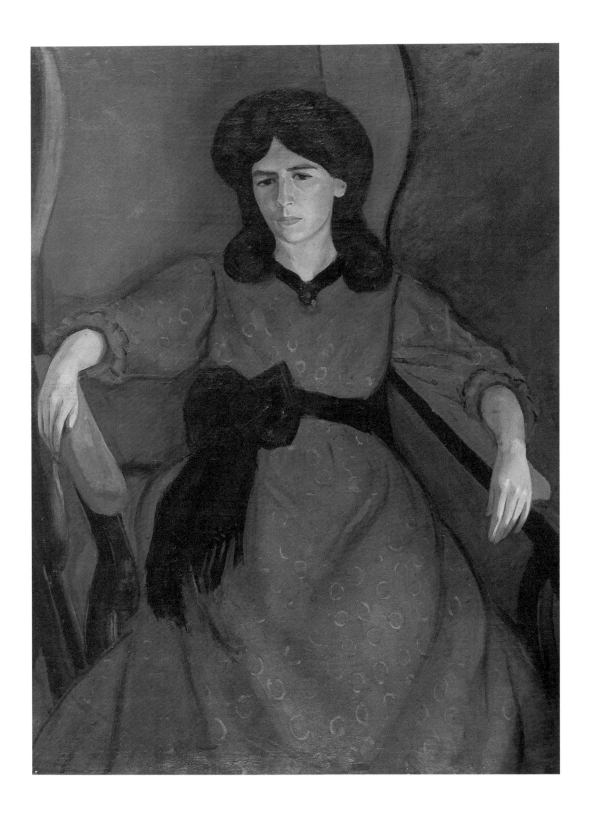

Ilya Mashkov: **Still Life with Poppies and Cornflowers** 1912–13
Cat.122

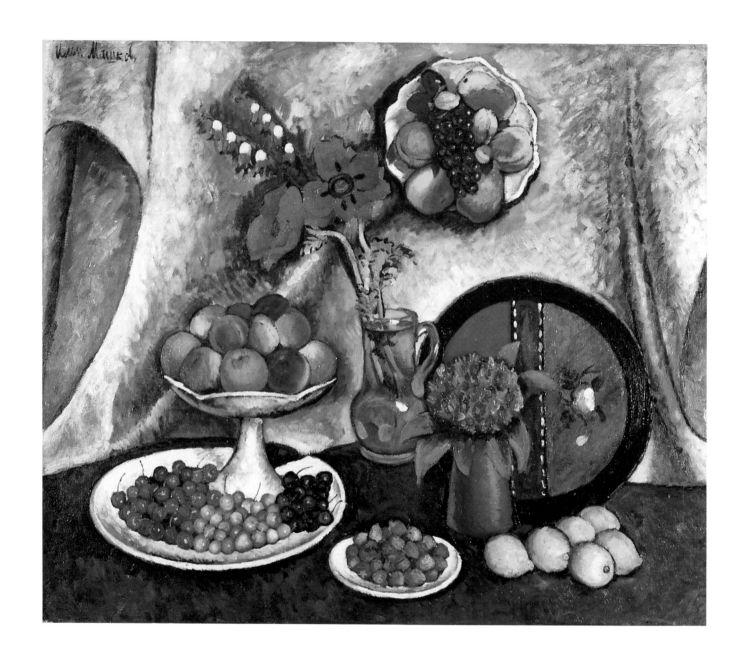

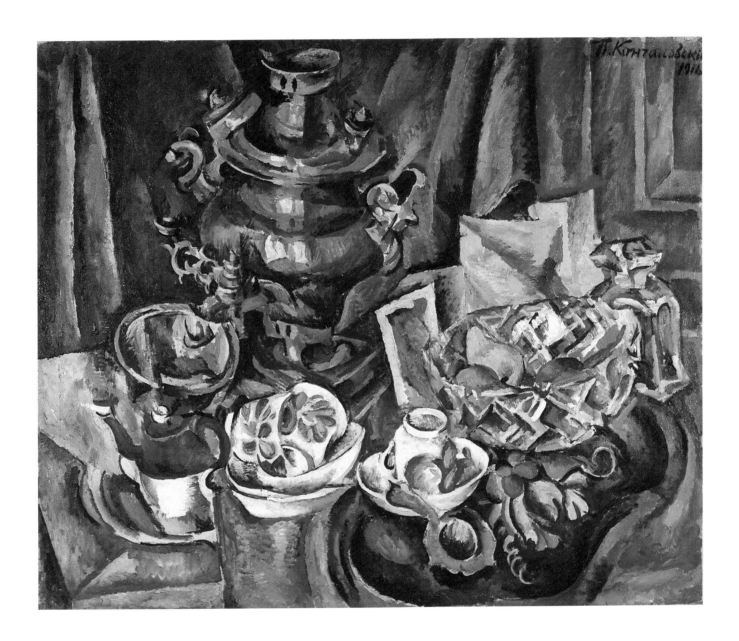

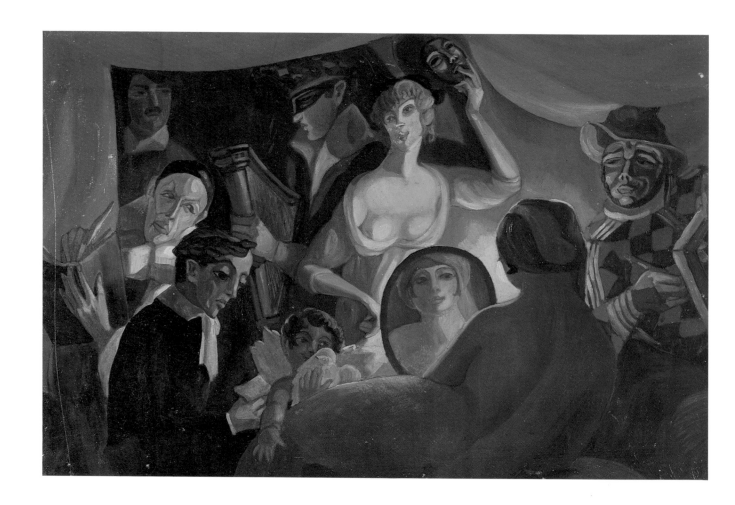

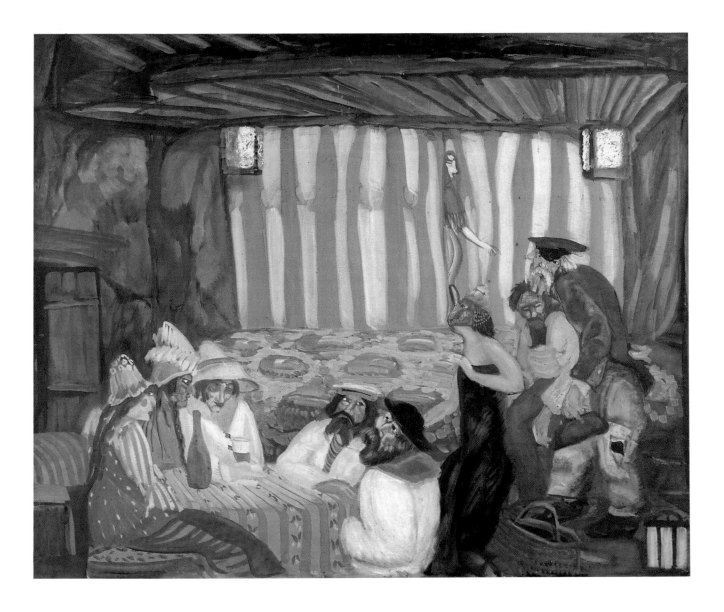

Unknown Artist: **Comrades, We Shall Celebrate Red October**
**with the Rifle and the Hammer'** *c.*1920
Cat.243

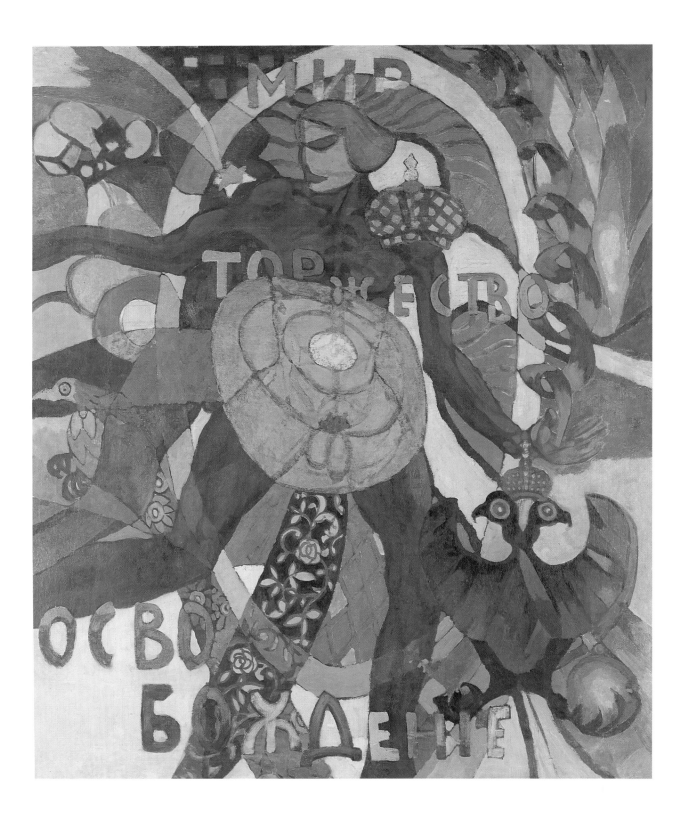

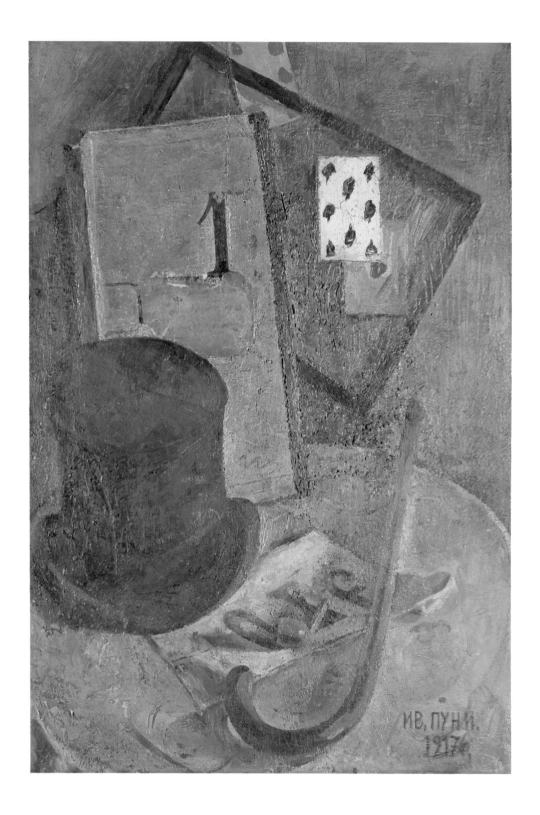

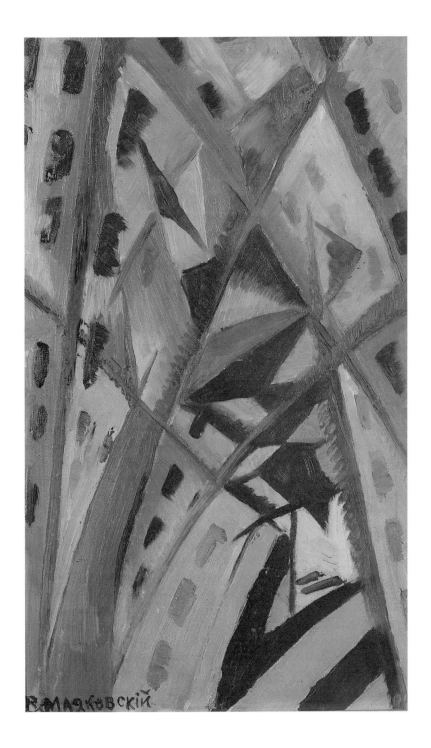

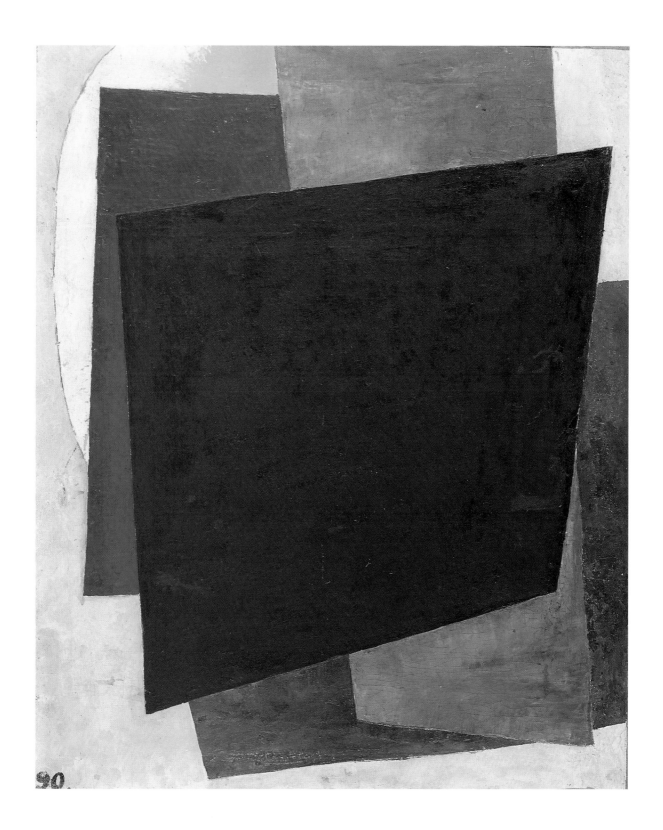

Aleksandr Rodchenko: **Non-objective Composition** from the series
'Movement of Projected Planes' 1918
Cat.169

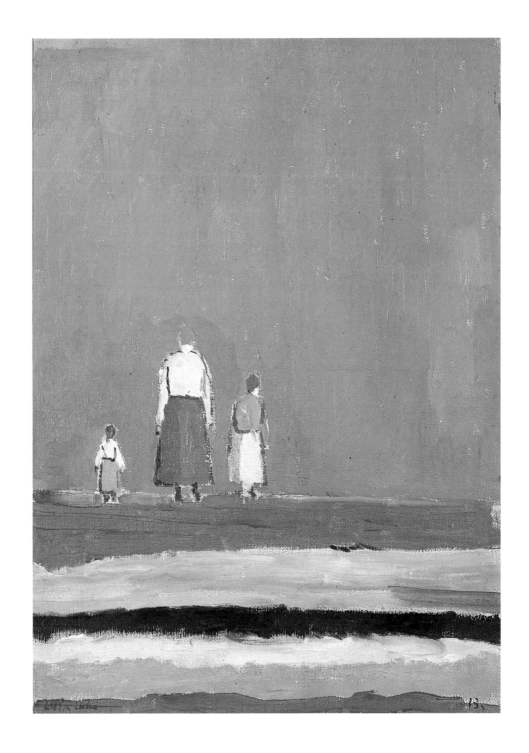

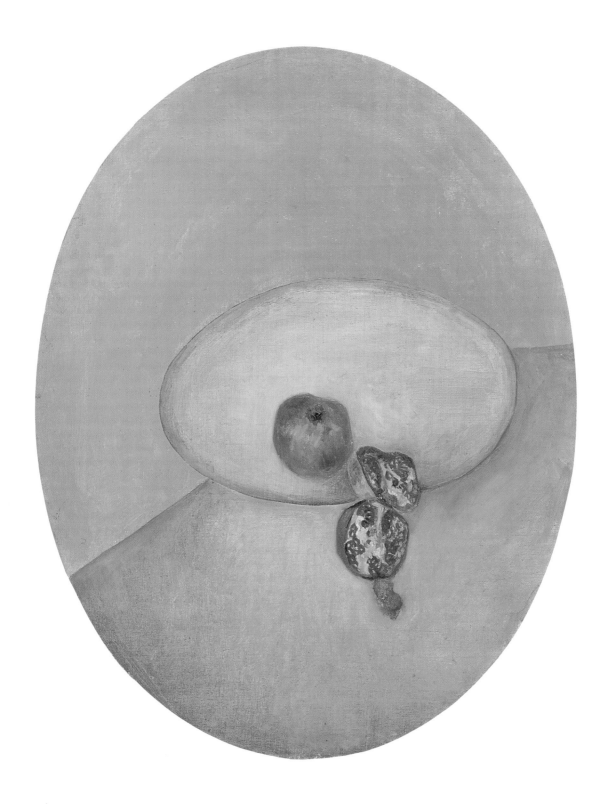

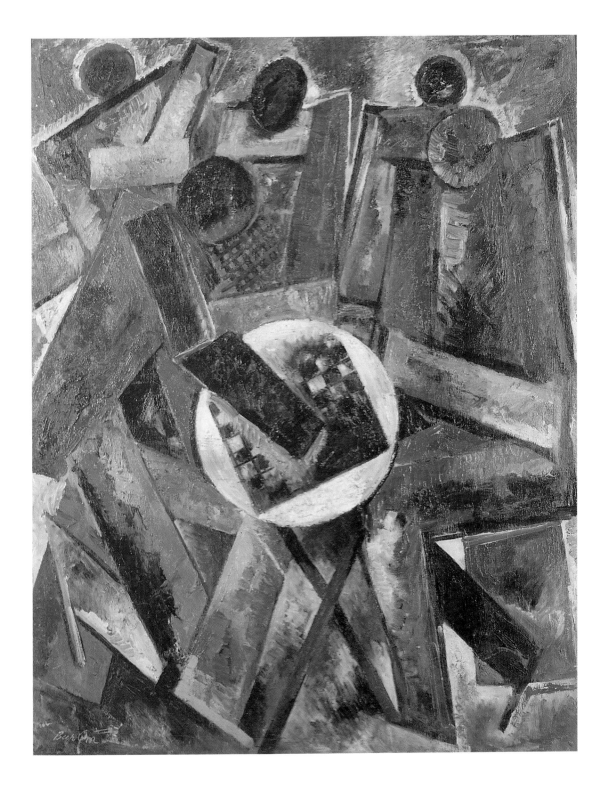

Dmitri Moor: 'October 1917. October 1920' 1920
Cat.137

Right
Nikolai Lapshin:
**Suprematist Dish** 1923
Cat.101

Far right
Nikolai Suetin: **Suprematist Dish**
late 1920s–early 1930s
Cat.206

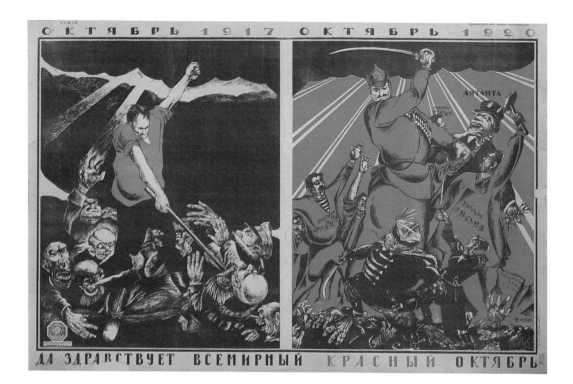

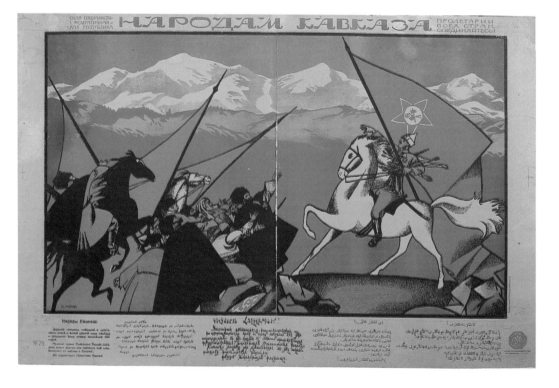

Right
Sergei Chekhonin:
'**From the Highest Peaks
of Science**' 1921
Cat.30

Far right
Aleksandra Shchekotikhina-Pototska
'**Card Game**' 1923
Cat.190

Dmitri Moor: '**To the Peoples of the Caucasus**' c.1921
Cat.140

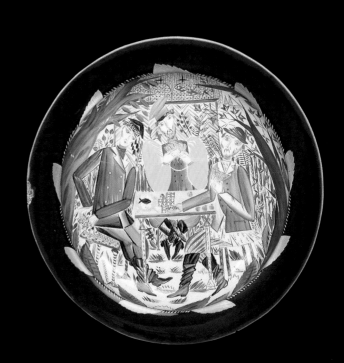

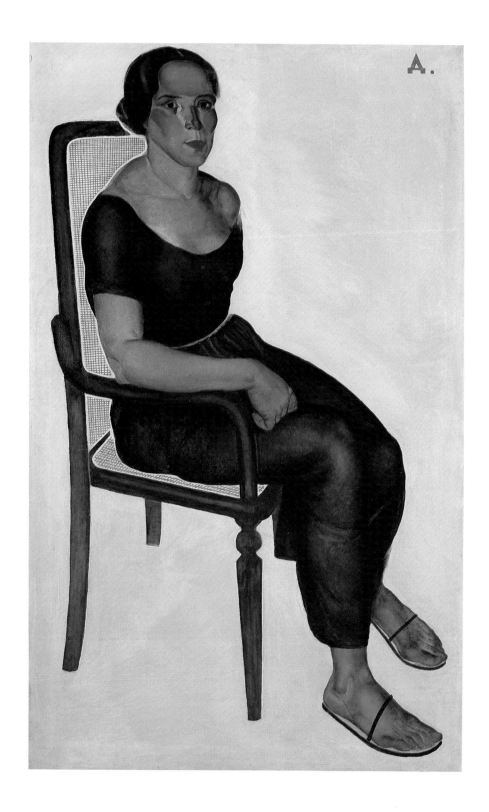

Kuzma Petrov-Vodkin: **Still Life with Violin** 1921
Cat.150

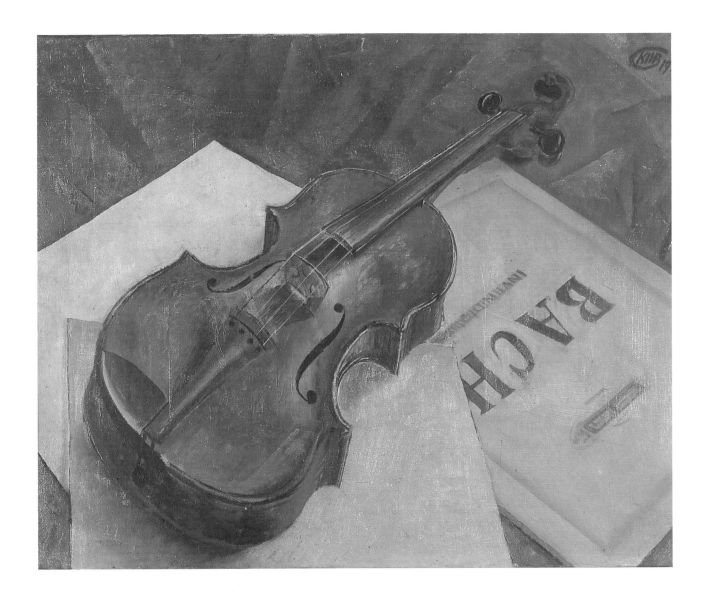

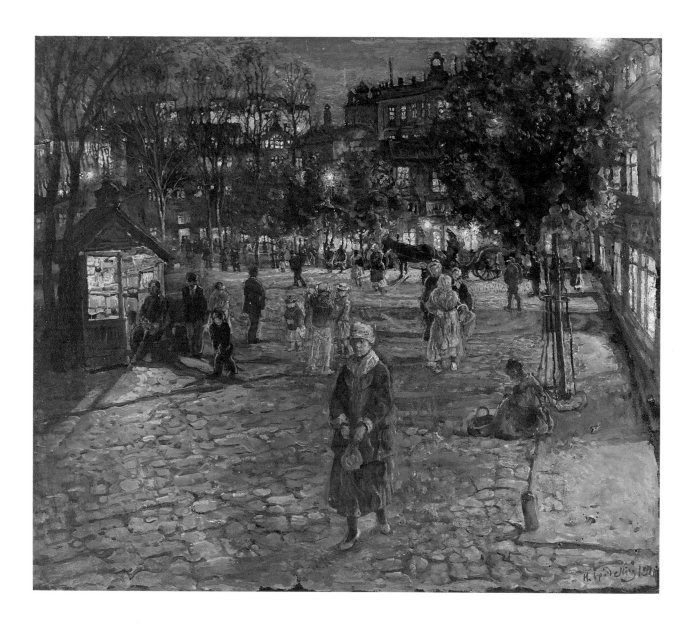

Leonid Chupyatov: **The Crown of Thorns** Undated
Cat.41

Aleksandr Tyshler: **Sports Parade** 1929
Cat.212

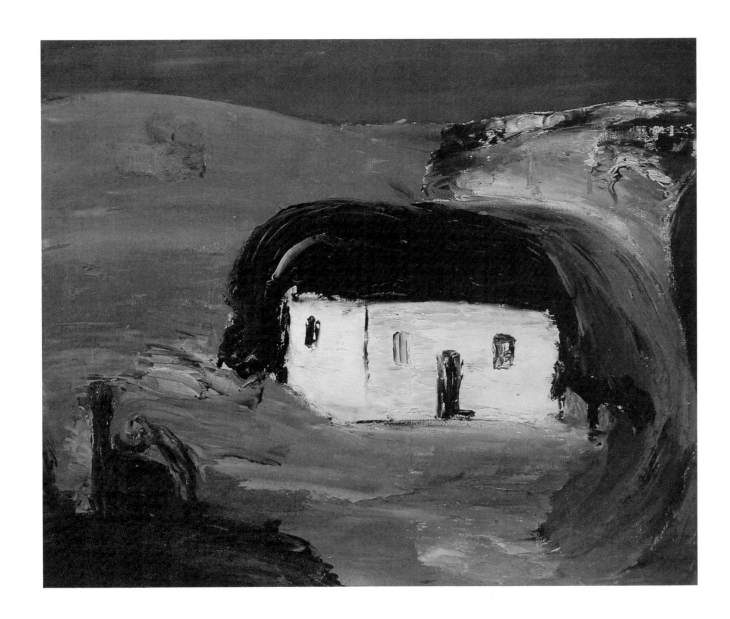

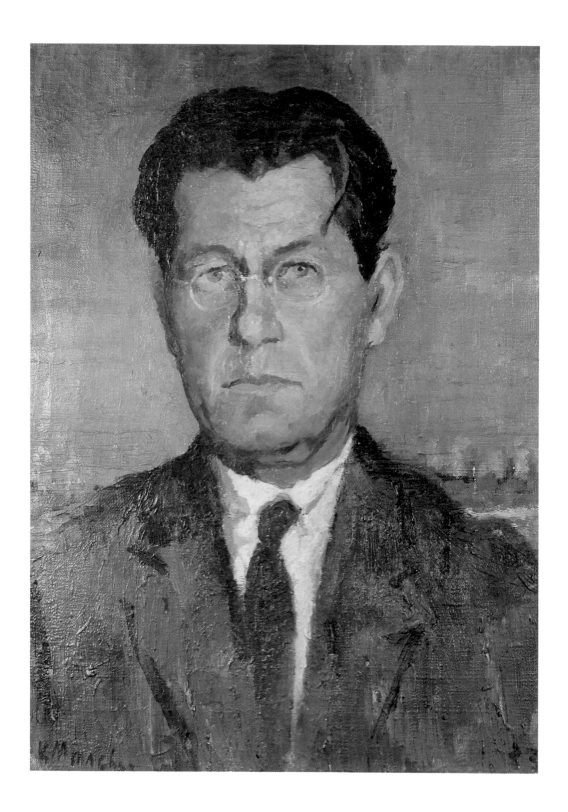

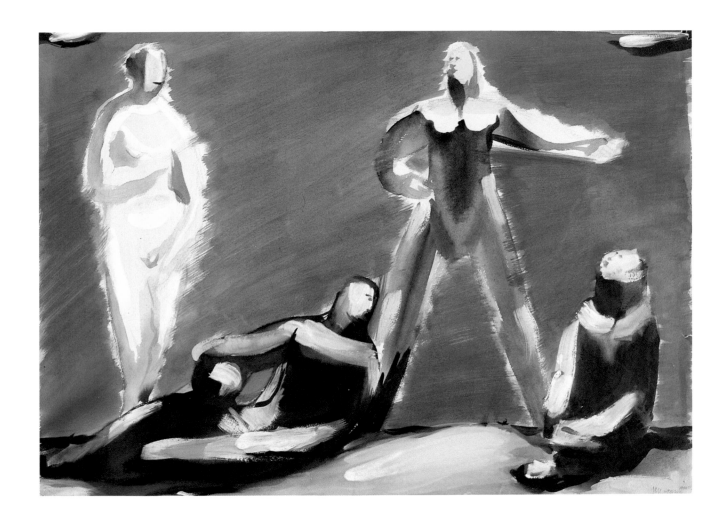

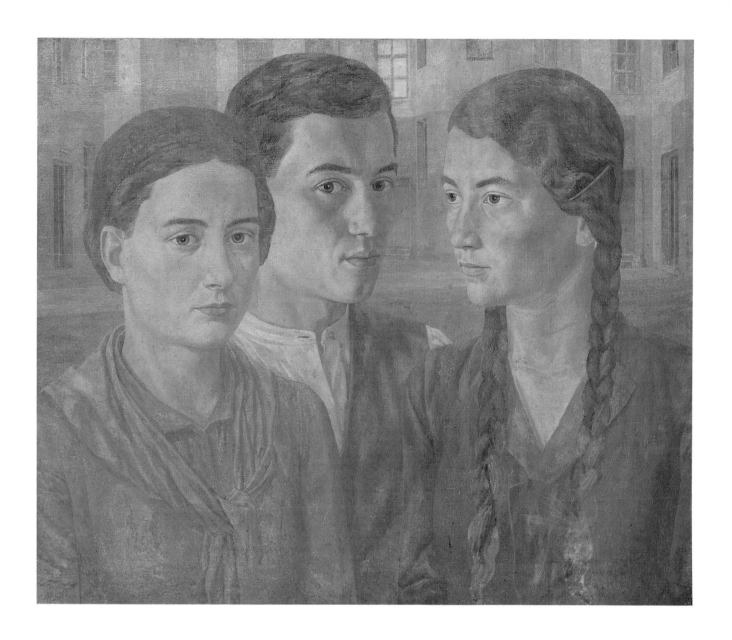

Aleksandr Rodchenko: **Acrobat** 1948
Cat.174

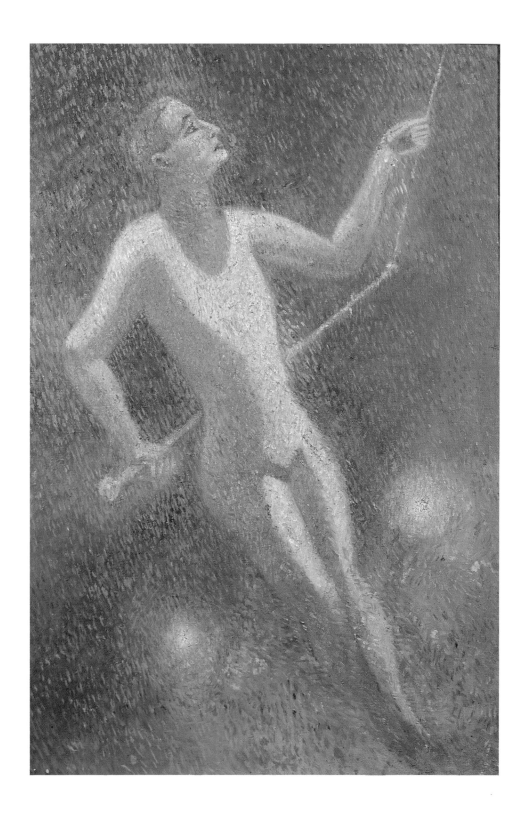

Vladimir Nemukhin: **A Blue Day** 1959
Cat.142

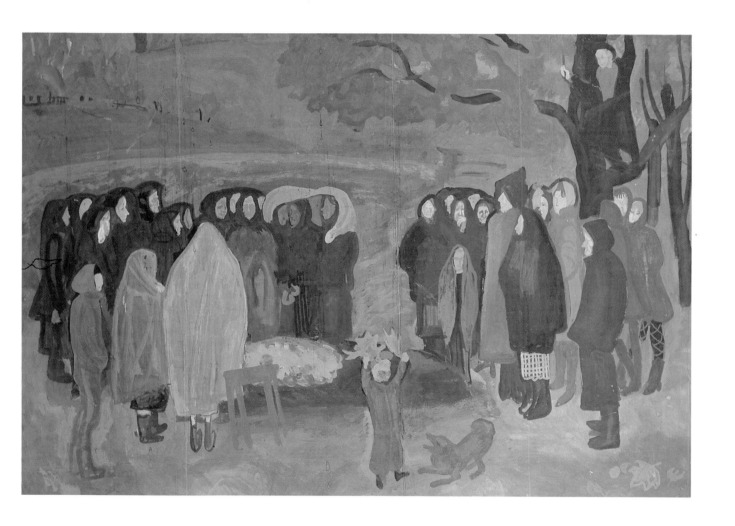

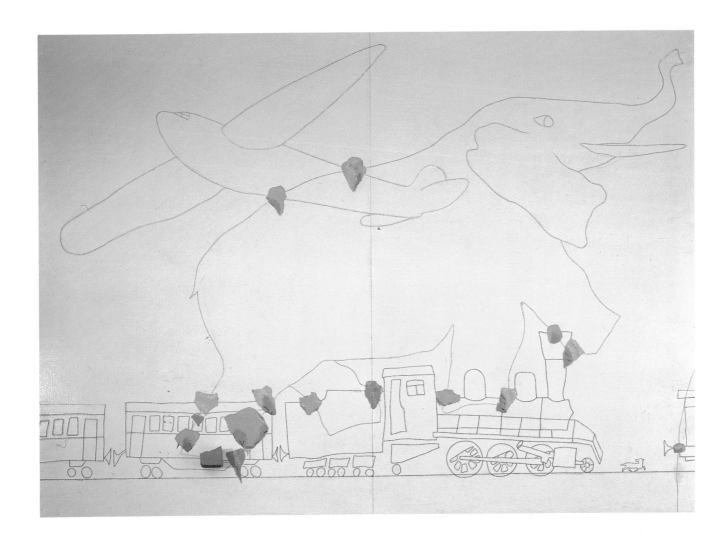

**Andreev**, Vladimir Yakovlevich. Born 1914. Moscow. Musician. Collection begun 1940s. Includes Russian painting and graphic works from 19th century to *c*.1930s, mainly by members of World of Art and Union of Russian Artists, also miniatures from the Lukutin factory (19th century) and the village of Palekh (20th century), Russian 19th- and 20th-century glass and ceramics and a few 17th- and 18th-century West European paintings. Works exhibited at Tretyakov Gallery, Russian Museum, Pushkin Museum of Fine Arts and Museum of Decorative and Applied Arts of the RSFSR, at Moscow exhibition halls and at exhibitions devoted to the work of individual artists. Some works from the collection given to Art Gallery, Orel, and a number published.

**Belyakov**, Grigory Pavlovich. Born 1904. Moscow. Retired. Collection begun 1922. Comprises Russian painting and graphic works *c*.1850s–1950s. Works shown at over fifty exhibitions in Tretyakov Gallery, Pushkin Museum of Fine Arts, Russian Museum and Academy of Arts of USSR, in many museums and exhibition halls in Moscow, Leningrad, Kiev and other towns. Over 450 paintings and drawings, and over 800 historic documents given to museums in USSR. A number of works from the collection published.

**Chizhov**, Aleksandr Borisovich. Born 1938. Moscow. Geologist. Collection inherited; his father, Boris Aleksandrovich Chizhov (1906–77) collected West European paintings, old Russian icons, Russian and West European ceramics and applied art. His mother, Nina Stanislavovna Sukhotskaya (1906–88) owned several works by Yakulov, Ekster, Goncharova, Kuznetsov, Lentulov, Falk, Grigoriev and others. Paintings shown at the exhibition Moscow-Paris (USSR, 1981) and an exhibition of the work of Ekster (Moscow, 1987).

**Chudnovskaya**, Yevgeniya Borisovna. Born 1911. Leningrad. Engineer and economist. **Chudnovsky**, Abram Filippovich. 1910–85. Professor and physicist. Collection begun 1953. Consists of paintings and graphics. Works shown at many exhibitions at museums in USSR including Russian Museum and Tretyakov Gallery, and in Finland, Denmark, Norway and Italy. Paintings can be seen in art museums in Saratov, Tula and other towns in USSR. A number of works from the collection published.

**Drevin**, Andrei Aleksandrovich. Born 1921. Moscow. Sculptor. Member of Union of Artists of USSR. **Drevina**, Yekaterina Andreevna. Born 1950. Moscow. Art critic and art historian. Collection comprises over 200 paintings and 500 graphic works as well as documents, manuscripts and photographs of the artist Drevin (1889–1938) and his wife Udaltsova (1886–1961). Works shown abroad, at exhibitions Moscow-Paris (USSR, 1981) and Art and Revolution (Japan, 1983, USSR, 1987), and in USSR in Tretyakov Gallery, Russian Museum, Pushkin Museum of Fine Arts, picture galleries in Kiev, Novosibirsk, Orel and Tula.

**Dudakov**, Valery Aleksandrovich. Born 1945. Moscow. Designer, art critic, author of publications on early 20th-century Russian art. **Kashuro**, Marina Konstantinovna. Born 1946. Art critic. Collection begun late 1960s. Includes Russian paintings, graphic works and sculpture from late 19th century to 1930s, ceramics from the immediate post-revolutionary years and paintings by contemporary artists working in non-traditional styles. Since mid-1970s works shown on many occasions at exhibitions in Russian Museum, Tretyakov Gallery, Pushkin Museum of Fine Arts, art galleries in the USSR and at exhibitions devoted to the work of individual artists. Paintings shown in Hungary, Austria, Denmark, Norway, West Germany and Italy. A number of works from the collection published.

**Efron-Blokh**, Natalia Nikitichna. Born 1916. Leningrad. Trained as a biologist. Collection based around that of her husband, Grigory Samoylovich Blokh (1889–1973), who was educated in the legal profession but worked in publishing and began collecting in 1913. Present collection of 20th-century Russian painting and graphic works begun 1945. Works shown at major exhibitions organised by museums in USSR and at exhibitions in Finland, Denmark, Norway and Italy. Many works have entered Russian Museum, Tretyakov Gallery and picture galleries in USSR, e.g. Tomsk, Cheboksara. Works reproduced in publications on Russian and Soviet art of first half of 20th century.

**Ezrakh**, Iosif Moiseevich. Born 1898. Leningrad. Trained as an engineer. Collection of applied art begun 1927 and in late 1950s began collecting Russian and Soviet paintings. Comprises 18th- and 19th-century applied art from West Europe and Russia, late 19th- and early 20th-century Russian painting and Soviet graphic works. Works shown at many exhibitions in USSR since the 1960s. 19th-century applied art exhibited at Petrodvorets near Leningrad (1985). Many works donated to Russian Museum, Hermitage and other museums in Leningrad. Paintings exhibited in Finland, Denmark, Norway and Italy. A number of works from the collection published.

**Gordeeva**, Zinaida Konstantinovna. Born 1910. Leningrad. Retired. Collection begun late 1930s with her husband Mikhail Grigorevich Gordeev (1905–1967), a journalist. Comprises painting and graphic works *c*.1900–1930s including works by Matisse, Picasso, Signac, Chagall, Malevich, Grigoriev, Petrov-Vodkin, Sudeikin. Paintings shown at many exhibitions in Russian Museum, Tretyakov Gallery, Pushkin Museum of Fine Arts, museums in Minsk and Kiev, and abroad in France (Paris-Moscow, 1979), Hungary, Austria (1988) and Italy (1989). A number of works given to Tretyakov Gallery and Pushkin Museum. A number of works from the collection published.

**Gorshin**, Sergei Nikolaevich. Born 1908. Moscow. Scientific worker (forestry and timber); professor, doctor of science. Collection begun 1945. Comprises mainly paintings and graphic works by Russian artists *c*.1850–1950, largely landscapes. Works shown in Vasnetsov Memorial Museum, Moscow; Museum of Fine Arts, Arkhangelsk, Picture Gallery, Yerevan, and in exhibition halls, Moscow. The greater part of the collection donated by Sergei Gorshin to Tretyakov Gallery.

**Gozak**. Andrei Pavlovich. Born 1936. Moscow. Architect. Collection begun 1959. Includes graphic works by Popova, paintings and graphic works by contemporary artists and architects from Moscow and Tallin. Works shown in exhibition hall, Central House of Artists, and in other exhibition halls, Moscow. Recently published in English a monograph on the Russian Constructivist architect, Ivan Leonidov.

**Ignatyev**, Yuri Alekseevich. Born 1936. Moscow. Engineer. Collection formed early 1970s, includes Russian and Soviet painting

and graphic works from late 19th century to c.1930s. Mainly works by artists of World of Art and Union of Russian Artists groups. Paintings shown in exhibition halls, Moscow.

**Katanyan**, Vasily Vasilyevich. Born 1924. Moscow. Film director. **Gens**, Inna Yuliusovna. Born 1928. Art and film critic. Collection inherited; part belonged to Lily Brik (1891–1978), who was connected with the artist and poet, Mayakovsky. Includes works by artists active c.1900–1930s, also works by artists connected with the magazine *LEF*, posters by Rodchenko, *lubki* [popular prints] by Mayakovsky, Malevich and Lentulov. The other part of the collection belonged to Yulius Borisovich Gens (1887–1957), a lawyer and art critic. Comprises graphic works by Jewish artists c.1900–1930s e.g. Chagall, Altman, Kaplan as well as *netsuke* and Chinese 18th-century sculpture. Works shown in Pushkin Museum of Fine Arts, exhibition hall, Central House of People of Letters, Moscow, and abroad in West Berlin (1983). Individual works transferred to State Literary Museum.

**Korolyuk**, Irina Konstantinovna. Born 1921. Moscow. Geologist. Collection begun 1945 with her husband, Vladimir Dorofeevich Korolyuk (1921–81), an historian. Comprises Russian folk, decorative and applied arts – ceramics, embroidery and painting – as well as primitive local icons, Soviet graphic works from c.1950s and some works of Russian and West European painting from 17th century to the present day. Collection of book plates shown at exhibition halls, Moscow.

**Kravchuk**, Vasily Grigoryevich. Born 1956. Moscow. Photographer. Collection features works by contemporary Soviet artists from the early 1980s.

**Lansere**, Svetlana Yevgenyevna. Born 1924. Moscow. Historian and archaeologist. Collection inherited; originally formed by three generations of artists of the Lansere family. The eldest, Yevgeny Aleksandrovich Lansere (1848–1886), a sculptor, collected paintings and sculpture. The most significant part of the collection was put together by Yevgeny Yevgenyevich Lansere (1875–1946), the painter, graphic artist, monumentalist, and member of World of Art group. Apart from works by Ye.Ye.Lansere and his sister Serebriakova, includes works by artists of World of Art – including Vrubel, Serov, Korovin, Benois, Somov, Bakst, Dobuzhinsky, Ostroumova-Lebedeva. Also sculptures by Ye.A.Lansere, Ober; a few examples of West European painting, Russian 19th-century paintings and works by Soviet artists. Works shown at many exhibitions in Tretyakov Gallery, Pushkin Museum of Fine Arts, exhibition halls in Moscow and Leningrad, as well as at exhibitions devoted to the work of individual artists. Some works donated to museums in Moscow, Leningrad, Tbilisi, Kharkov and Makhachkal.

**Lentulova**, Marianna Aristarkhovna. Born 1913. Moscow. Art critic. Collection includes paintings and graphic works by her father Aristarkh Vasilyevich Lentulov (1882–1943). Works shown at many exhibitions in Tretyakov Gallery, Russian Museum and other museums in USSR, and at exhibitions devoted to the work of the artist, including in Austria and Italy (1988). A number of works from the collection published.

**Miturich-Khlebnikov**, May Petrovich. Born 1925. Moscow. Artist, member of Union of Artists of the USSR. Collection based around the legacy of the Khlebnikov family – the artists Khlebnikova (1891–1941) and Miturich (1887–1956). Works shown at exhibitions of these two artists in Russian Museum, Tretyakov Gallery and art galleries in USSR. Paintings and graphic works by Miturich and Khlebnikova from the collection can be seen in Russian Museum,

Tretyakov Gallery and Pushkin Museum of Fine Arts.

**Nepalo**, Yevgeny Mikhailovich. Born 1936. Moscow. Musician. Collection formed early 1970s. Comprises Russian and West European painting of late 18th to early 20th centuries and Russian and West European decorative arts. Works shown at Pushkin Museum of Fine Arts and exhibition halls, Moscow. A number of works from the collection published.

**Nutovich**, Yevgeny Mikhailovich. Born 1934. Moscow. Photographer. Collection begun 1959–60. Comprises paintings and graphic works by contemporary artists, mainly of the 'Moscow School' which included different, mainly avant-garde tendencies of the 1960s and 1970s. Latterly works by artists of the 'New Wave' included. Works shown at exhibitions in museums and exhibition halls, Moscow, Tbilisi, Tartu and other towns in USSR.

**Odintsev**, Boris Mikhailovich. Born 1918. Moscow. Lawyer. Collection begun 1948. Includes paintings and graphic works, mainly by Moscow artists c.1900–1930s who were part of the SRKh group (Union of Russian Artists). Works shown in touring exhibitions, exhibitions of SRKh, at thematic shows or exhibitions devoted to the work of individual artists at Tretyakov Gallery, Academy of Arts of USSR, galleries of Union of Artists of USSR and RSFSR and in museums in Moscow.

**Razumovskaya-Bogorodskaya**, Sofya Vasilyevna. Born 1901. Moscow. Art critic, author of a number of monographs on Russian and Soviet 20th-century art. Collection based on works given to the artist Bogorodsky (1895–1959). Includes paintings and graphic works by the artists Ioganson, Deineka, Pimenov, Sokolov-Skalya, Yakovlev. Works shown at exhibitions devoted to the work of individual artists. Part of the collection given to the picture gallery attached to the local museum in Yesentuka.

**Rodchenko**, Varvara Aleksandrovna. Born 1925. Moscow. Graphic artist. The Rodchenko family possesses the archive of the artists Rodchenko and Stepanova. Collection includes documents, manuscripts, letters, photographs, creative and commercial works, paintings, graphic works, polygraphy, design and photography. Archive begun 1920 in connection with the artists' work at INKhUK and the VKhUTEMAS/VKhUTEIN, in the theatre and cinema and for different publishers. The artists' family regularly organise exhibitions in USSR and abroad using the material in the archive, which has also been used in publications on the work of the two artists and art of the 1920s.

**Rubinshteyn**, Tatyana Vikentyevna. Born 1944. Moscow. Art critic. **Moroz**, Vladimir Alekseevich. Born 1929. Artist. Collection founded 1953, based around that of Yakov Yevseevich Rubinshteyn (1900–83), an economist. Comprises Russian paintings, and graphic works c.1900–1930s, agitational posters and ceramics from the immediate post-revolutionary years, old Russian paintings, *lubki* [popular prints] from the First World War and examples of contemporary amateur art. Works shown at many exhibitions in USSR, and in France, America, Japan and England. During 1960s and 1970s works shown in exhibitions of the work of individual artists in Moscow, Leningrad, Tallin and other towns of USSR.

**Rybakova**, Olga Iosifovna. Born 1915. Leningrad. Trained as engineer. Collection based around that of her father, Iosif Izrailevich Rybakov (1870–1938), who began collecting paintings and decorative and applied arts in 1914. Includes decorative and applied arts of the 19th and 20th centuries. Works shown at many major exhibitions in USSR, at exhibitions devoted to the work of individual artists, in Finland, Denmark and Norway. Icons from the 15th to 17th

centuries have entered Hermitage and many paintings are now in Russian Museum and art galleries in Saratov and Gorky. Several works donated to Hermitage, State History Museum and other museums in USSR.

**Rzhevsky,** Yakov Aleksandrovich. Born 1922. Leningrad. Building engineer. **Rzhevsky,** Iosif Aleksandrovich. Born 1922. Leningrad. Member of the armed services. Collection inherited but greatly enlarged since 1940. Includes Russian art from early 19th century to 1930s: paintings, graphic works, sculpture, decorative and applied arts, also works by contemporary artists in non-traditional styles. Works shown at exhibitions in Russian Museum, Kiev Museum of Russian Art, at exhibitions devoted to the work of individual artists and in many exhibition halls. A number of works from the collection published.

**Sanovich,** Igor Grigoryevich. Born 1923. Moscow. Orientalist. Collection begun 1940s. Comprises Russian and Soviet 20th-century paintings and graphic works, old Russian paintings, Russian decorative and applied arts, Eastern decorative and applied arts (China, Japan, Iran) and some West European works. Items shown at many exhibitions in Tretyakov Gallery, Pushkin Museum of Fine Arts, Museum of the Peoples of the East, Moscow, and at exhibitions devoted to the work of individual artists and at exhibition Paris-Moscow (France, 1979). A number of works from the collection published.

**Sarabyanov,** Dmitri Vladimirovich. Born 1923. Moscow. Member of the Academy of Sciences of the USSR. Professor of Russian and Soviet Art in the History Faculty of Moscow University, author of a number of books and articles on Russian art of the 19th and 20th centuries. Collection grew with gifts from artists and their heirs. Includes many works by Popova, as well as works by Falk, Tatlin, Vesnin, Larionov, Kuznetsov, Lentulov and other artists *c.*1900–1950. Paintings and graphic works shown at many exhibitions in USSR and abroad.

**Semyonov,** Vladimir Semyonovich. Born 1911. Moscow. Diplomat. **Semyonova,** Lidiya Ivanovna. Born 1940. Moscow. Art critic. Collection began to take shape 1947 but in its current form dates from 1963. Comprises 20th-century paintings, graphic works and sculpture *c.*1900–1930s as well as examples of contemporary art. Many works shown at exhibitions in State museums in USSR, at exhibitions devoted to individual artists and in Cologne (1980), Esslingen (1984) and Mainz (1984). Works donated to Hermitage, Pushkin Museum of Fine Arts, and art galleries in Armenia and Kazakhstan.

**Shchuseva,** Inna Georgievna. Born 1932. Moscow. Art critic. **Shchusev,** Aleksei Mikhailovich. Born 1932. Architect. Collection inherited from Aleksei Viktorovich Shchusev (1873–1949), an academician and leading Russian and Soviet architect. Comprises Russian fine and decorative arts, old Russian painting and West European art. Works shown at exhibitions in USSR.

**Shlepyanova,** Nina Yevgenyevna. Moscow. Graphic artist. **Shlepyanov,** Aleksandr Ilyich. Born 1933. Moscow. Film scriptwriter. Collection begun mid-1960s. Comprises paintings, graphic works and theatre designs *c.*1900–1930s, agitational ceramics and examples of Russian and Eastern decorative and applied arts. Paintings shown at a number of exhibitions in USSR and in Finland, Denmark, Norway and Italy. Works can be seen in Tretyakov Gallery, Hermitage and other museums in Leningrad and in the Baltic States. A number of works from the collection published.

**Shterenberg,** Violetta Davidovna. Born 1918. Moscow.

Artist, member of Union of Artists of USSR. Collection comprises works by her father, Shterenberg (1881–1948), one of the leading artistic figures of immediate post-revolutionary years. Works regularly shown at exhibitions since the 1950s at Russian Museum, Tretyakov Gallery, and art museums in USSR, and abroad, at the exhibition Paris-Moscow (France, 1979), in Japan (1983), Finland, Denmark and Norway (1988). Works can be seen in Russian Museum, Tretyakov Gallery, picture galleries in Sverdlovsk, Yerevan and other museums in USSR.

**Shuster,** Solomon Abramovich. Born 1934. Leningrad. Film director and art critic. Father and grandfather well-known Leningrad collectors. **Kryukova,** Yevgeniya Valentinovna. Born 1931. Art critic. S.A.Shuster began collection of paintings, decorative and applied art early 1950s. Comprises Russian and Soviet painting *c.*1900–1950s and examples of West European and Eastern applied art. Works regularly shown at exhibitions since late 1950s in USSR, e.g. Russian Museum and Tretyakov Gallery and at exhibitions devoted to the work of individual artists, and abroad at the Paris-Moscow exhibition (France, 1979), in Japan (1983), Finland, Denmark, Norway and Italy. Collection of his father, Abram Ignatyevich Shuster, given to Hermitage (department of 15th- and 16th-century West European painting) and several works from his own collection given to Tretyakov Gallery. A number of works from the collection published.

**Sidorov,** Aleksandr Ivanovich. Born 1941. Moscow. Photo journalist. Collection formed 1970s. Comprises contemporary Soviet paintings and graphic works by non-traditional artists including Bulatov, Chuykov, Prisov. Works shown in many exhibition halls and at exhibitions devoted to the work of individual artists, as well as exhibitions in Italy, France, Switzerland and other countries.

**Smolyannikov,** Anatoly Vladimirovich. Born 1913. Moscow. Doctor, full member of Academy of Medical Sciences of USSR. Collection founded 1954. Mainly comprises Russian paintings and graphic works from the late 19th and early 20th centuries, and Soviet ceramics of the 1940s and 1950s. Works shown at Tretyakov Gallery, Academy of Arts, Moscow and at exhibitions of individual artists. A number of works from the collection published.

**Sokolov,** Mikhail Nikolaevich. Born 1931. Moscow. Artist, member of Union of Artists of USSR. Collection inherited from the artist Sokolov (born 1903) and Ivanovich (1885–1954), a physicist, and actively increased since 1953. Comprises Russian paintings and graphic works from the 19th and early 20th centuries, works by mid-19th-century French artists and decorative and applied art – ceramics and antique weaponry. Works shown at exhibitions in Tretyakov Gallery, Russian Museum, Minsk Picture Gallery and in exhibition halls, Moscow. Some works donated to Museum in Uglich and to museum in honour of the physiologist I. Pavlov, Ryazan. A number of works from the collection published.

**Stychkin,** Aleksei Yevgenyevich. Born 1942. Moscow. Translator. Part of the collection inherited; major part formed after 1975. Comprises Russian paintings and graphic works from the late 19th century to *c.*1930s, contemporary Soviet paintings and graphic works in non-traditional styles and examples of decorative and applied arts. Works shown in exhibition halls, Moscow.

**Voskresenskaya,** Tsetsiliya Aleksandrovna. Born 1923. Moscow. Collection based around works which belonged to the family of the avant-garde poet Ilya Lvovich Selvinsky (1889–1968). Comprises paintings and drawings by 20th-century artists e.g. Falk, Tyshler, Voloshin and Pasternak. Works shown at exhibitions

devoted to individual artists and at exhibition halls in USSR, Hungary and Austria (1988).

**Zaltsman,** Yelena Pavlovna. Moscow. Art critic, member of Union of Artists of USSR. Collection comprises works by her father Pavel Yakovlevich Zaltsman (1912–85), including 18 paintings and about 200 graphic works. Exhibitions of works in Moscow, Leningrad and Alma Ata. Individual works shown in Canada, Poland, Yugoslavia, Belgium, Sweden, West Germany and other countries. A number of works from the collection published.